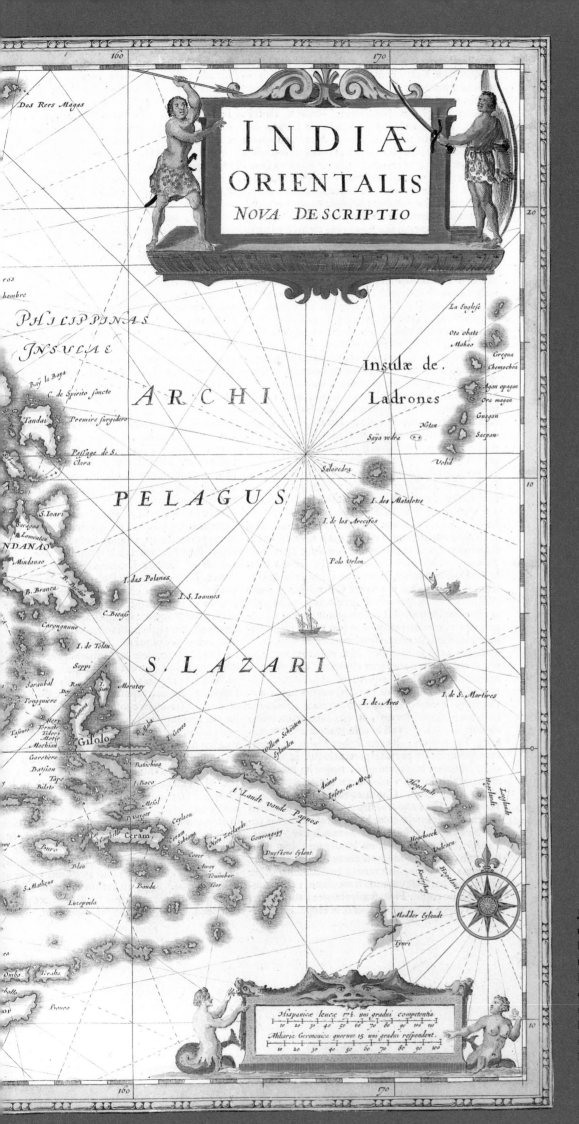

Jansson's *Indiae Orientalis*, a Dutch map of 1649, notes the "Islands of Good Fortune," west of Sumatra and south of the equator. This name for the Mentawai Islands stems from an incident in the early seventeenth century in which a European vessel became lost and drifted, losing most of its crew before eventually running aground there, thus saving its last survivors.

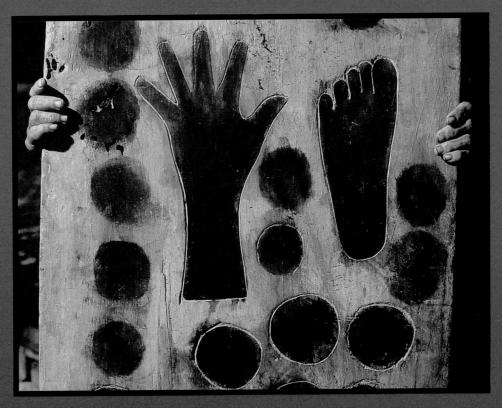

The death symbol (*takep*), made in wood relief, bears the tracings of the hand and foot of the deceased; the black disks represent the moons of mourning. This painting memorializes Aman Lau Lau Manai's father, whose death precipitated the young shaman's initiation.

The silty river begins to narrow and clear. From behind the reeds by a bend float eerie notes from a primitive flute; one little girl steps out to stare. The water becomes shallow and we leave the dugout canoe, continuing on foot. Drumbeats are punctuated by silence, as if the drummers are warming up. There's thunder in the distance. Men and women are chanting and laughing, and children are playing. My heart is pounding as they motion me on, balancing on the log pathway, coming within view of the longhouse. Some of the men are dressed like birds, with flowers and leaves mimicking feathers. Everybody stares . . . there's a strange, charged silence. One of the shamans, his face dyed yellow, his headdress full of flowers, approaches to greet me. We are introduced but I hear nothing, captivated by the eye-to-eye contact: we cross barriers without language. This is the story of our eight-year friendship, begun during Aman Lau Lau Manai's initiation as a

MENTAWAI SHAMAN

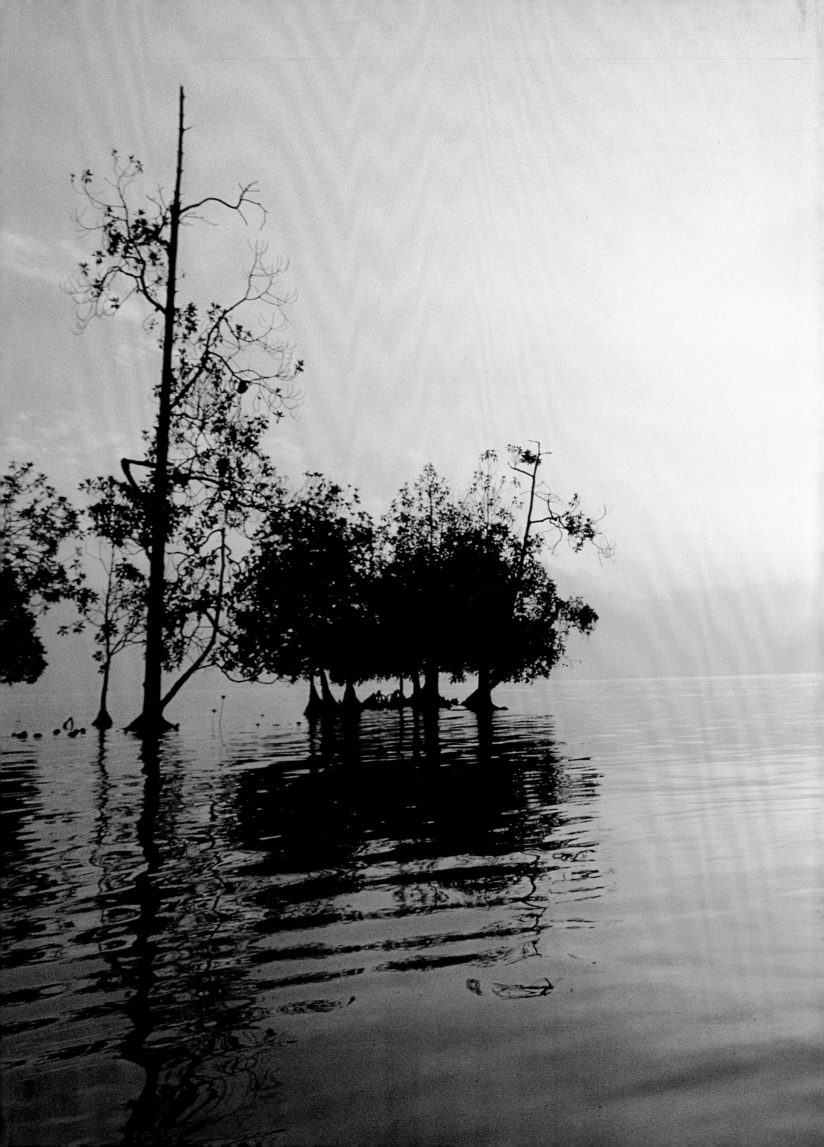

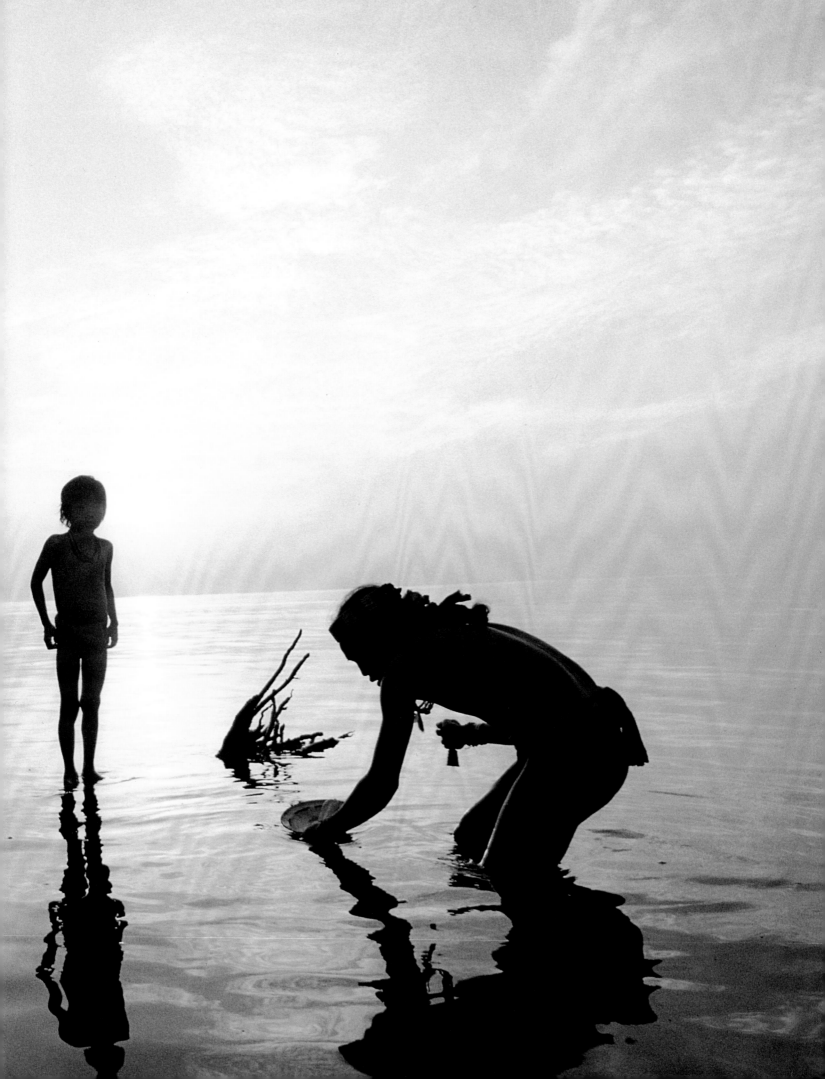

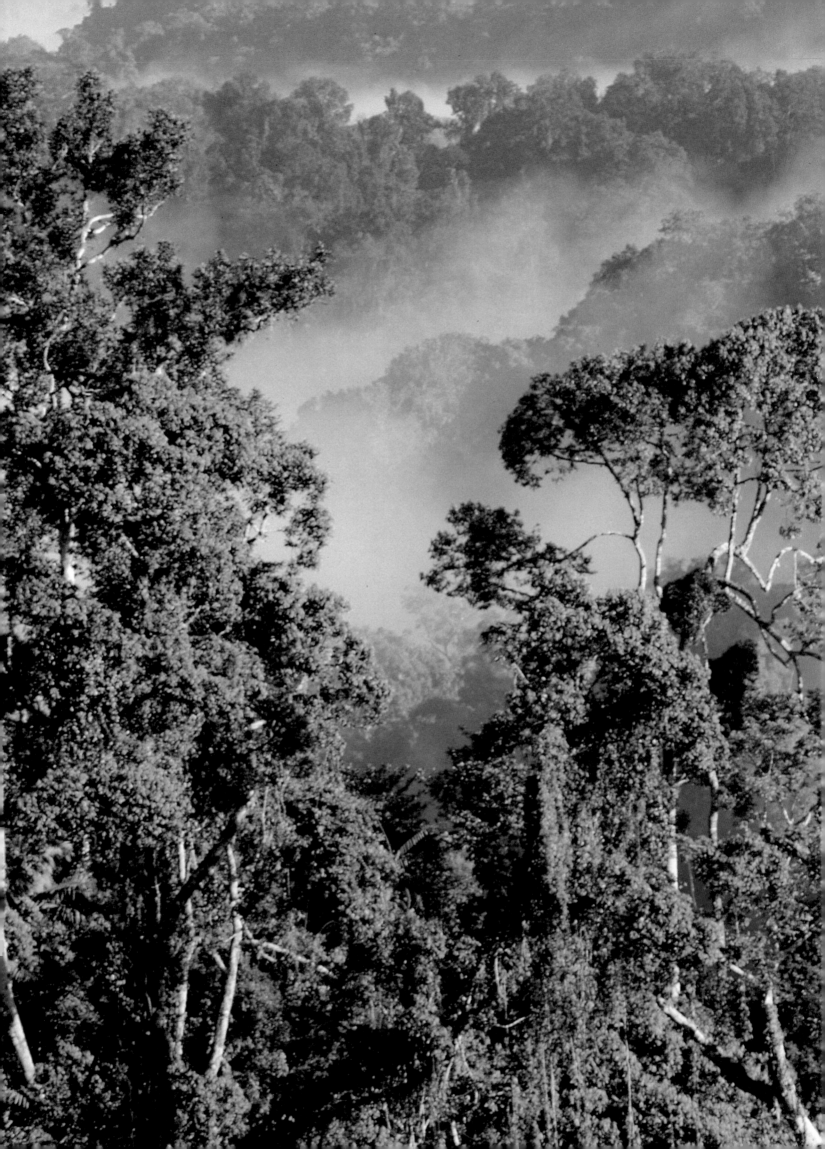

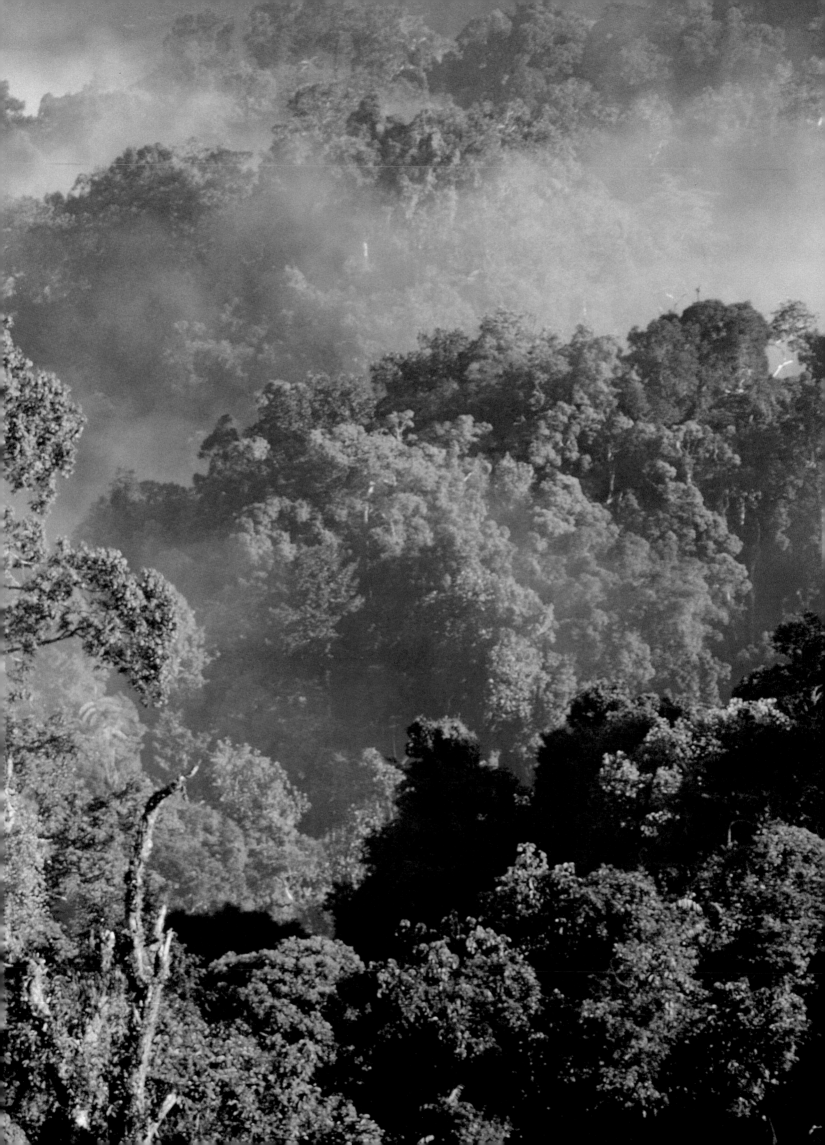

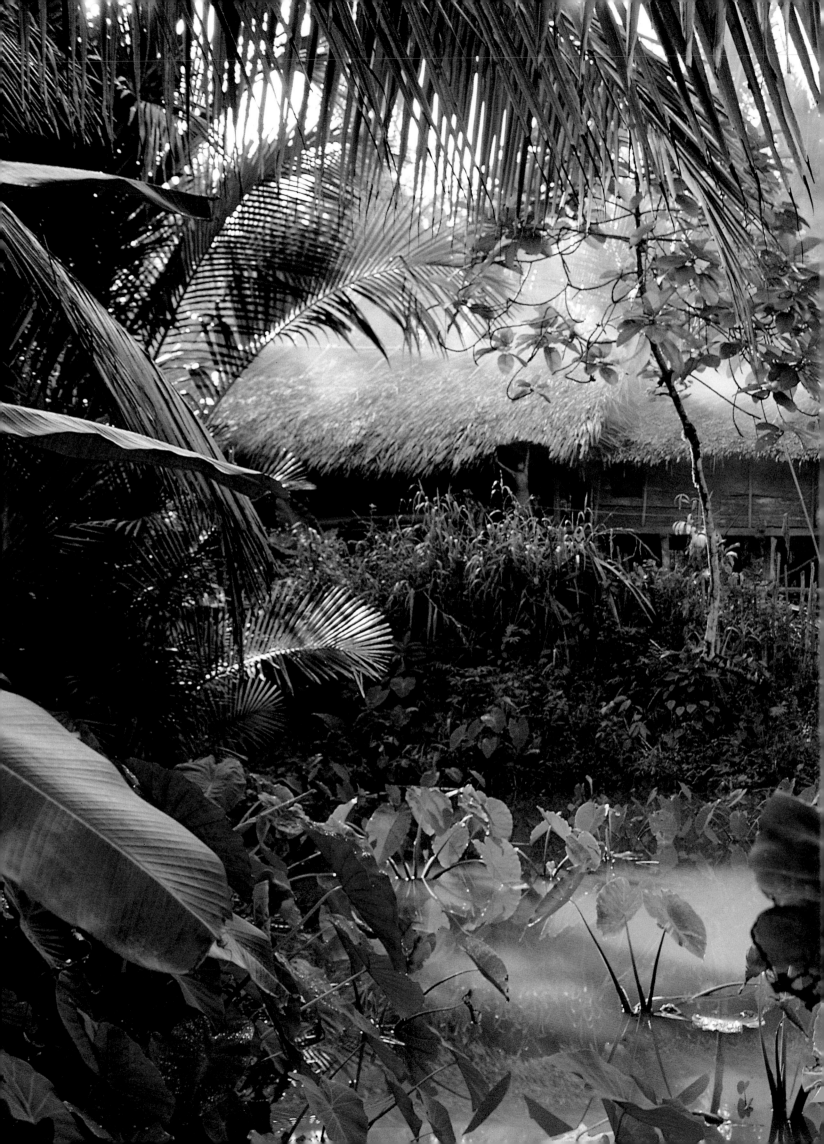

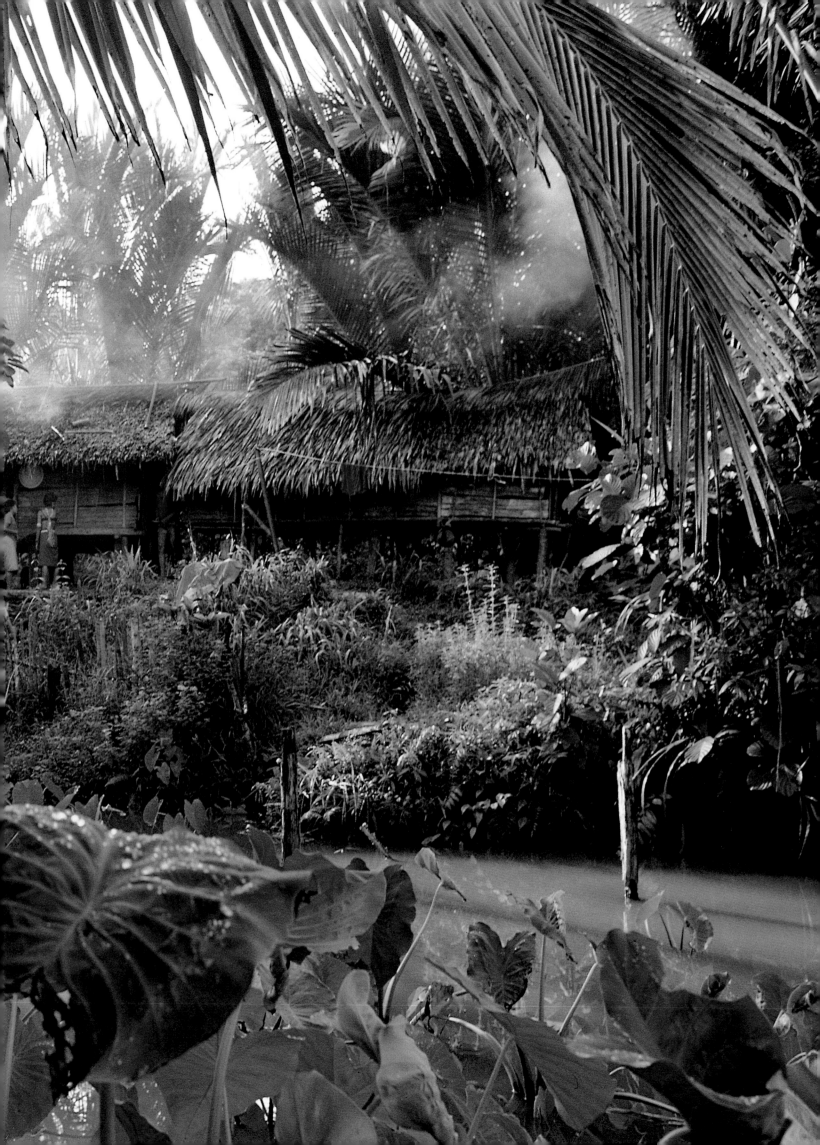

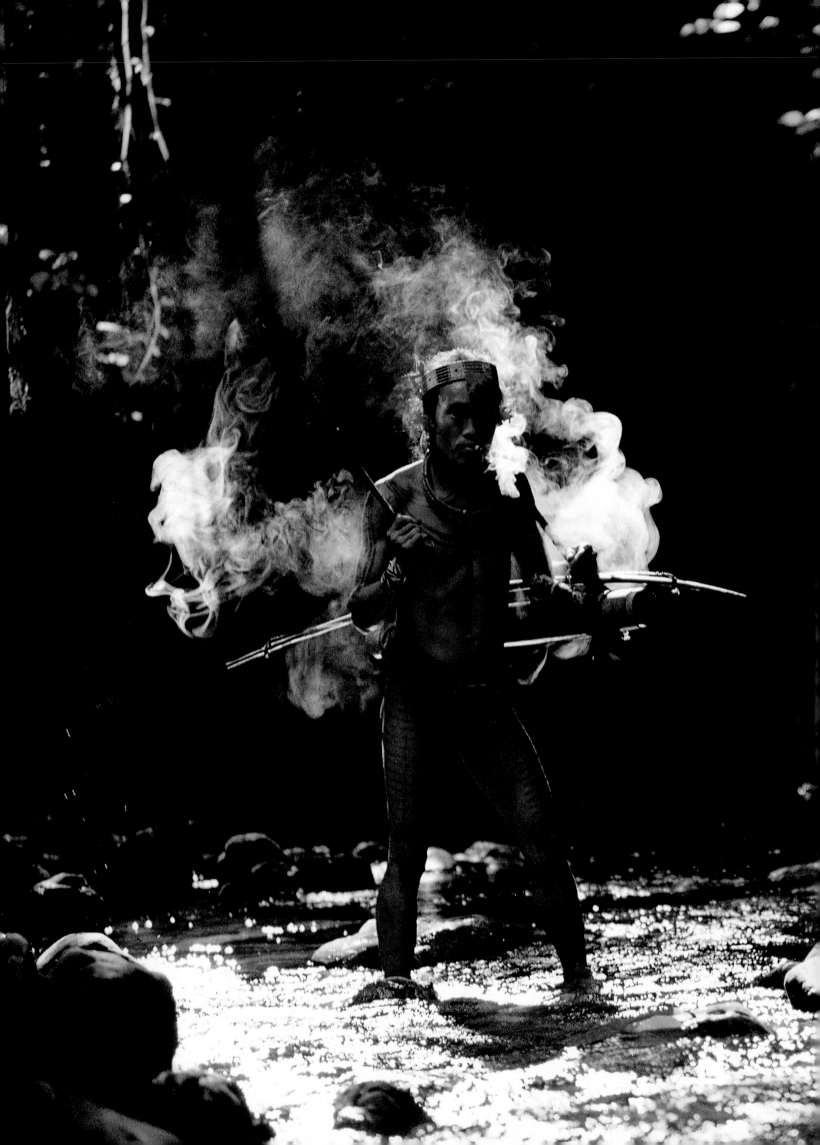

KEEPER OF THE RAIN FOREST
MENTAWAI SHAMAN

MAN, NATURE, AND SPIRITS IN REMOTE INDONESIA

PHOTOGRAPHS AND JOURNALS BY
CHARLES LINDSAY

HISTORICAL ESSAY BY
REIMAR SCHEFOLD, PH.D.

AN APERTURE BOOK

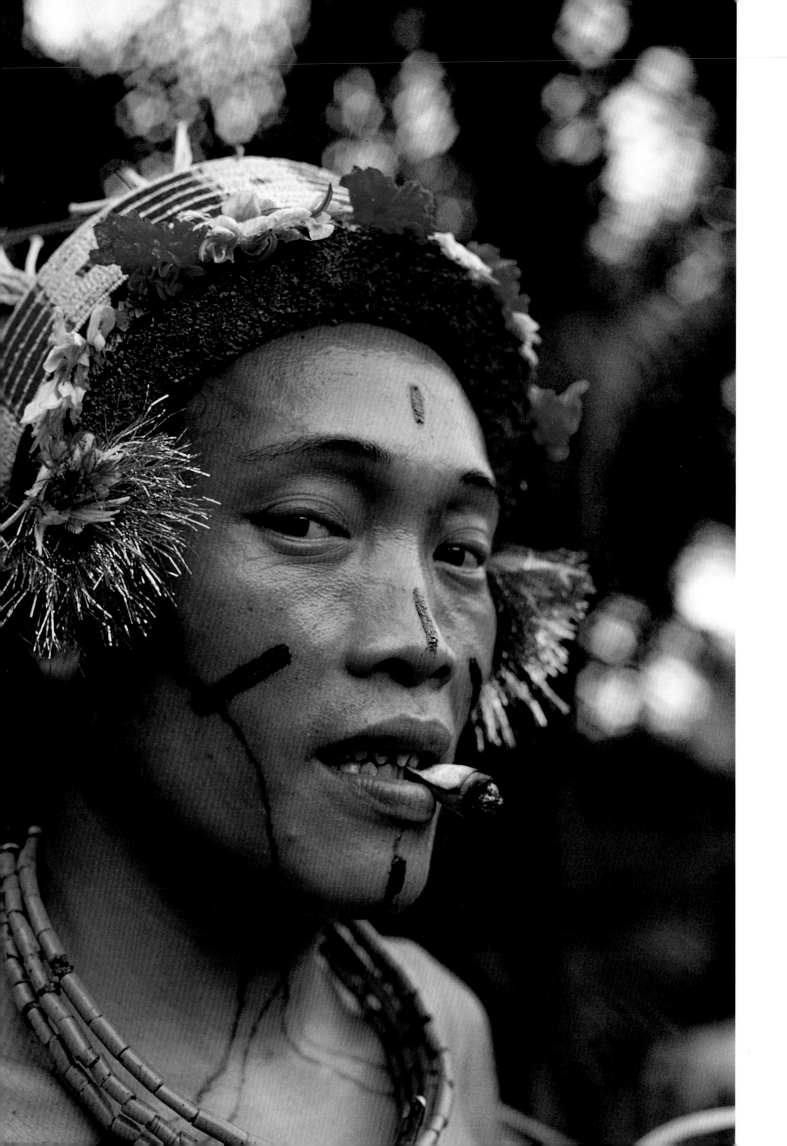

PROLOGUE

CHARLES LINDSAY

Chanting, Aman Lau Lau Manai prepares himself for the culmination of an archaic ritual to become a shaman, or *kerei*. The Mentawaian herbalist and witch doctor is a respected healer and medium for the spirits (*sigmagere*) inherent to all things. The shaman is a rare link to an earlier time when man understood nature. He is the keeper of the rain forest, responsible for maintaining man's harmony therein.

To Aman Lau Lau Manai I am a rarity, a faraway person, *sasareu*: a lone white man who favors tradition, eats monkey, and barters fairly, unlike most outsiders the Mentawaians have known, from Muslim traders to Christian missionaries.

The Mentawai Islands lie approximately sixty miles west of Sumatra. Siberut, Sipora, and North and South Pagai have evolved on their own for millennia. While the southern islands have been largely Christianized and logged since the late 1800s, areas of Siberut remain untouched. These endangered areas are recognized for their ecological wonder.

This remote and mysterious island of Siberut first captured my attention during a trip through Indonesia in 1984. Information was vague and hard to come by, and it took a great deal of patience and paperwork to obtain travel permission from the police in Padang. At the main port where the boat docks on Siberut, I saw a few tattooed people at a peripheral trading post and was intrigued. After a few days of smoking clove cigarettes with the local authorities I was granted a guide to the interior. The guide, whom I was paying, was traveling upriver anyway with two M-16–toting military personnel and a government edict to once again impress upon the Mentawaians the value of wearing clothes and abandoning their old ways.

The backcountry villages were quiet, many of the people having fled from repeated harassment. I became curious about what remained of the original culture after the decades the government had spent trying to erase it. I began the task of creating a phrase book for the unwritten Mentawaian language, learning from children who studied Indonesian in the mission schools in the villages. The more I learned, the more my interest focused on the few remote clans who were trying to preserve their traditions. Early on I knew I'd return, alone.

The Mentawaian culture has existed, ecologically balanced, for centuries. Now the last traditional Mentawaians waver on the brink of assimilation. Bureaucrats with their chalkboard "modernization" plans, power-hungry police with too little to do, and greedy loggers are the agents of shortsighted change. The traditional Mentawaian religion has been banned, along with loincloths, tattoos, and long hair—the pride of the *kerei*.

On my second trip I arrive like a trader from the 1850s with kilos of tobacco, glass beads, salt, mirrors, and machetes, and am invited to attend

Pages 2 and 3: Dawn at the edge of the mangroves on the east coast of Siberut. The shaman and his son summon our spirits for a journey.

Pages 4 and 5: A view over central Siberut's primary rain forest from a seldom-visited cliff. Like all significant geographic features on the island, the bluff, which was created by a landslide, is considered the home of powerful spirits.

Pages 6 and 7: The traditional longhouse (*uma*) is home to Aman Lau Lau Manai's family of twelve. During festivals, when all the in-laws are present, the *uma* shelters more than thirty people.

Pages 8 and 9: Aman Lau Lau Manai, *kerei* and hunter, traversing one of the many streams that create a travel network through the island of Siberut.

Opposite: Portrait of the *kerei* Aman Lau Lau Manai, master of archaic Mentawaian traditions.

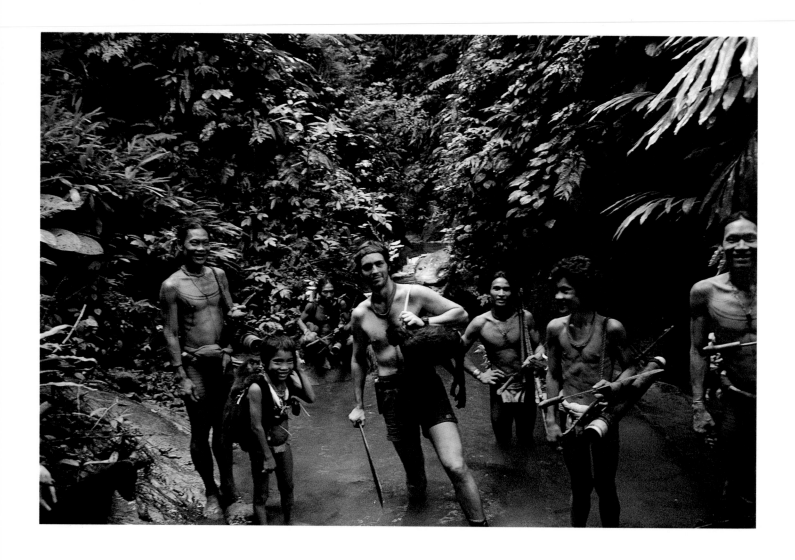

Portrait of Charles Lindsay with hunters taken by Aman Lau Lau Manai.

Aman Lau Lau's festival. Some people are shy toward me, while others joke about my nose and my hairy legs like a monkey's. Aman Lau Lau's *uma*, or longhouse, is a traditional dwelling situated alone in the upper reaches of a drainage basin, unlike the government-established villages downriver where most Mentawaians now live. Communal life in the *uma* affords little privacy; the *kerei* sing their songs and chant, babies cry and are cared for, dogs fight over scraps, chickens cluck, and pigs snort below the floorboards.

Although the young shaman had no experience with whites other than seeing missionaries once a year, he welcomed me. Our form of communication was basic at first, and yet on a higher, more intuitive level, we trusted each other. Our similar ages, and Aman Lau Lau's father's recent death, helped to strengthen our bond, which was perceived as a rare gift.

Time passes easily. The young *kerei* and I bathe in a secret pool and anoint ourselves with *kiniu*, the wild turmeric root. It is clear that my interest in shamanism is being taken seriously, and I am grateful. We share tobacco and watch as the girls gather flowers for the festival. There is great merriment in outfitting me in a loincloth of bark, with arm bands and headband, leaves, and flowers. Dance lessons from Aman Lau Lau's mother, Lumang, are sneaked in between her more serious duties. My presence draws more guests to the festival, and this is a source of great pride for the family.

Before the festival can commence, pigs and chickens need to be raised to pay the young *kerei*'s teacher and to provide for the guests, who include four other shamans and their wives and children. During major festive periods, called *puliaijat*, all work is taboo except for necessary cooking and rituals.

Though the Mentawaians have many *puliaijat*—for the cutting of trees, the building of canoes and longhouses, weddings, funerals, spiritual wars, and peace parties—this festival for the new shaman is the most important and occurs infrequently. The Mentawaian belief system is animistic and has many taboos limiting the harvest of game and timber, thus maintaining balance and preserving the connection between man and nature. The *kerei* is the mediator of this relationship. The well-being of his people depends on an unfailing attention to this balance.

Sagu, the main food staple, is readied; firewood has been collected, along with bamboo for cooking and storing meat. It is *tadde*, the first of five main festive nights, when the house is ritually cleansed and the spirits are summoned. The shaman's initiation festival takes place after many months of study and anticipation under a master *kerei*.

Aman Lau Lau glides through the house, touching the tail feathers of a chicken to each person and to the main beams of the *uma*. While chanting, a nonshaman commits the sacrifice, and the *kerei* gather around to interpret the message written on the intestines. The results are favorable, and a pig is noosed at the ankles from a nearby cage. There is horrendous squealing as the pig is drawn onto the porch, struggling and heaving. Ominous chants begin and are repeated, hand bells ring, and sacred water is poured on the beast. The action reaches its peak when the iron dagger is plunged through the pig's throat; then the noise eases and the animal is charred, divided, and cooked. Once more the intestines are interpreted, this time along with the heart and spleen. One of the boys uses a live ants' nest on a stick to chase off the barking dogs. Pervasive ritual and endless taboo are the norm; the mood is calm and optimistic.

Over the course of five weeks, four of the five main festive nights climax with dancing and spiritual visions, which last until dawn. Between these days, Aman Lau Lau continues his study and initiation in the company of the other *kerei*. I go with them into the forest to collect magical and medicinal plants. The elders explain to me the myriad reasons for and the intricacies of illness, from supernatural emanations and black magic to the violation of taboos. To the shaman, the jungle is alive in a way unfathomable to modern man. There are multitudes of meanings in the physical form, smell, and taste of plants and trees. Cures have developed over centuries of trial and error and continue to evolve today.

As we walk quietly along a streambed, an infinite number of spirits surround us. The *kerei* stop to pick a heart-shaped leaf, used to treat heart problems; a pitcher plant holding magic water; a wonderful flower for its scent; and a branch that symbolizes a mythical beast of the woods whose name, *Silakkikio*, is only whispered. Some medicinal recipes might require a plant that grows near a bat cave; such a plant would receive its properties from the cave. The *kerei* point out and explain many of the plants we walk past without taking them: it would be a breach of taboo to take what is not necessary.

Some nights later is *sigeugeu*, the time for the *kerei* to receive spiritual power. Later still comes *letchu*, when he is fitted with a magic anklet of woven rattan, for bodily protection. Weeks of rituals pass during this spiritual period. Every action has meaning; the shaman's reverence for the natural balance is awe-inspiring. I have come to admire Aman Lau Lau for his pride, intelligence, and humor.

On the fourth festive night, one of darkness and silence, *sigepgep*, I am suddenly overcome with a dangerously high fever and an excruciating headache. It is an eerie time; no dancing takes place. The shamans are concerned

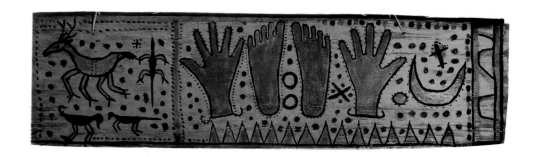

about my fever. Word has spread of a young Dutch musicologist who died on the coast from complicated malaria a few months earlier. I hear the shamans utter the words *kisei* and *sanitu*, referring to either a break in taboo or an evil spirit. Aman Lau Lau leaves by torchlight and later returns with a preparation of medicinal plants, which he grates and presses between a leaf. He instructs me to squat on the dance floor with my eyes wide open, eyes and palms facing the ceiling, then leads the other *kerei* in a wild sort of "exorcism." They circle me, ringing their hand bells, chanting faster and faster, coming in and out of focus as they drip the concoction onto my head and torso. I am instantly chilled. They continue to circle until at last the men squeeze my head, forcing the evil from my cranium onto a religious plate. The pain of the finale makes the rest pale by comparison, and I retire for the night in wonder and exhaustion.

The following day I wake feeling better; my fever has subsided. In the distance a gong echoes three times for each of seven pigs sacrificed. During the early morning hours, the children tease me from behind a slatted wall. With a pulsing headache to blame, I sit up and yell—startling the children. Aman Lau Lau's daughter, Ruki, comes down with identical symptoms, and it is assumed that the lingering evil has leapt from me to her. In fact, I am soon well again, though weakened.

On the trail one day, we come across a team of Indonesian loggers who are resurveying expired timber claims. As we approach, I see that they are using bottled poison to stun shrimp in the river for their dinner. They're killing hundreds—every last one. I despise them but smile my way into their tent to inspect the claim maps and see the areas proposed for clear-cutting. Speaking Mentawaian, which the loggers don't understand, I tell my friends what the writing means, that these men are their adversaries. But they don't really comprehend—even though they've heard of deforestation elsewhere.

With the final week comes *alup,* the last festival night, which culminates the initiation of the new *kerei.* Huge bamboo poles are erected near the river. Wood carvings of birds, men, and fish hang from their tops, bending them over. There are seven of these poles, one for each pig sacrificed. They welcome the guests and spirits. The three remaining live pigs are brought into the house; they are especially large. The noise is raucous; several of the *kerei* and their wives go into trance during the remembrance of *ukkui,* their ancestors. After the pigs are sacrificed, two of them are bound above the floor. The shamans run underneath with their youngest children, blessing them so that they may raise many pigs one day.

Many people arrive in the evening. Some come from traditional settings, while others, from villages downriver, are dressed in shorts and T-shirts. Though they are all Mentawaian, I wonder how much the change in clothing symbolizes a change in mentality. One of the villagers shows off his shortwave radio, which emits a static-filled BBC London broadcast.

Python-skin drums are heated by the fire to tighten the skins. Singing and

stomping on the dance floor drowns out all else. The outside world is very far away. More than twenty different dances are performed throughout the night, ending with a story and dance about the Mentawaians coming to Siberut on a wild sea. The dancers use a specially carved wooden boat, its mast and sail made from a seven-cent pack of Kaiser cigarettes. The *kerei* move with the mythical storm, pounding the dance floor, riding the waves, and end in trance.

In the chilly predawn hours, the teacher asks the last few questions to test Aman Lau Lau. He answers, enacting parts of a bird dance in silence. Then the teacher blows in Aman Lau Lau's ear so that he can hear the spirits. Next, the men lock eyes, staring at each other intensely as if asking and answering questions without speech. At last the teacher's energy surges forth, knocking Aman Lau Lau backward. He crashes to the floor in a quaking trance. The other *kerei* join in to calm him, fanning and blowing.

With sunrise comes a final bit of magic, *gaut*: incantations and special ingredients are added to the protected amulets. The wives take part, bringing symbolic food. Then the *kerei* sit on the floor and help negotiate Aman Lau Lau's payment to his teachers. The discussions are cordial; leaves and sticks are used as counters. Eventually a fee is arranged. It is high by Mentawaian standards: one small and two large pigs, two coconut trees, eight durian trees, two *sagu* areas containing twenty to thirty young palms each, two cocks, two hens with chicks, one taro patch, one machete, and one ax. Aman Lau Lau Manai is now a *kerei*, a shaman, the embodiment of the cultural apex of the Mentawaians. A ritual monkey hunt follows the festival.

Preparing for a ritual monkey hunt after a major festival. The men recount stories as they anoint their arrow tips with fresh nerve poison.

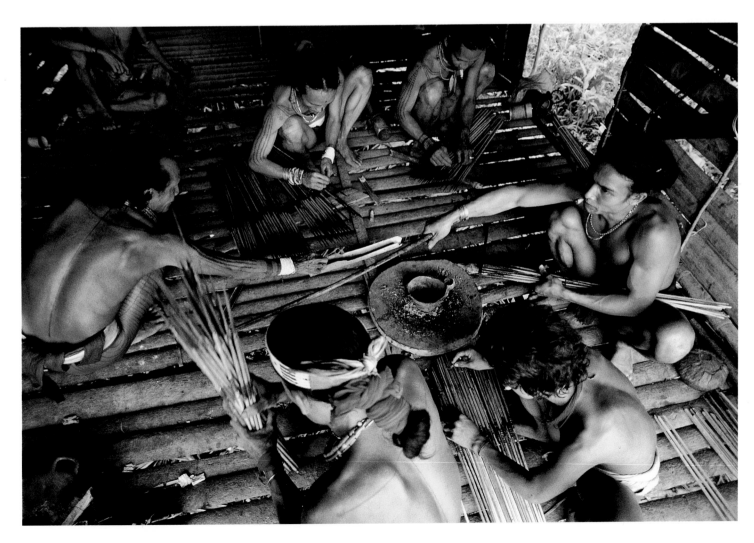

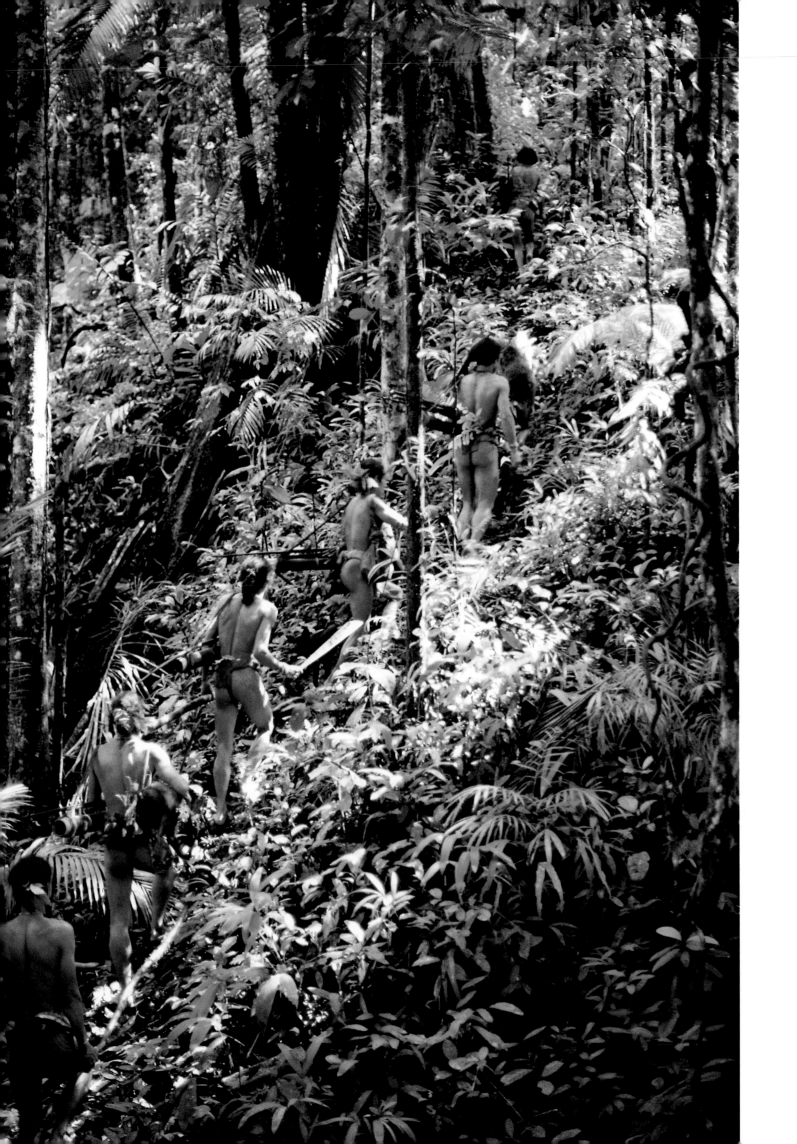

THE MONKEY HUNT

The monkey hunt is planned, but we say only, "I'm going to gather arrow shafts," upon departing the longhouse. No mention of hunting, arrows, or poison tips may be made for fear of the spirits' vindictive reprisals. There is no show of emotions. Yesterday the poisonous *raggi* bark was ground with *laingi* tuber and chili, a circulatory stimulant, then pressed and heated to anoint the arrows.

Small offerings are made to the monkey skulls hung piously in the rafters. It is believed that living monkeys allow their souls to be reunited with their dead ancestors via the kill. Aman Lau Lau explains, "We must give some of everything we take to the spirits. We offer *sagu*, coconut, plants, and fish from the river, to protect us from sickness. We go now in silence."

The trail is muddy in the low-lying areas where sago palms are plentiful. We hike out of the swamp, up into the forest hills. Scorpions lurk under rotting trees, and leeches cling to overgrown plants. Pig routes crisscross the paths we search for the tracks of wild boar and deer. The walking is not uncomfortable, but it's tedious. Networks of roots create uneven steps, and footholds are hacked into the sedimentary base; fallen trees laid end to end provide paths over slippery and deep spots. Mentawaians, however, have extremely strong, tough feet. Each toe works independently and is capable of taking advantage of the smallest hold.

Opposite: On the trail in central Siberut during a ritual hunt. The game is decorated with leaves, symbolizing gratitude and pride. *Below:* Aman Lau Lau aims at a fleeing monkey, bearing down with a poison-tipped arrow.

Overleaf: The hunt campsite is a long day's walk from the longhouse, where married women and children remain behind. The girls gather firewood while the men build a temporary shelter. Because of taboo, *keikei*, the girls won't fish until after the first monkey is taken.

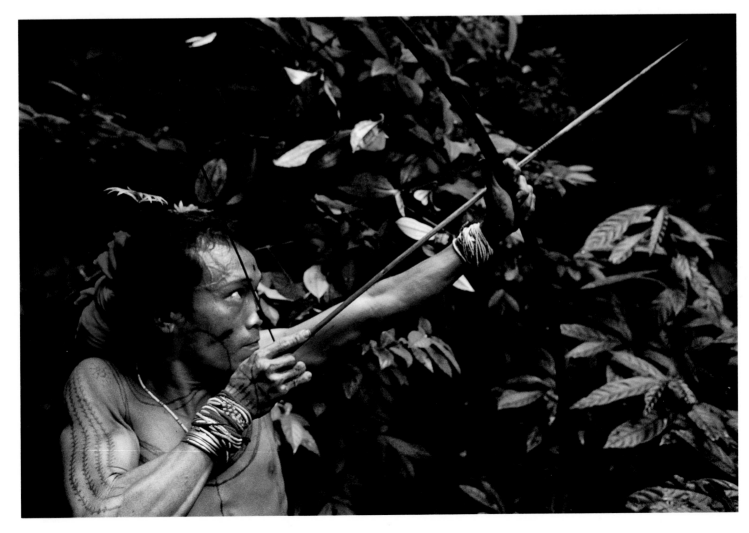

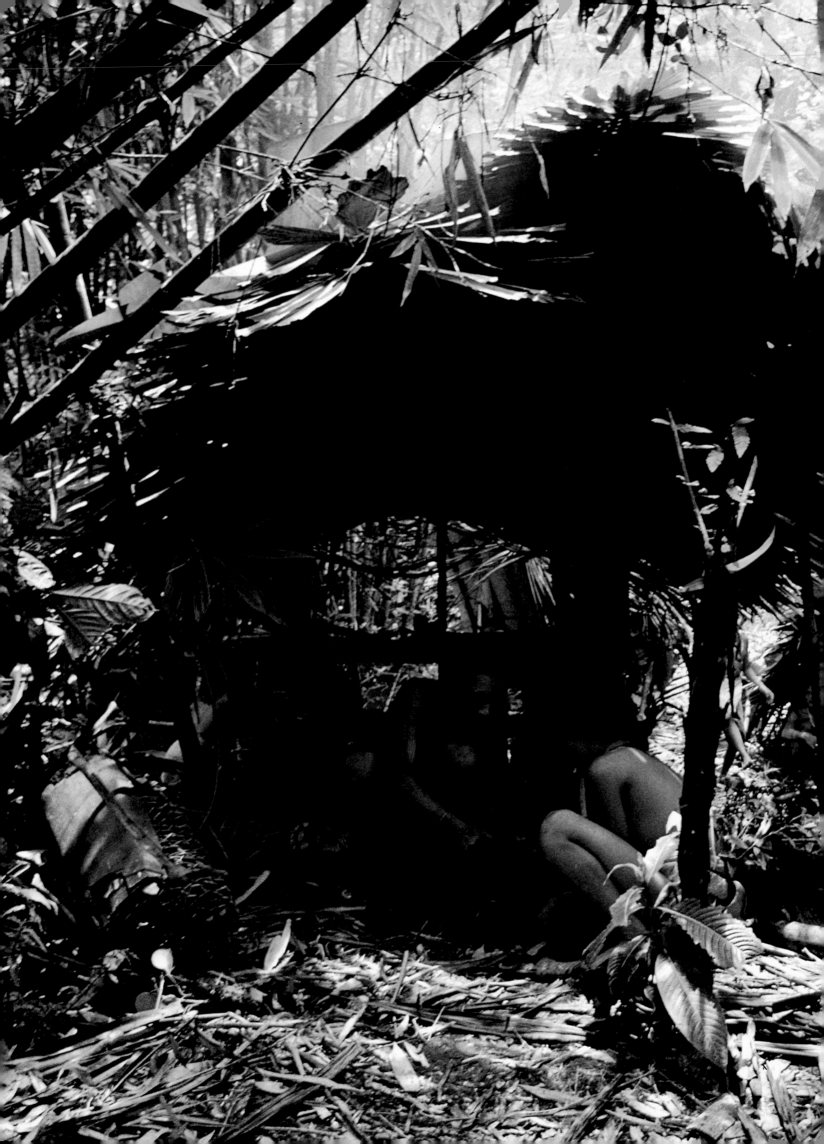

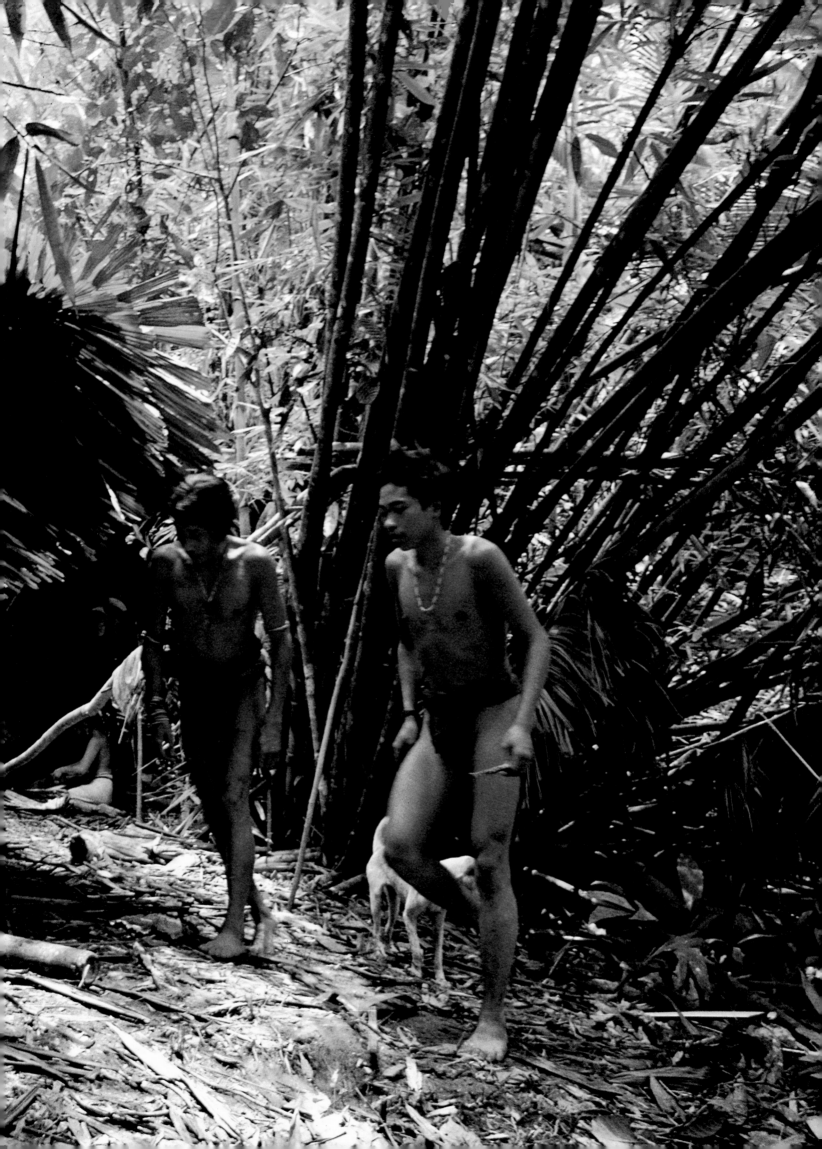

For safety, I am never first or last on the trail. The men clear just enough of the path to accommodate their small size—Aman Lau Lau is five feet, two inches tall. My extra height results in more than a few bruises as we pass through the jungle. The shaman may not kill without rites, but the deadly green viper seems to be an exception; Aman Lau Lau is swift and accurate with his machete when the snake crosses our path.

The hunters try to approach the monkeys without being seen or heard. Early morning is best. The langur, macaque, and pigtailed langur are prized, but the Kloss gibbon is not hunted due to strict taboo. Once the poison takes effect, one of the men climbs high into the tree to retrieve the monkey.

Torrential rain is a joy once the cameras are protected. As the roar of the rain approaches, the hunters stop hiking and hurriedly chop and arrange wild banana leaves to create small lean-tos. First the rhythmic tip-taps of raindrops, then the fresh wind borne on the wave of the downpour moves the woods. Bands of rain fall in varying densities and the forest canopy sways with the strong gusts. The squall quickly passes. Even before the rain abates, the sky brightens, and we prepare to hike again.

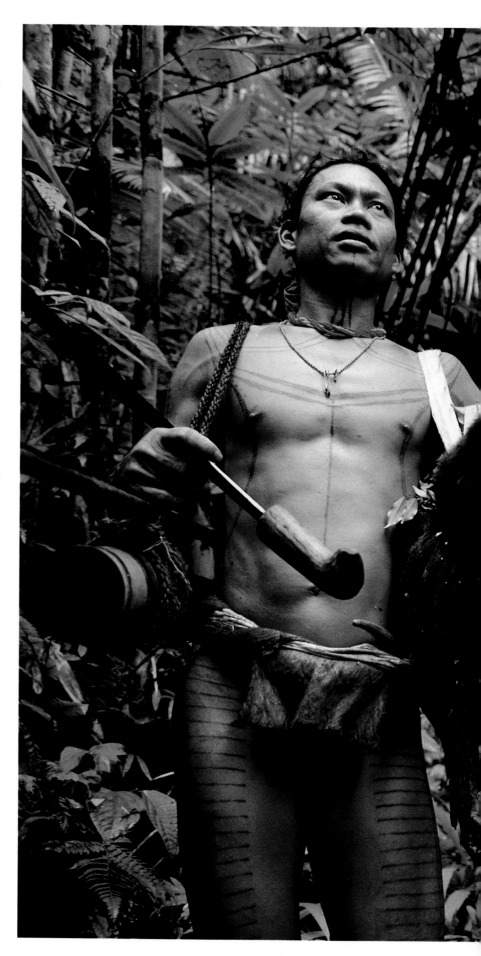

The hunters (left to right) Aman Depa, Irat Kerei, and Matolat return to the camp after spending a night in the forest. They have been successful, taking four pigtailed langurs early this morning.

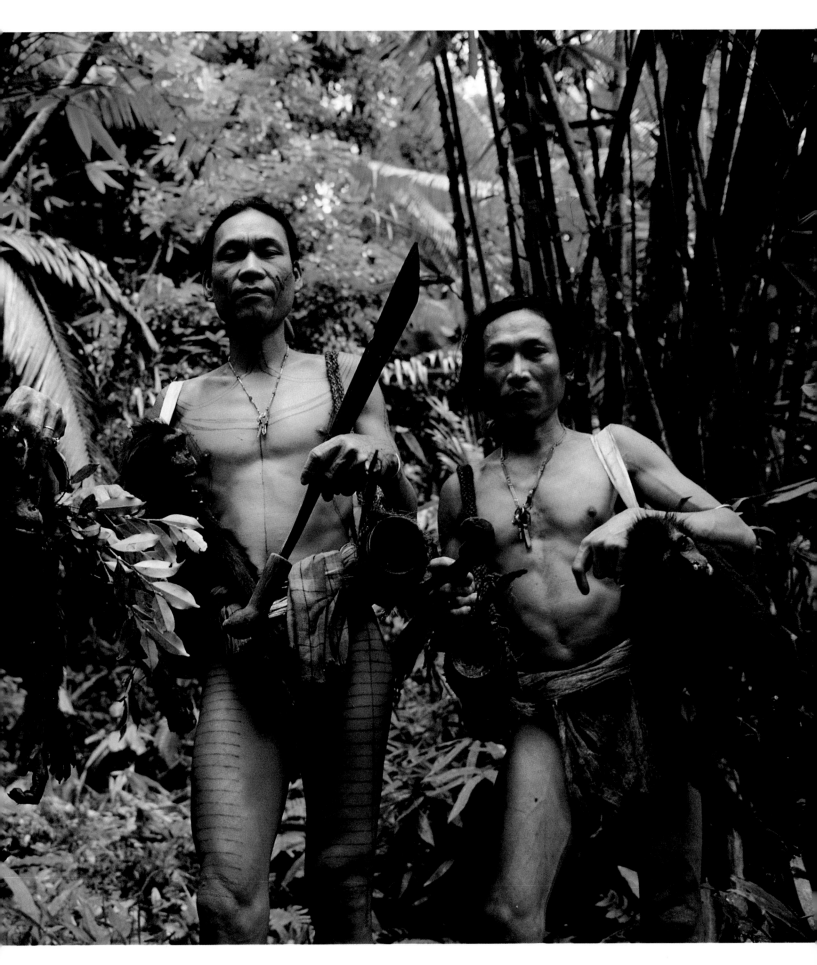

A LEGEND FROM THE WEST COAST of Siberut, the original Mentawaian homeland, tells of an adept hunter who took great pride in preparing his poison-tipped arrows. After traveling some distance, he realized that one of his anointed arrow tips was missing, but he continued on. At a ridge he heard the speaking drums (*tuddukat*) announcing a death in his name. He hurried home, confused, to find that his son had played with the missing arrow tip and fatally pricked himself. Feeling responsible for the death, the hunter took his own life by the same means. Aman Lau Lau recounts this legend, making clear his responsibility for all of us on the hunt and and for our families as well. Should an illness or death occur while we're away, he would be held to blame, and in severe cases his possessions seized to balance any misfortune.

Below: Aman Lau Lau's brother, Pakae, cleans a pigtailed langur, while Ulak, son of Aman Depa, cleans another in the background. *Opposite:* Ulak tends to the monkey soup, made from heads and innards. The remaining parts are smoked and saved for the family waiting at home.

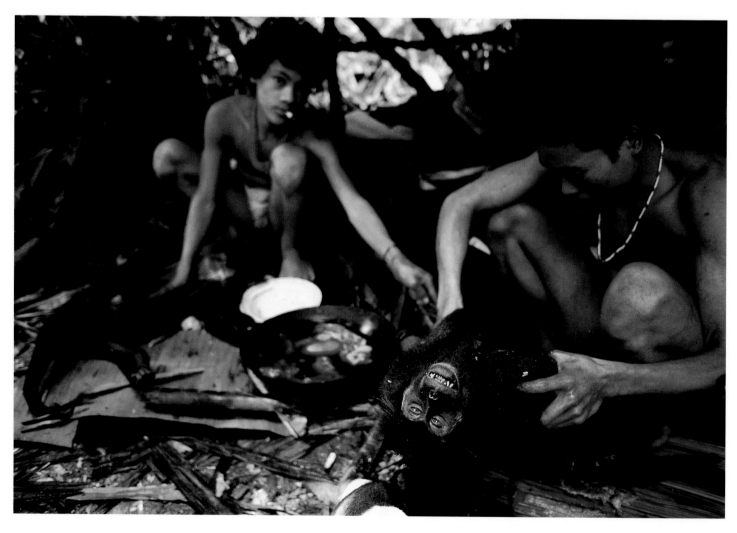

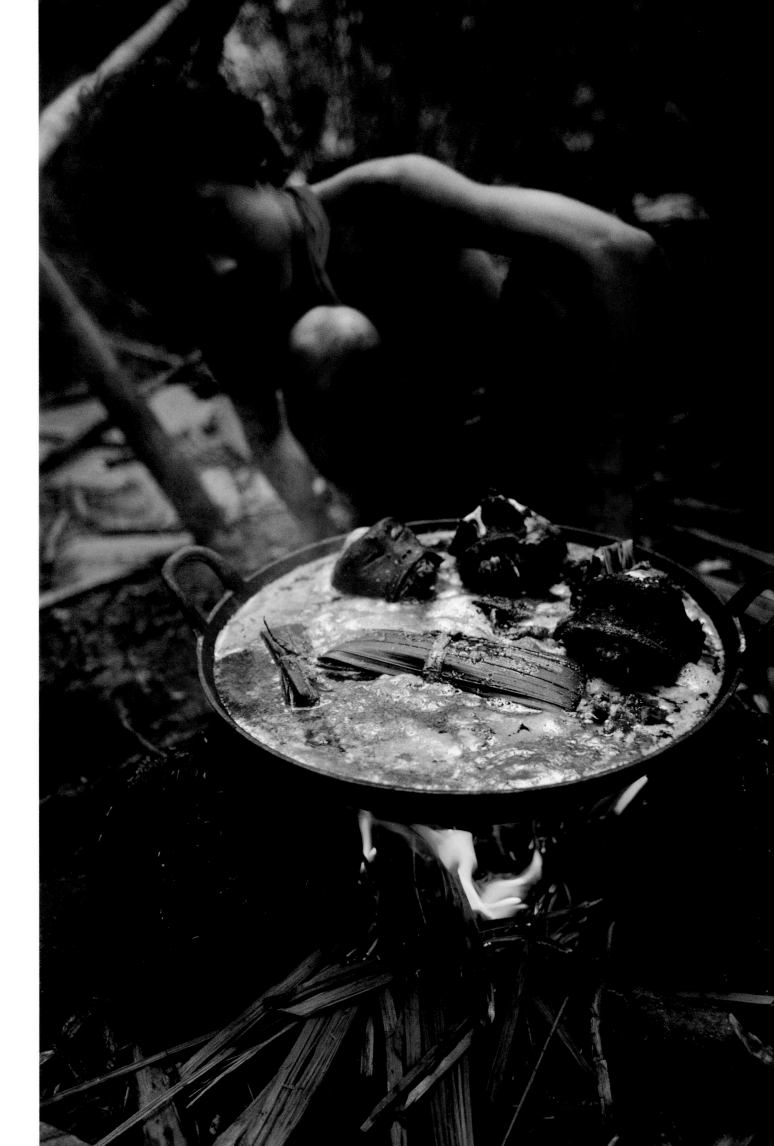

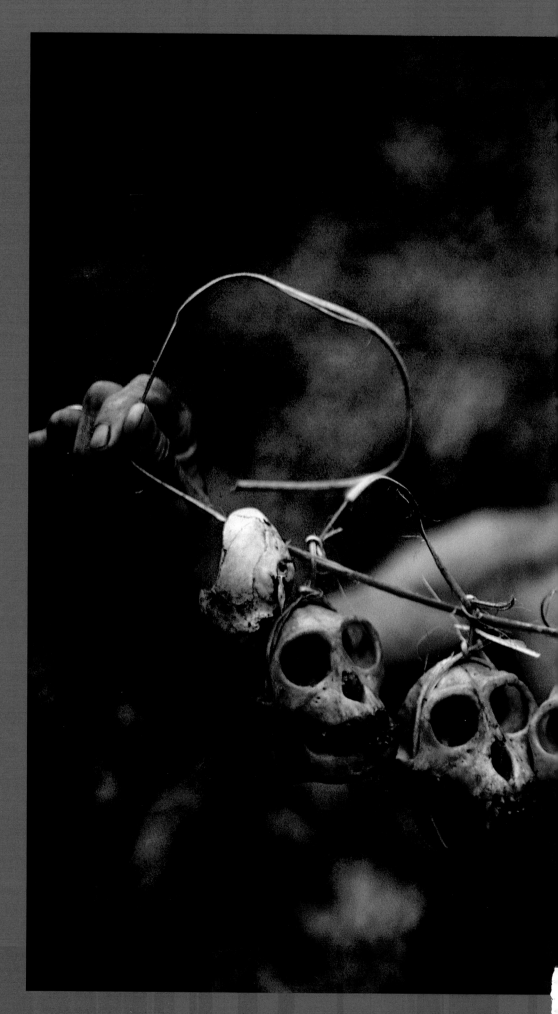

Tosi displays the trophy from the hunt. Once the hunters are home, the talking drums proudly announce their success, challenging the other clans to better this hunt. The skulls are placed in the *uma* to retain the monkeys' spirits.

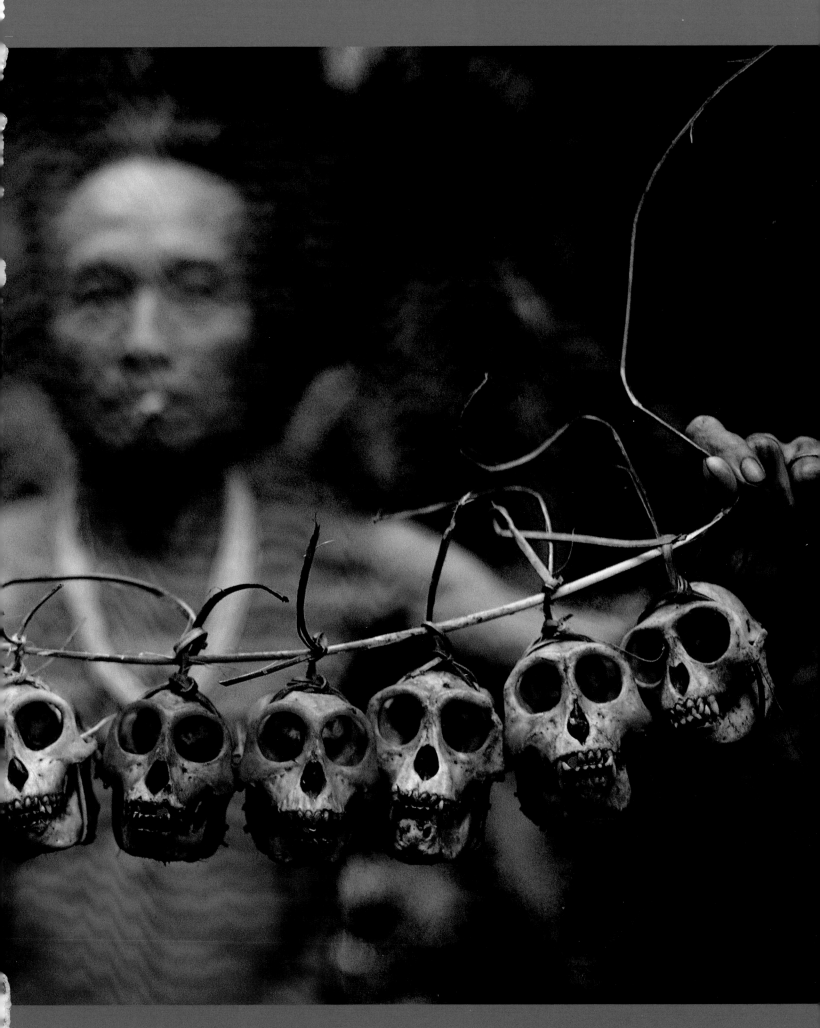

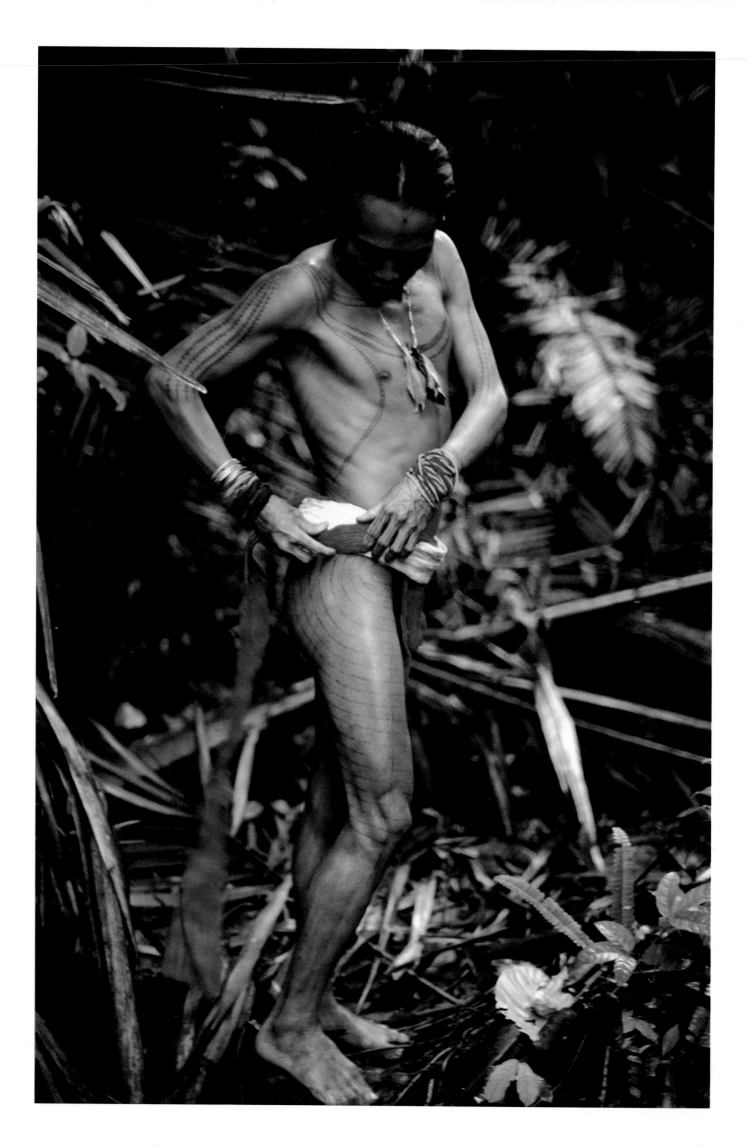

THE FESTIVAL

The festival begins once the spirits allow the capture of large domesticated pigs, which are usually left to roam and fatten in the swamps. This morning three pigs were trapped in an enclosure a twenty-minute walk from the longhouse (*uma*). It has taken almost a week of waiting.

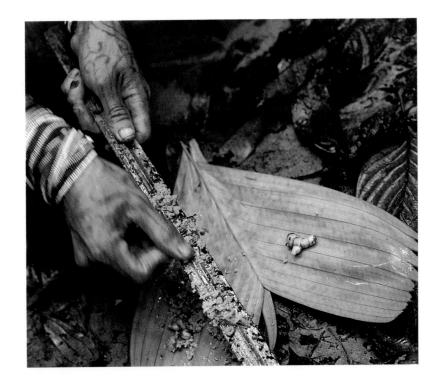

This page and opposite: Aman Lau Lau begins his beautification, which includes bathing in a secluded area, smearing his body with fragrant ground turmeric, painting his face, and fitting himself with a special loincloth of softened bark.

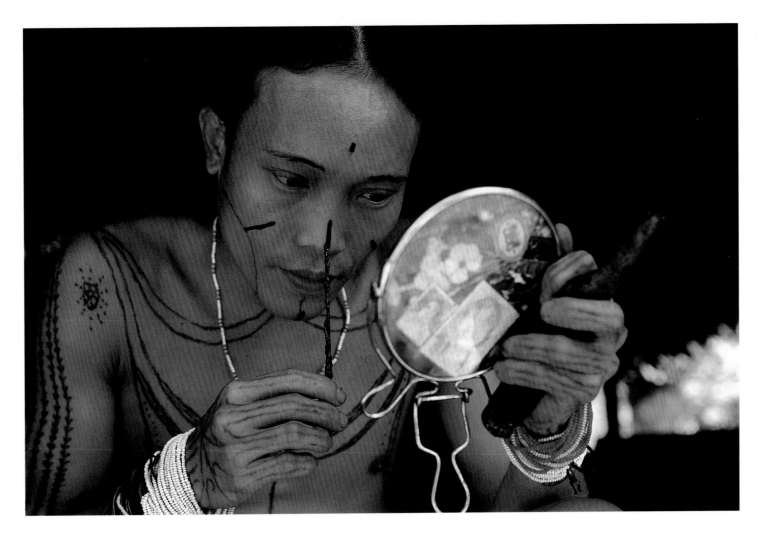

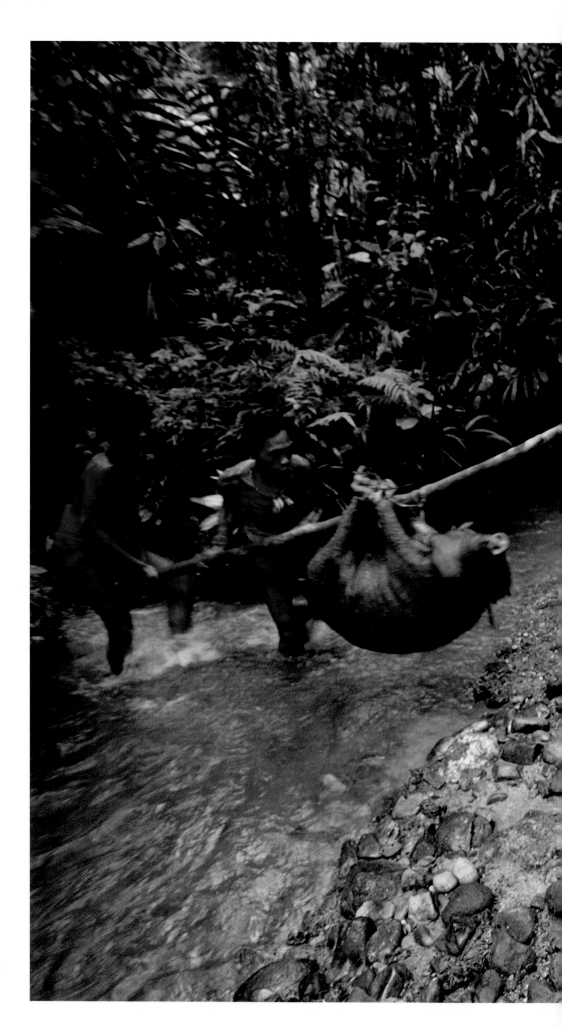

The pigs are bound to a pole and carried
alive through the swamp and streambeds
to the *uma* to await the sacrifice.

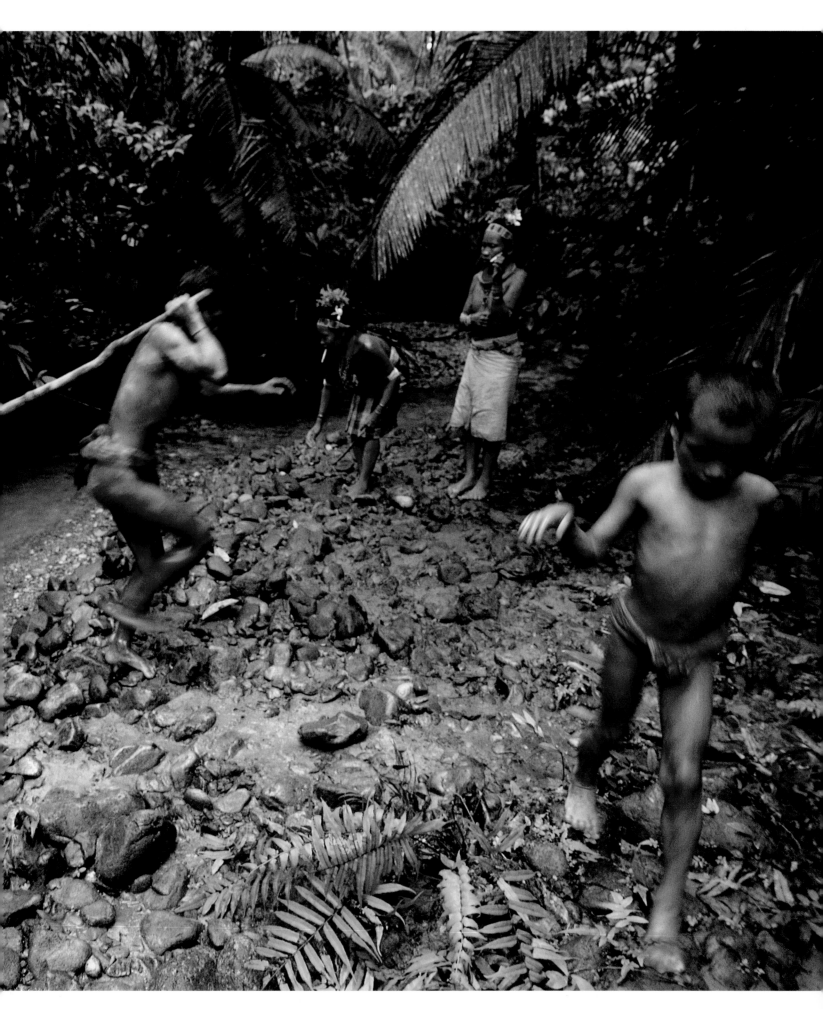

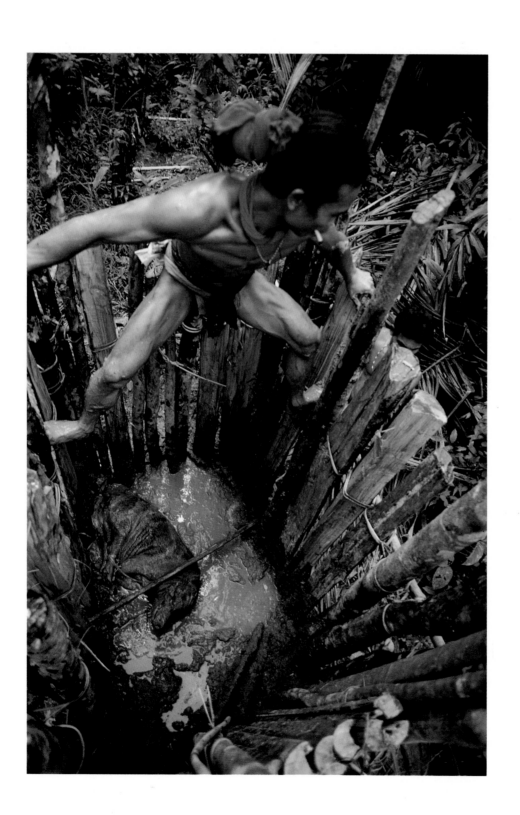

Left: Repairs are needed where cracks, caused by the pigs bashing the bound sapling walls of the enclosure, appear on the rattan ties. Eventually the pigs are noosed at the ankles and carried off one by one. Before and after the capture, the *kerei* lay out magic leaves, grated and arranged in multiples of three. *Opposite:* Magic waters are poured from a specially prepared coconut, blessing the sacrifice and those taking part.

Pages 32 and 33: Once the sacrificial pigs are confined, Aman Lau Lau sets off from the longhouse to invite the guests, seen here crossing the old covered bridge from the village, called Ugai.

Pages 34 and 35: Aman's wife, Bai Lau Lau, prepares her headdress with help from Aman's sister Leiai. Bai Lau Lau's daughter, Tingi, and a guest watch.

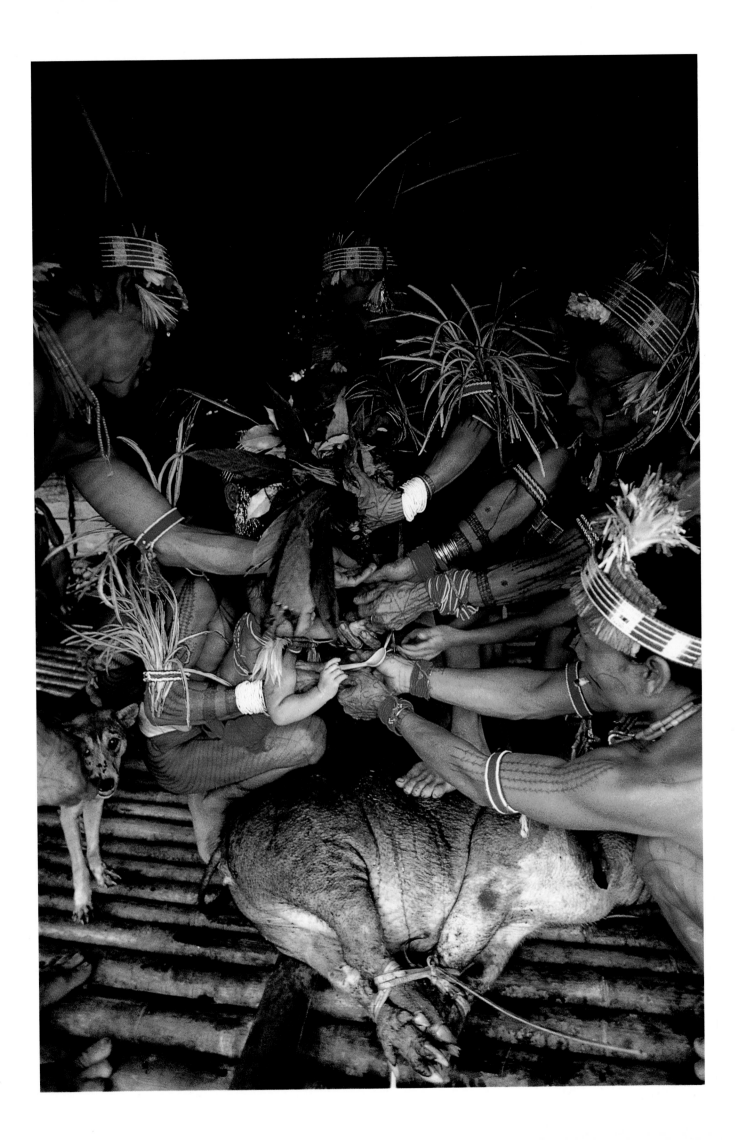

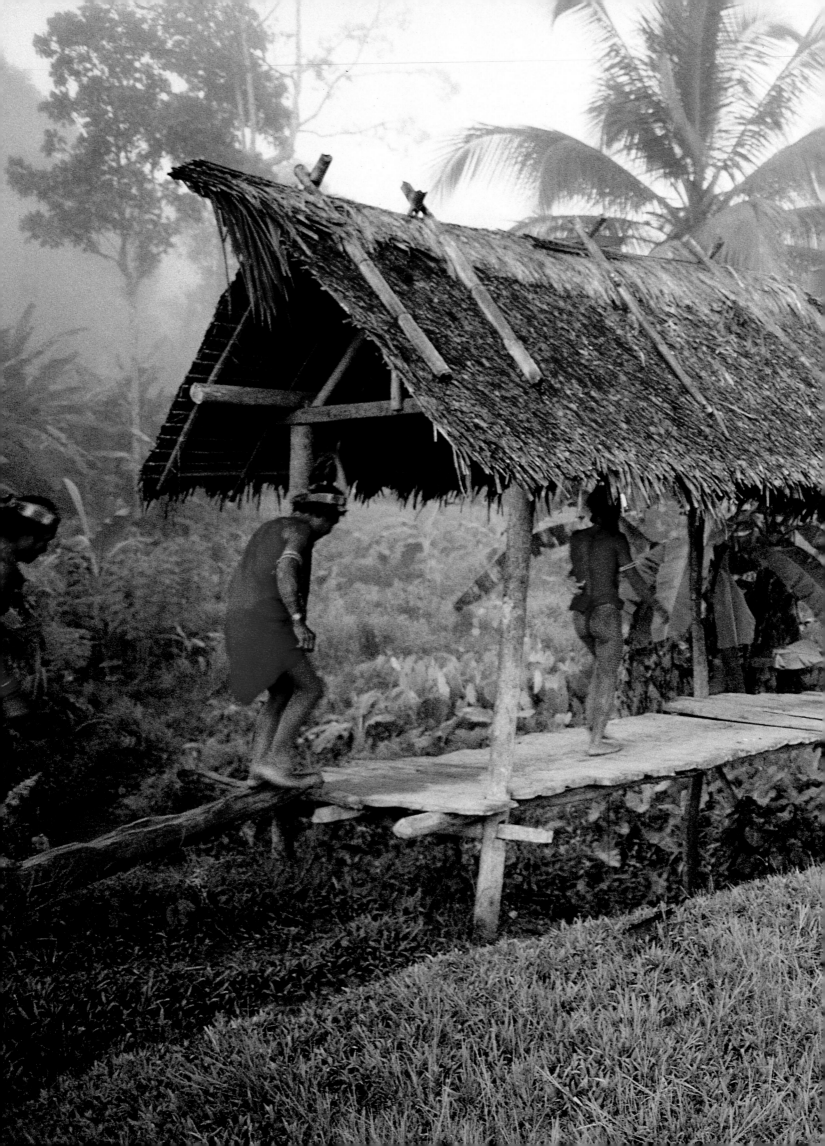

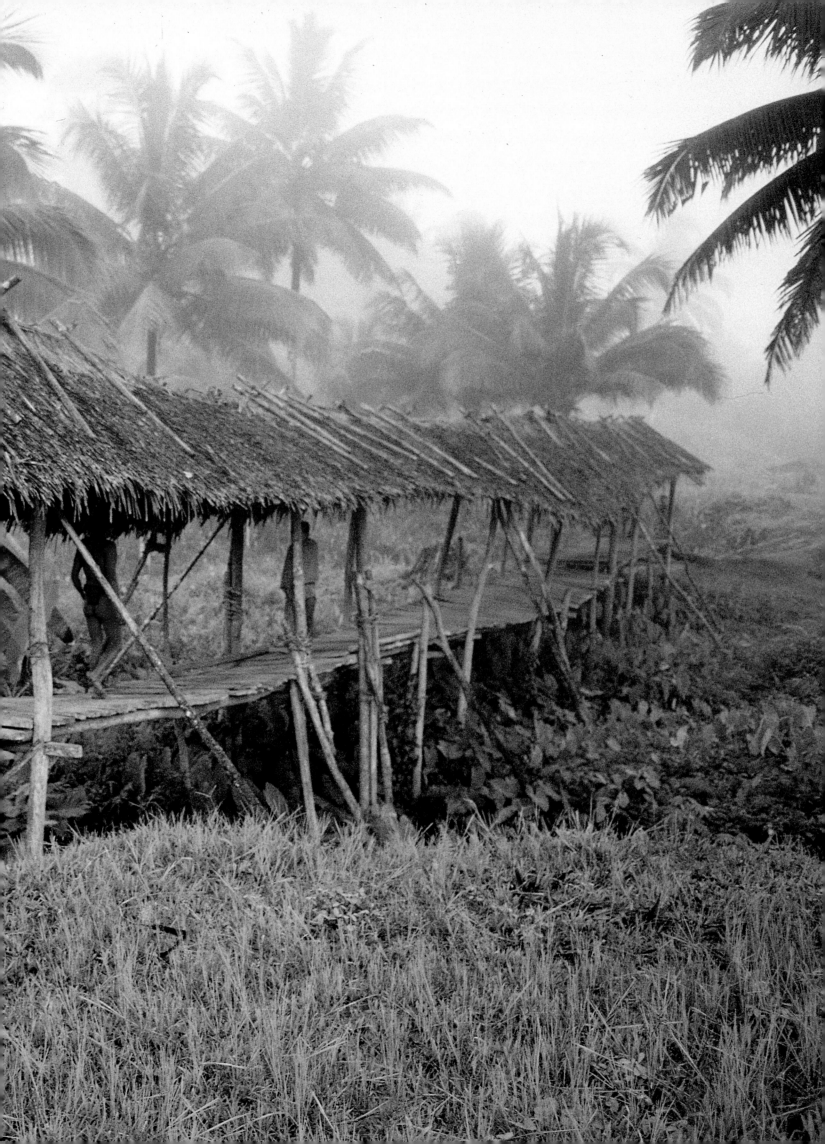

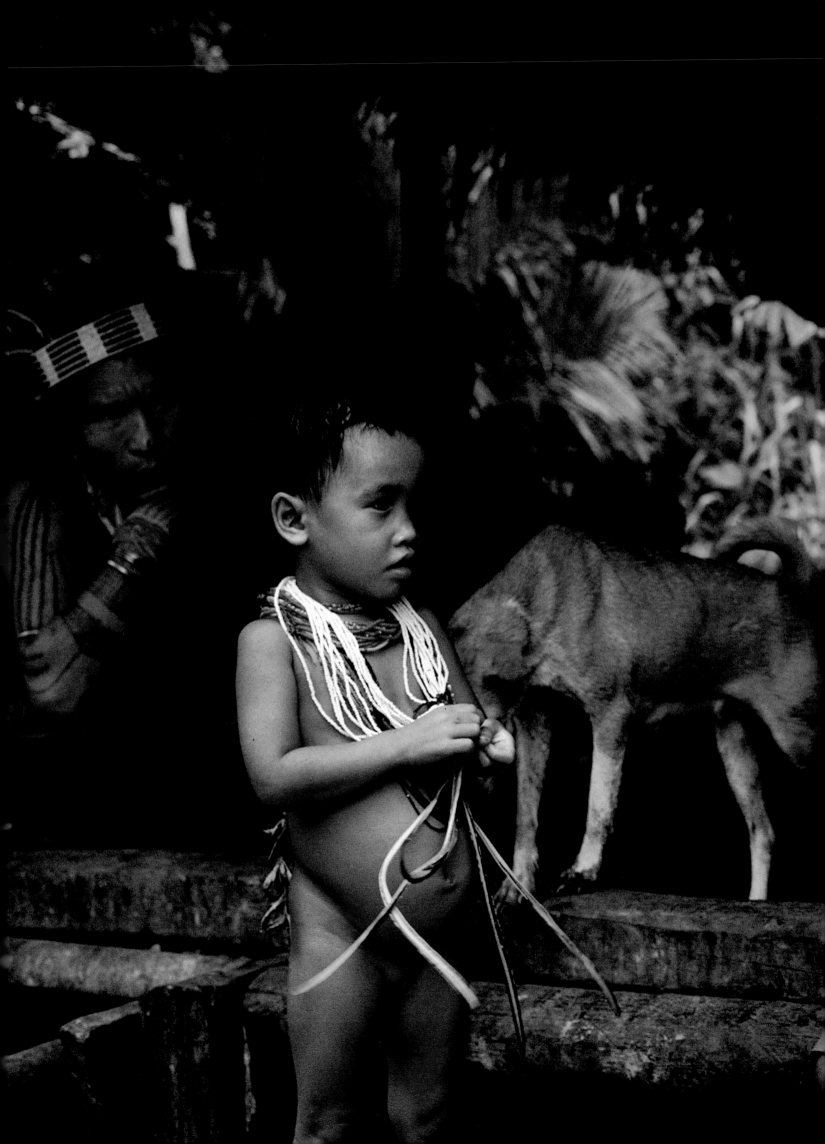

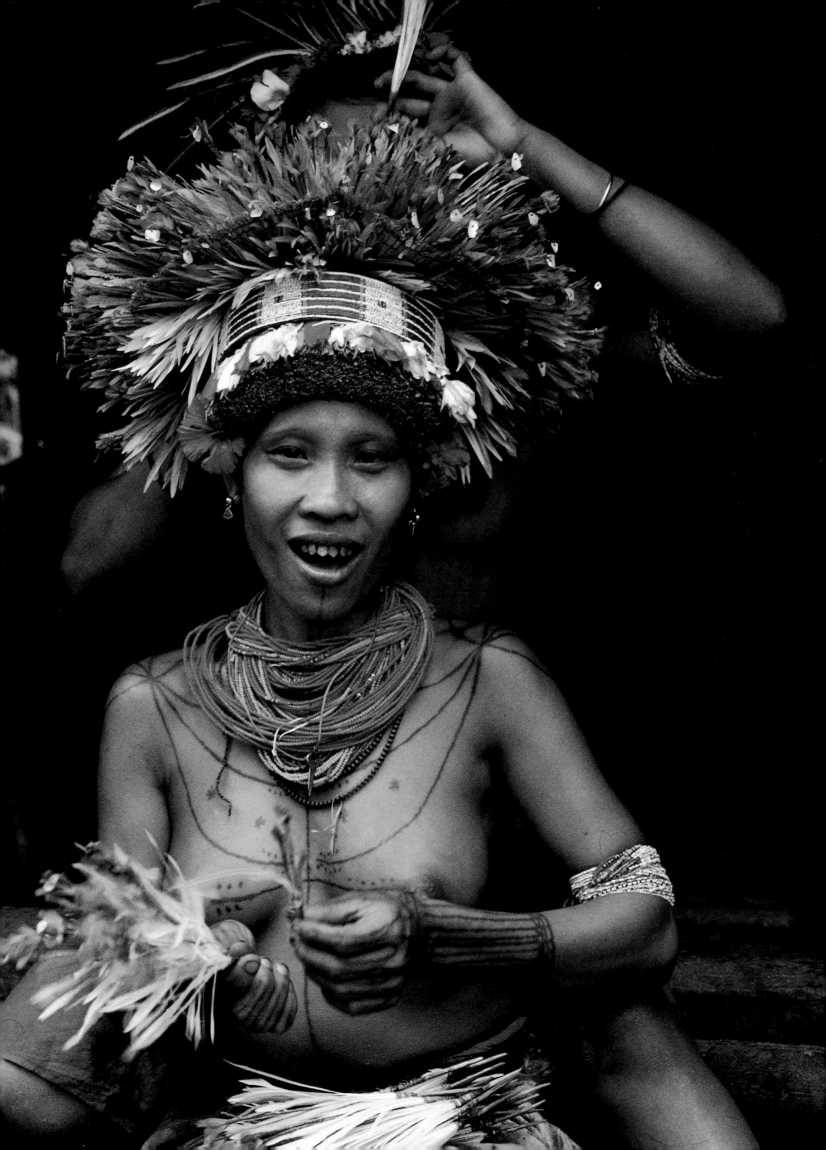

THE CONCH IS BLOWN, a momentous call that, along with the low resonance of a gong, warns outsiders that the *uma* is now off limits. The sounds alert the family that the time has come for the chicken sacrifice. Now omens are sought concerning the outcome of the festival. Aman squats near a simple altar and speaks in quick, pious phrases. He moves quietly through the house, brushing each person and the longhouse's main beams with the live fowl's tail feathers. The family stays silent as the *kerei* returns to the altar.

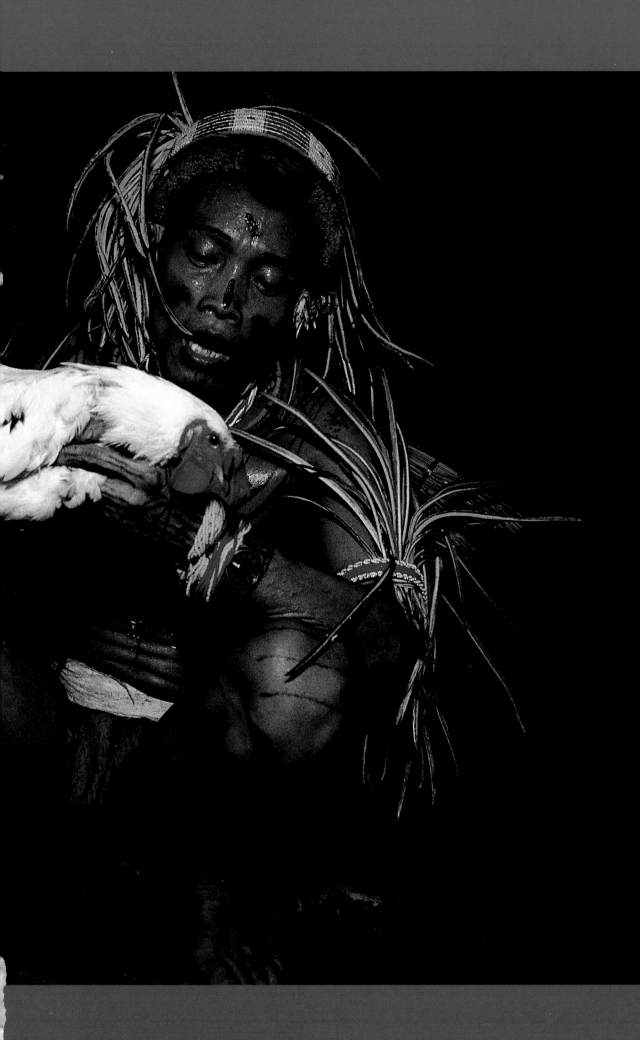

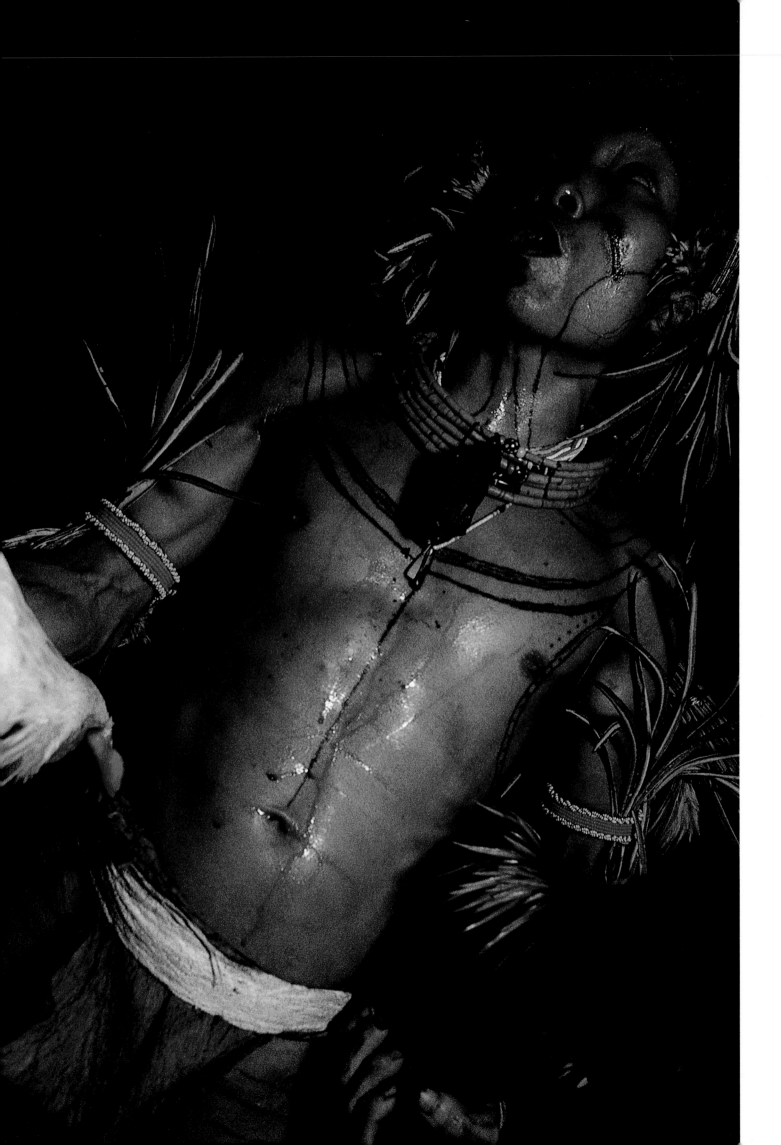

Opposite: Aman Lau Lau recites incantations. *Right:* A non-shaman snaps the chicken's neck and procures the intestines for the *kerei* to interpret—lines on the membrane carry positive or negative connotations. The meat is then cooked and served at the feast.

Overleaf: In a rare occurrence, six *kerei*, fully dressed by daylight, gather around an altar for the young shaman's inception; Aman Lau Lau chants at left.

Pages 42 and 43: While the feast is prepared, the *kerei* sing, ringing their hand bells. The chants come from an older language, known only to the shamans. On Siberut, different dialects are used in each drainage basin. The interpretation of myths and shaman secrets are a blend from these various regions. The language of Simatalu, the mythical place of origin, is nearly unintelligible to Aman Lau Lau's people.

Pages 44 and 45: It is early morning, after the calling of the spirits (*simagere*). During the ceremony Aman Lau Lau chants near the altar, ringing his hand bells faster and faster, then bursts through the main entrance of the *uma* waving a torch to chase off the evil spirits.

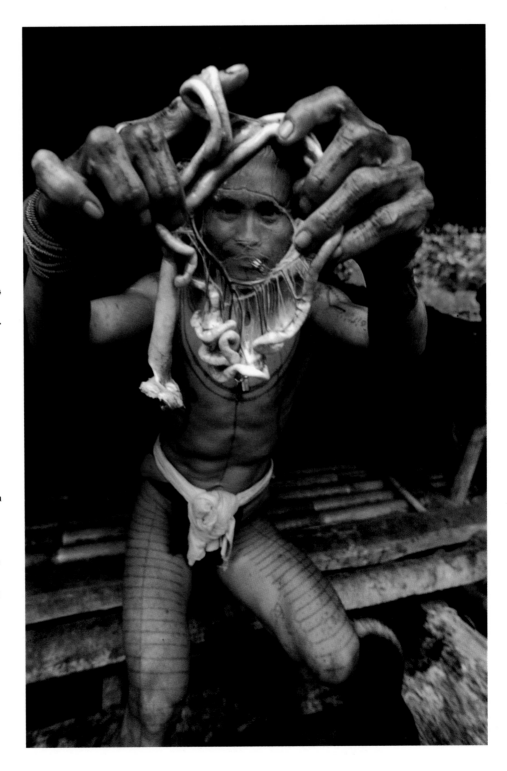

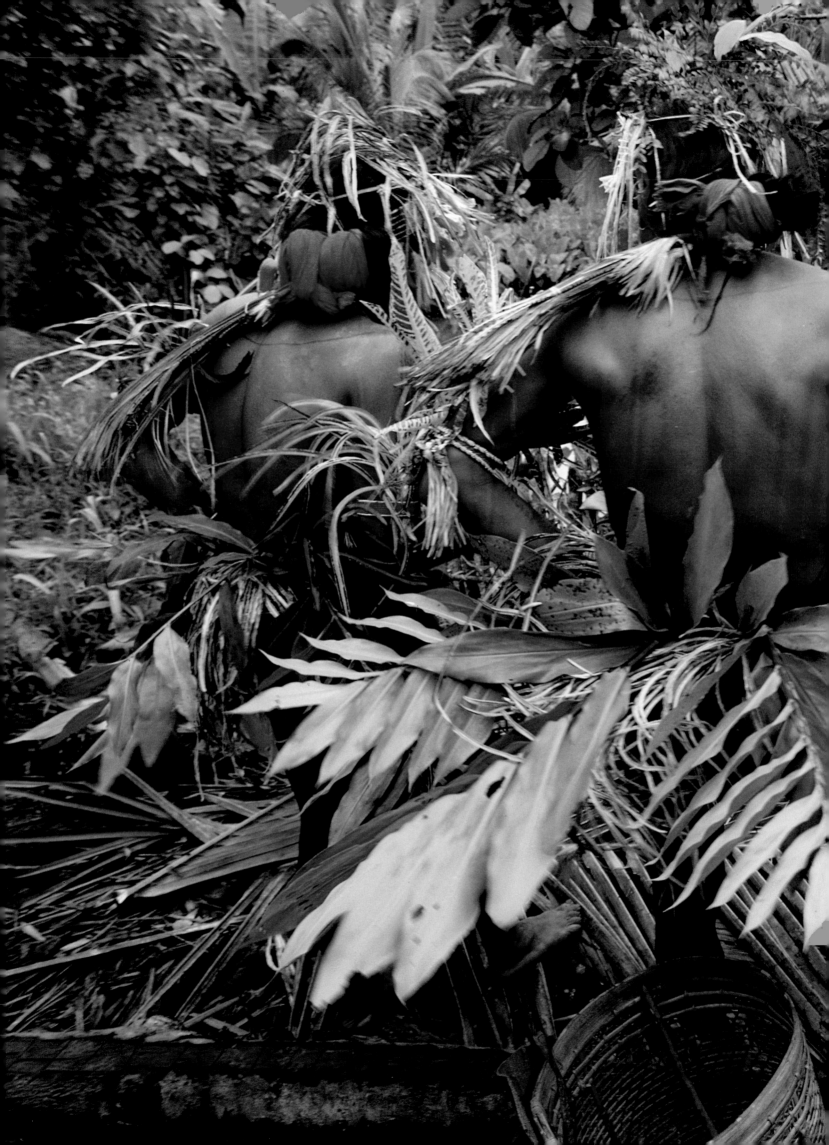

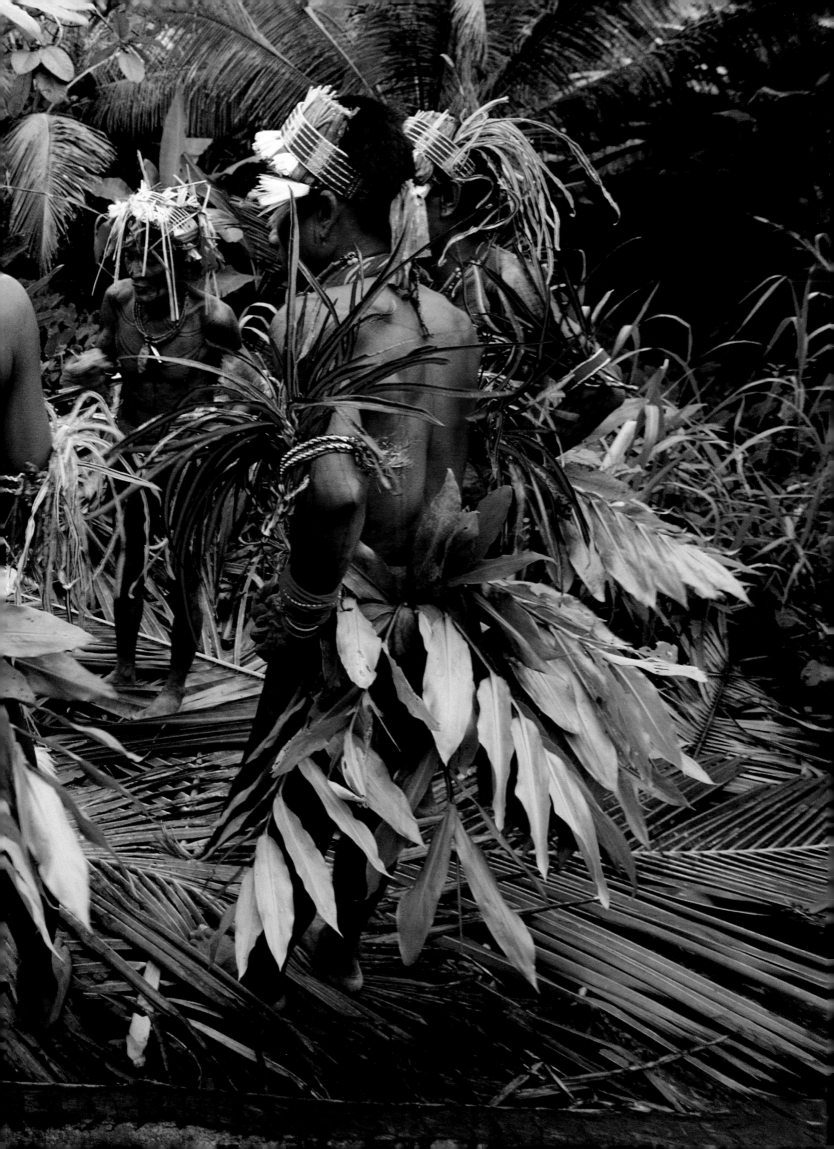

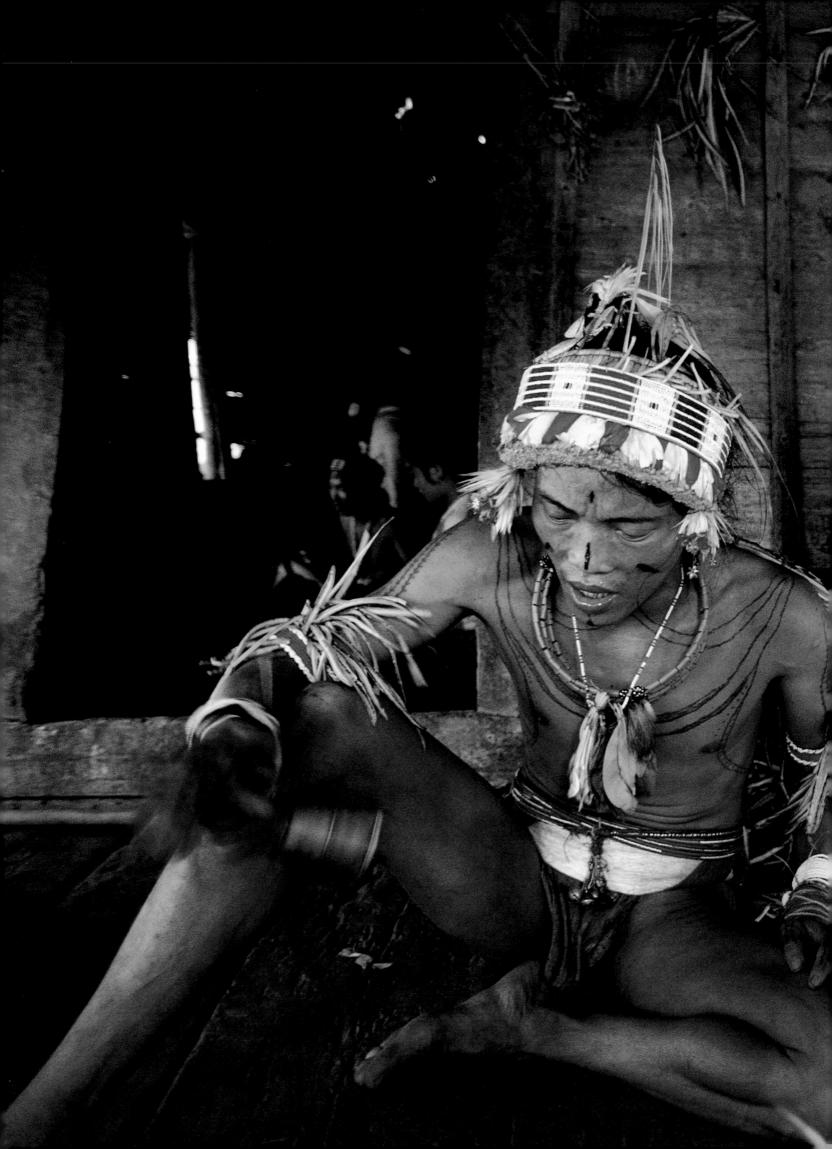

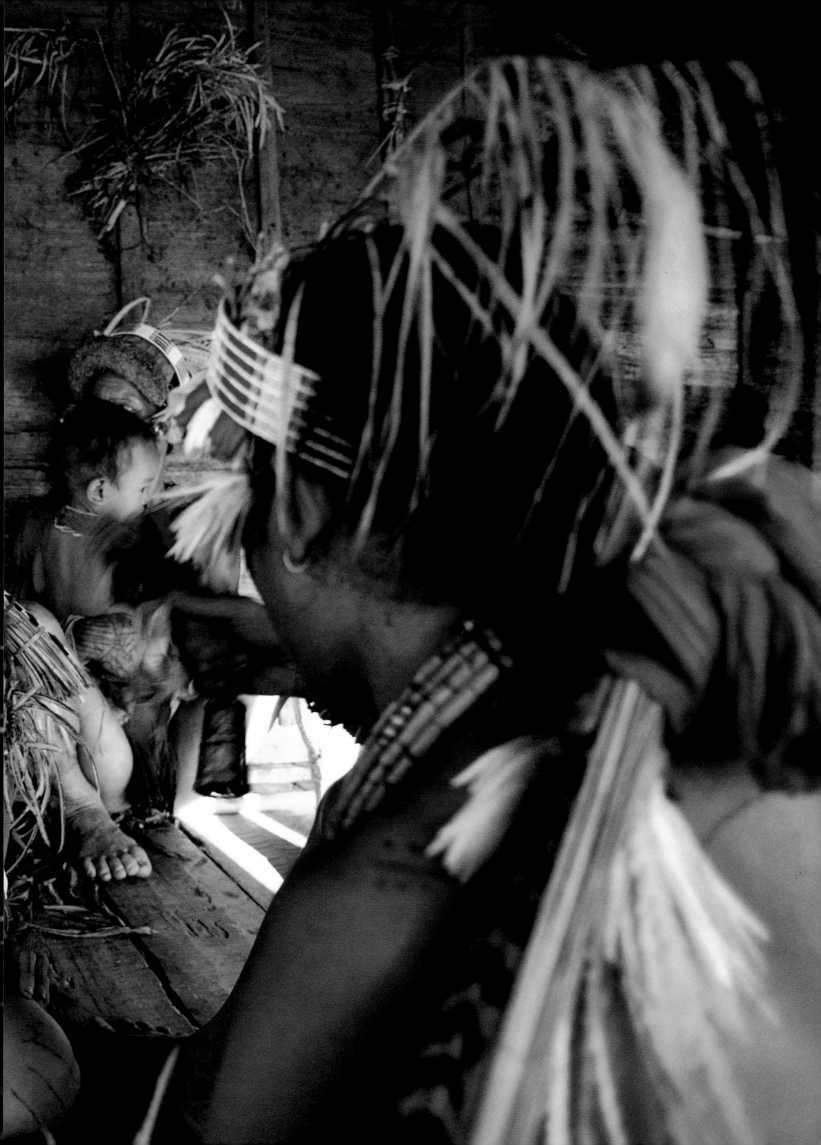

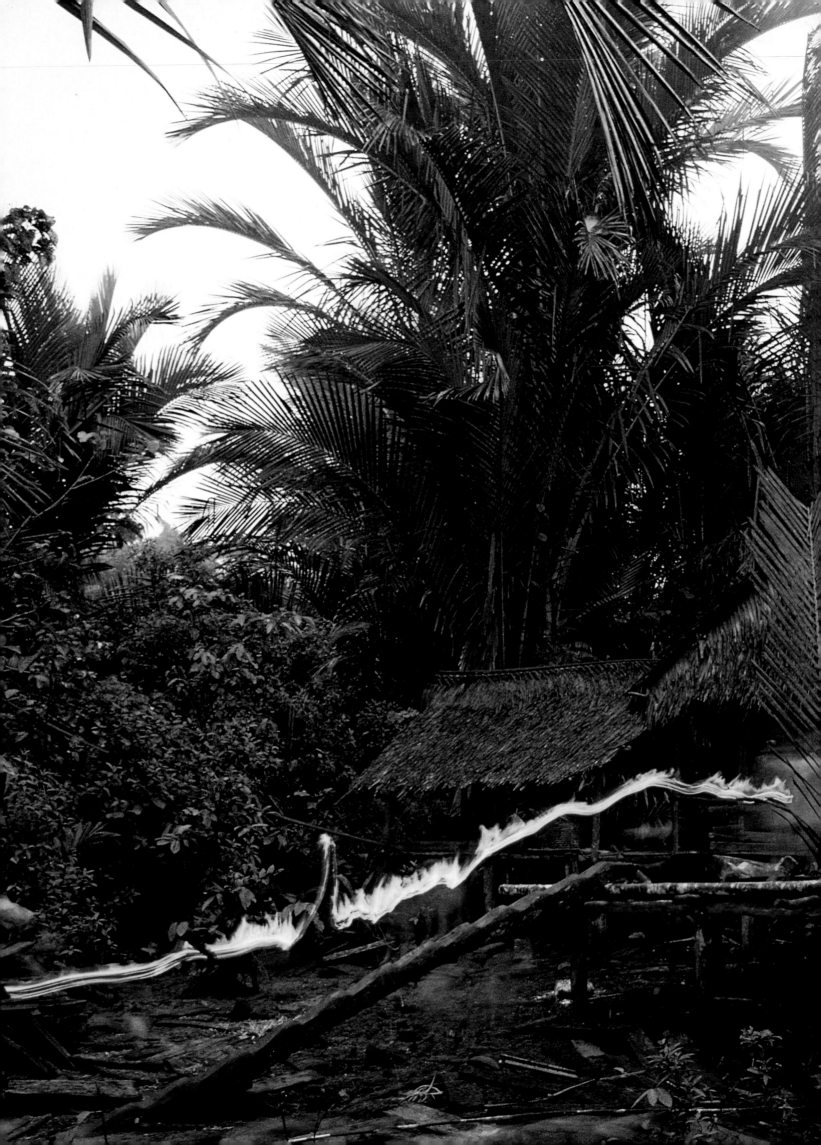

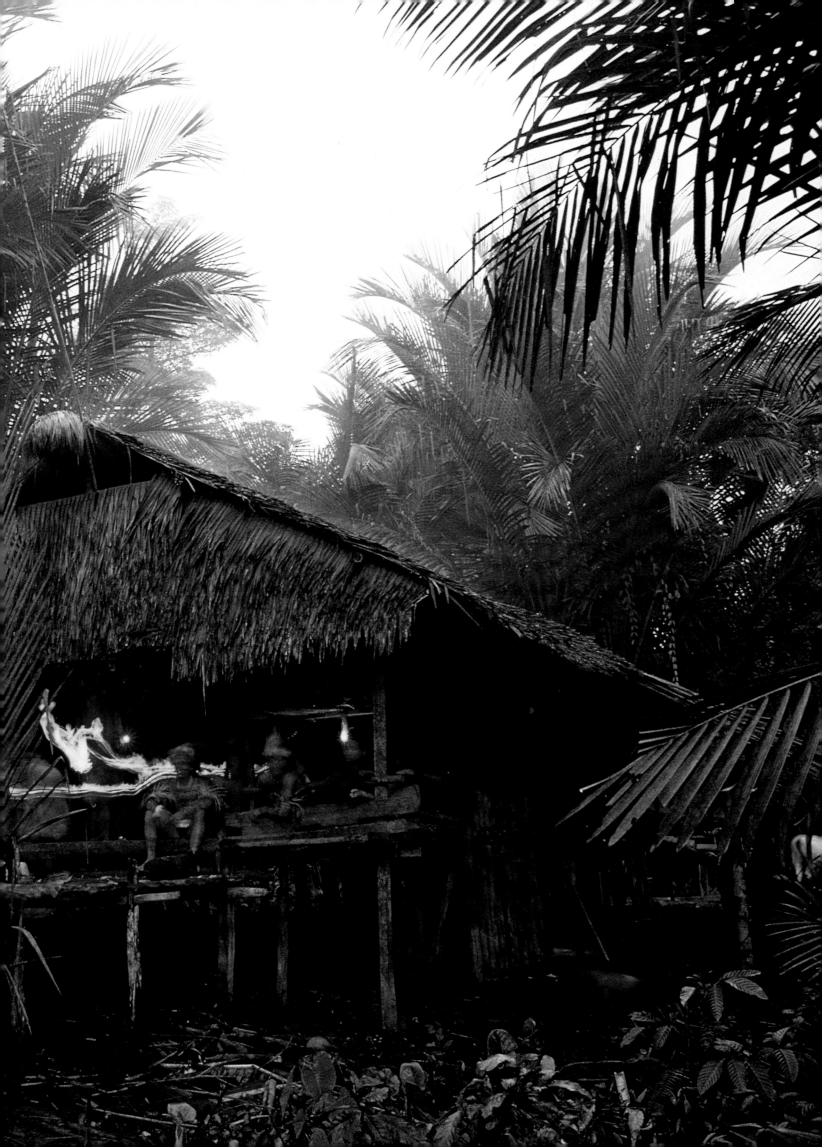

UKKUI, SPIRITS OF THE DEAD

At a crook in the stream, the men squat and shake wands made of sacred grasses. Sorrowful chants begin. "*Ukkui,* we've come for you, be pleased, we remember you and mourn for you, our ancestors. Come eat and dance with us." The men open their souls, venting immense sadness; their eyes fill with tears, and they cry.

When the *kerei* return from the intuitively chosen spot near where the *sagu* swamp meets a rise in the rain forest, a hush falls. I was privileged to accompany the men where nonshamans may not go and to witness the most intimate of rituals, the summoning of *ukkui,* the spirits of the dead, when the Mentawaians seek their ancestors' forgiveness.

The trail back to the longhouse is marked with leaves pointing the way for the spirits. Inside, the atmosphere is heavy. Belongings are methodically laid open on the floor for ritual cleansing. There are beads and aprons of the deceased, fabrics, potion bottles, leaves, bells, and old Dutch coins to entice the spirits.

As the *ukkui* hover about, Aman Lau Lau's mother, Lumang, and then Aman Lau Lau himself are seized by spasmodic fits, their eyes rolled back, their bodies sweating and shaking vigorously. The others jump in to calm the religious fervor. A burden seems to have lifted. The private items are stowed away and dancing soon follows. Aman Lau Lau and I share tobacco and await the feast.

Opposite and overleaf: **After feasting, the drummers begin. The ritual for *ukkui*, the spirits of the dead, is an intimate one, performed without spectators from the village.**

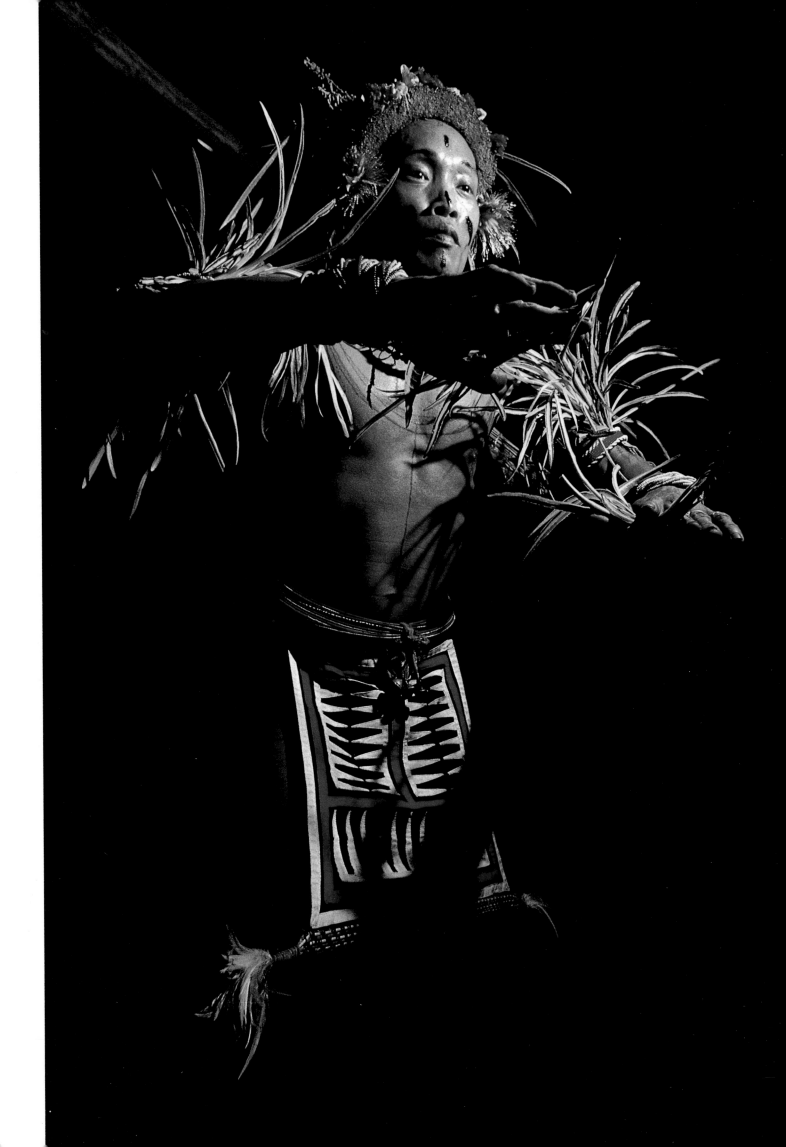

SOMETHING WONDROUS is happening here. Fantasy and reality merge—nothing to ground me, I am consumed by the dance. Exhaustion at three in the morning; a torch paints the way out into the darkness, and the sound of insects surrounds the *uma*. Low rumbling thunder from the west coast, silhouettes of hanging boars, headdresses backlit—and the dance goes on.

The women and children are sleeping beneath covers as the drummers and I witness the dance—python-skin drums establish the rhythm. The *kerei* move counterclockwise in a circle, flapping their wings and mimicking bats, monkeys, and crocodiles. They sing ancient chants, some in the old language, and emit high-pitched taunts; they stop, hips level, knees, thighs, and calves flexing to pound the dance floor. They stomp, then swing around again, working themselves into a frenzy, a surging climax that results in trance and vision.

"You must not sleep," the *kerei* say. I tell them I won't until the light of dawn. After the weeks of concentration and interrupted sleep, my mental stamina is being tested. There are no hallucinogens or alcohol here; taking part in the dance is the best cure for fleeting energy—the sweat chills in the long predawn hours. We don't sleep.

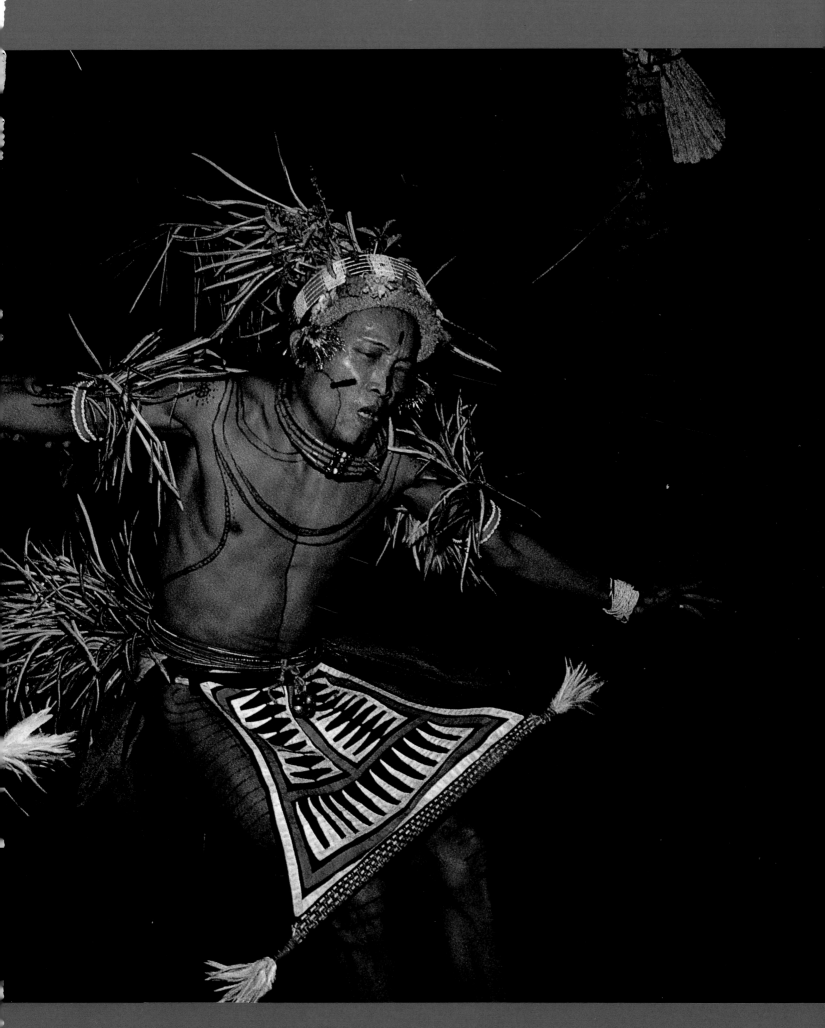

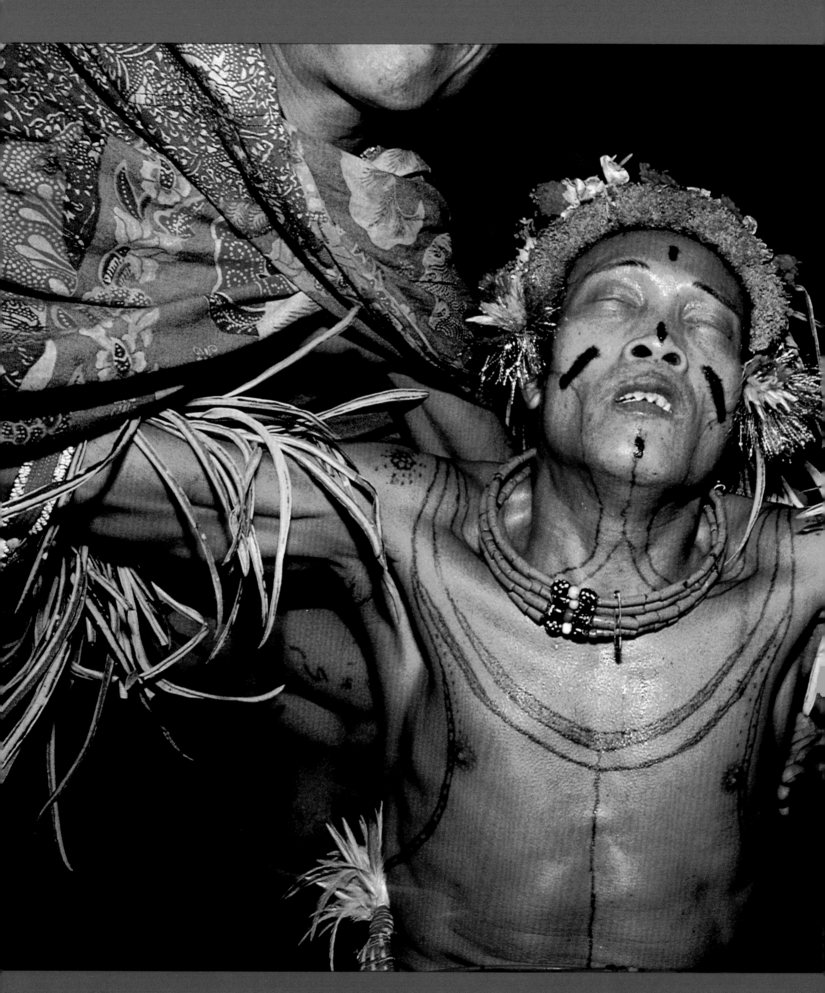

Aman Lau Lau rocks in trance during the final spasms. The Mentawai shaman seeks visions or messages, and it is difficult to know when the drama is superseded by inspiration.

The shaman traverses a ravine in a double exposure—the ancestral spirits are sent back to the jungle gratified—the quest for balance continues.

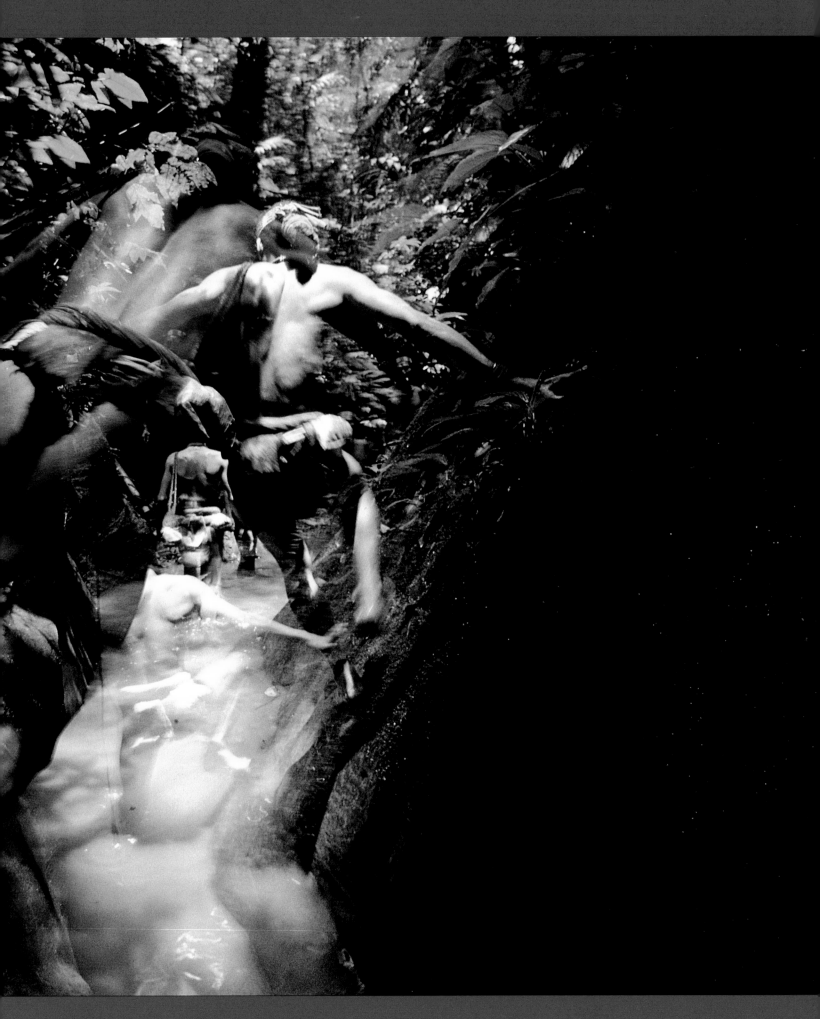

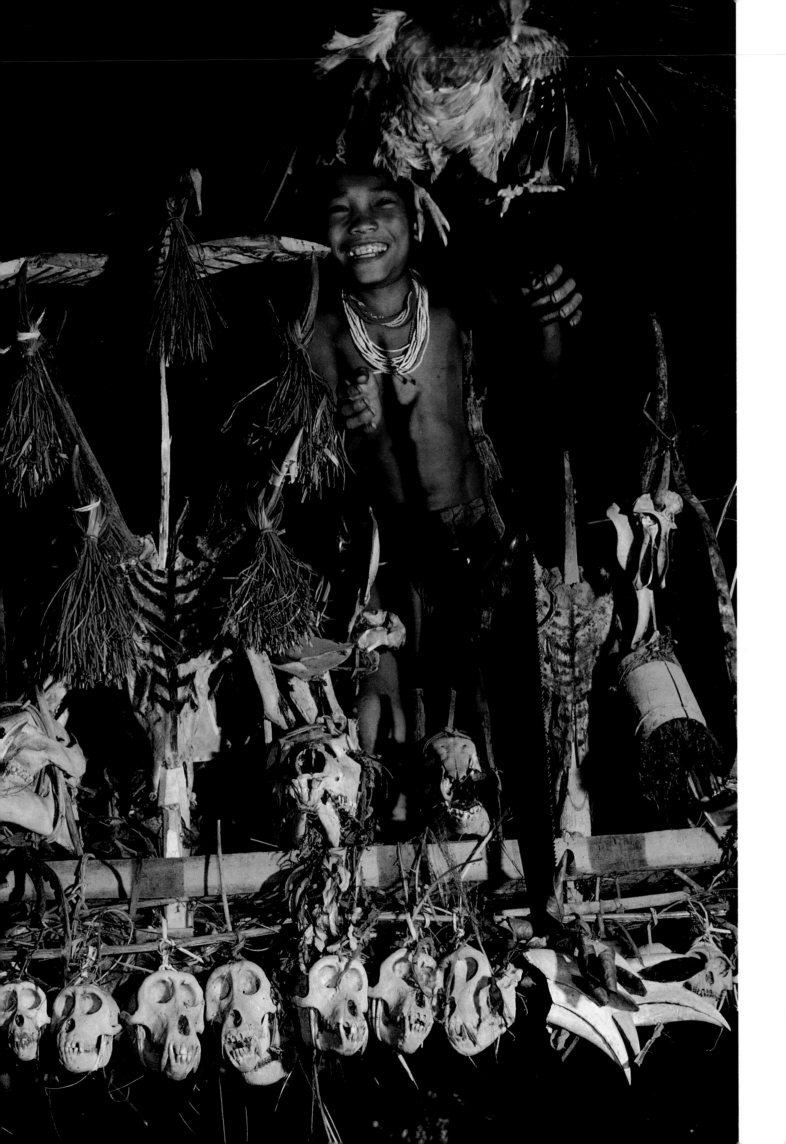

AT HOME IN THE UMA

My rapidly expanding vocabulary gives me insight and pleasure. We joke and compare worlds. By now, my fifth trip to the island, Aman Lau Lau is confiding to me the most intimate details of Mentawaian life: village politics and petty plots, old rivalries, intense jealousies, and adulteries, for which fines are levied. There is work around the house, but there is plenty of time for gossip.

Aman Lau Lau takes great pleasure in telling stories. He recounts that one morning a woman came through the bush near where I was bathing. After discovering me, she set out for Aman Lau Lau's *uma* to claim an embarrassment fee of one chicken, since he was my host. Nudity and embarrassment are serious issues for the Mentawaians. Aman Lau Lau said to her, "That spot is our bathing place. I cannot watch over everything. Perhaps you wanted to see how the white man looks. After all, you were hiding behind the bushes. Come now, have some tobacco and we'll forget it."

Opposite: The *kerei*'s first son, Lau Lau, chases a hen from the rafters of the *uma*, where the skulls of deer, pigs, monkeys, and hornbills are kept. *Below:* At home, Lau Lau and his father feed *sagu* to the cows, my gifts to the family. *Sagu*, or sago, is the main feed for their animals.

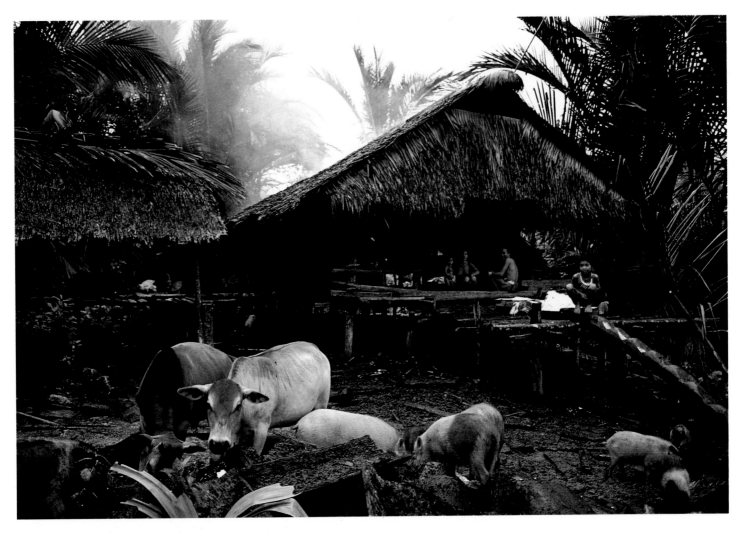

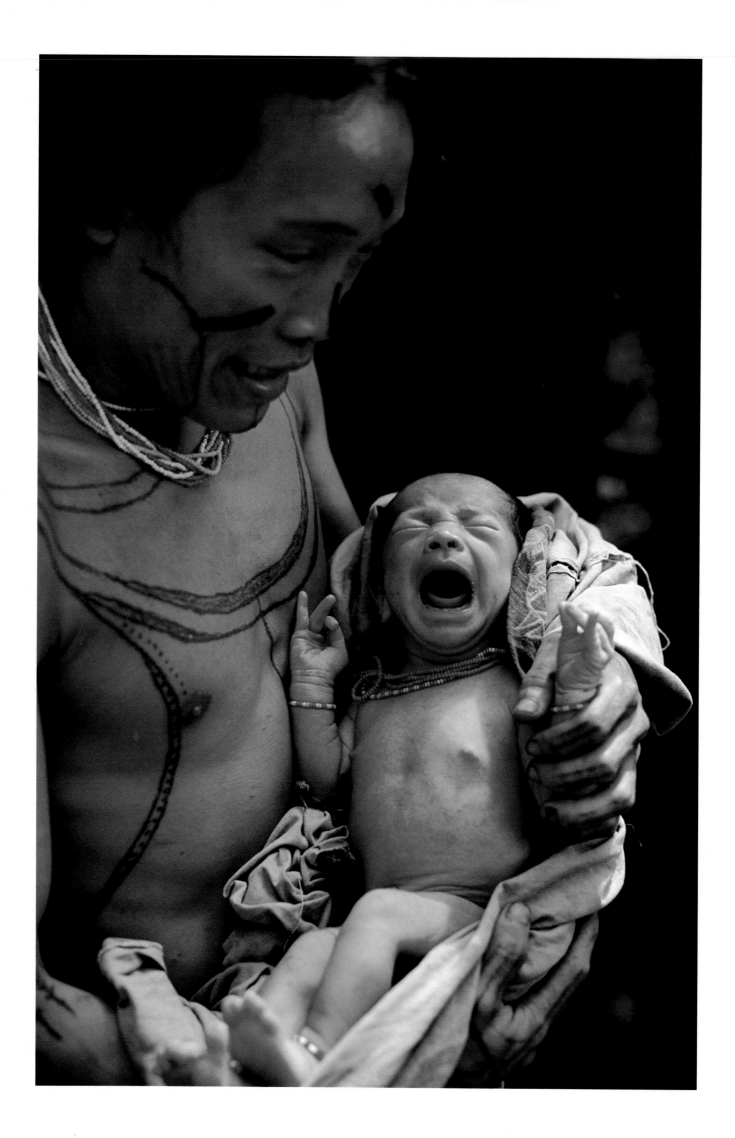

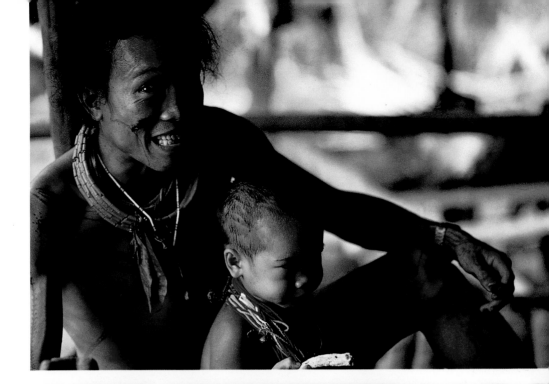

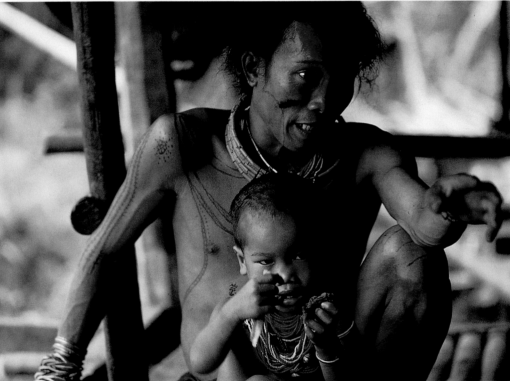

Opposite: My arrival has coincided with the birth of a son, a favorable occurrence in Aman's eyes. *Right, top to bottom*: Aman proudly holds his second son. Mentawaians change their names after a death in the family; the "Aman" preceding his name indicates that all of Aman Lau Lau's children are living.

Overleaf: Women carry on their conversations in the cooking area, the only part of the *uma* that is enclosed. Mentawaian tradition separates the women and children's sleeping area from the men's. The men sleep beside the dance floor.

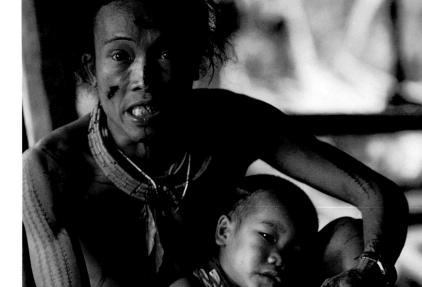

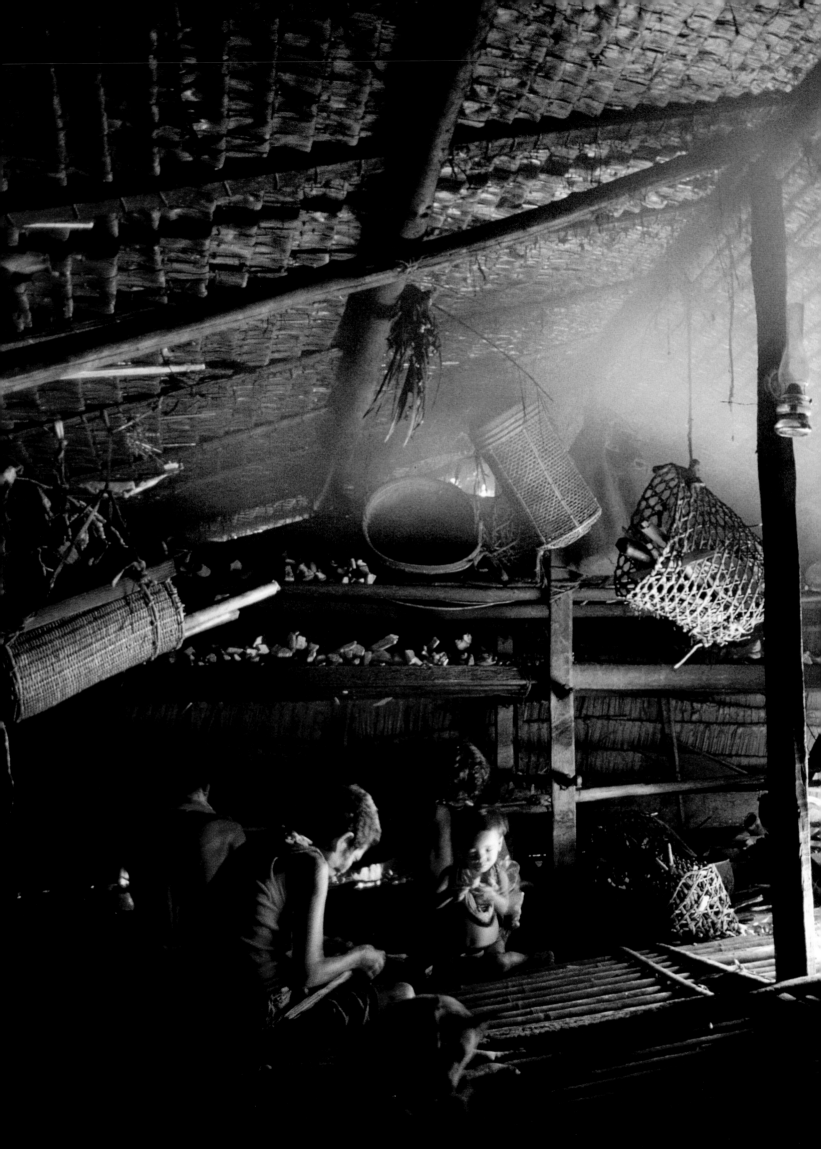

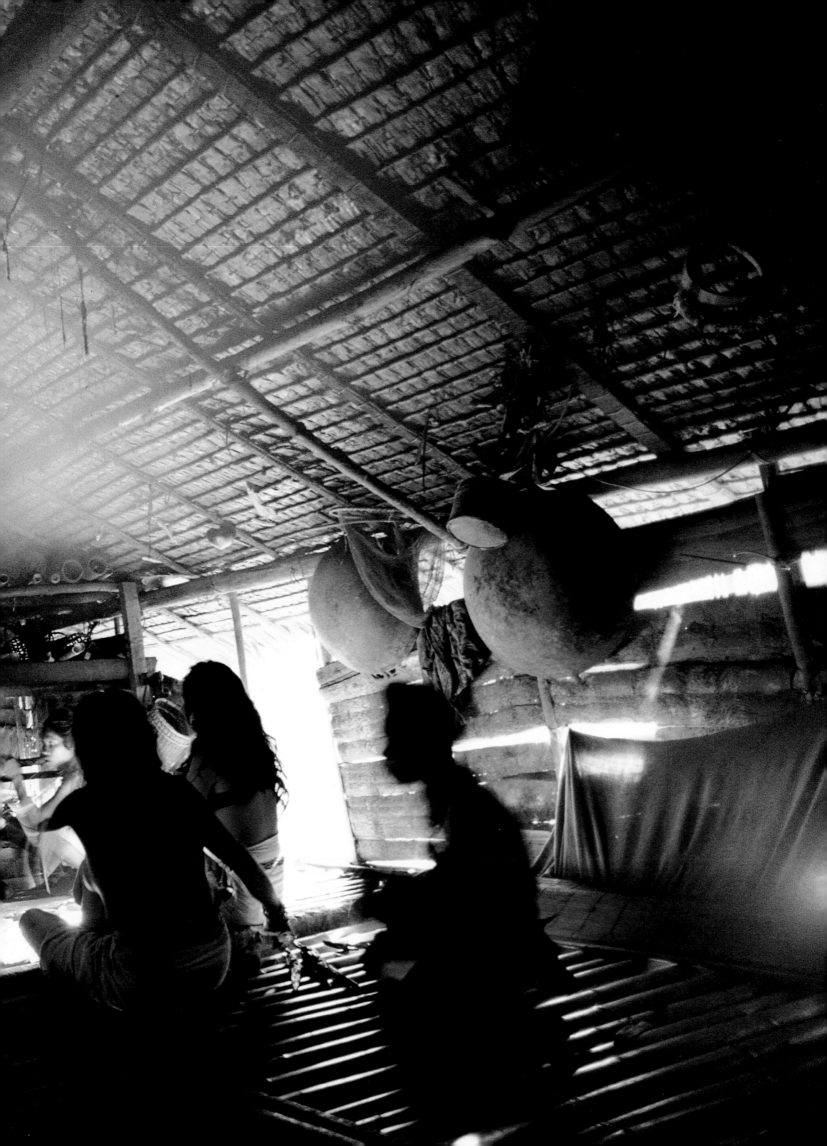

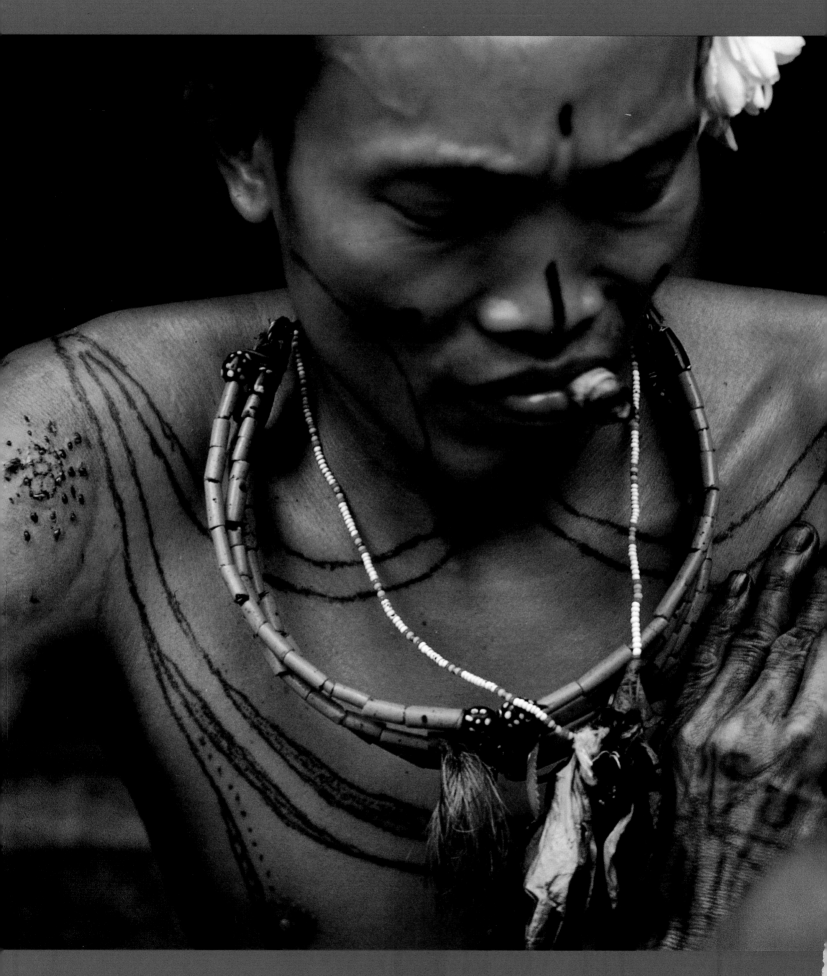

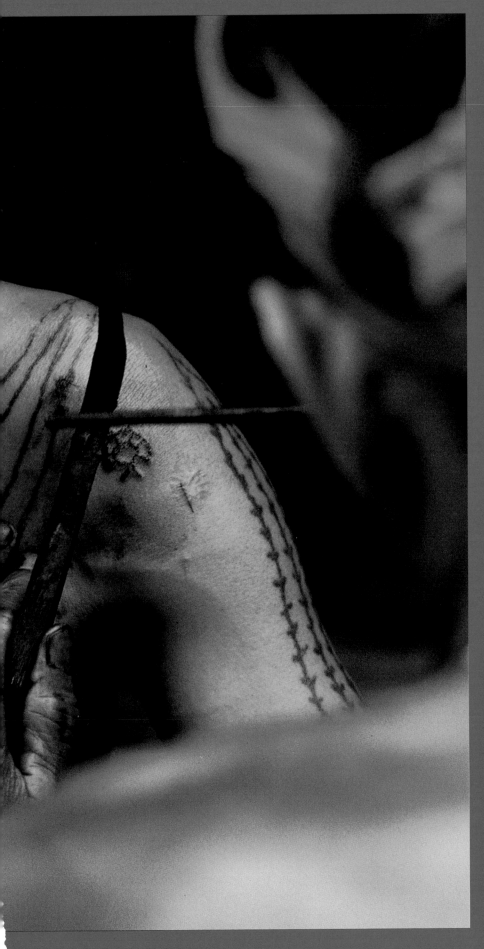

TATTOOS ARE AN EXTENSION of Mentawaian clothing. They are applied by a designated tattooist at specified stages in life. A donation of one chicken is the usual payment. First the chin and back are tattooed, then hands, chest, thigh, and buttocks. The shins come last. Patterns vary slightly in different regions. Traditionally, the first session occurred at about age seven; now the practice begins in the midteens, if at all. The Indonesian government has pressured the Mentawaians to stop it because tattooing is associated with criminal elements elsewhere in Indonesia.

The symbolic flower tattooed on Aman Lau Lau's shoulder means that evil should bounce off his body like raindrops from a flower.

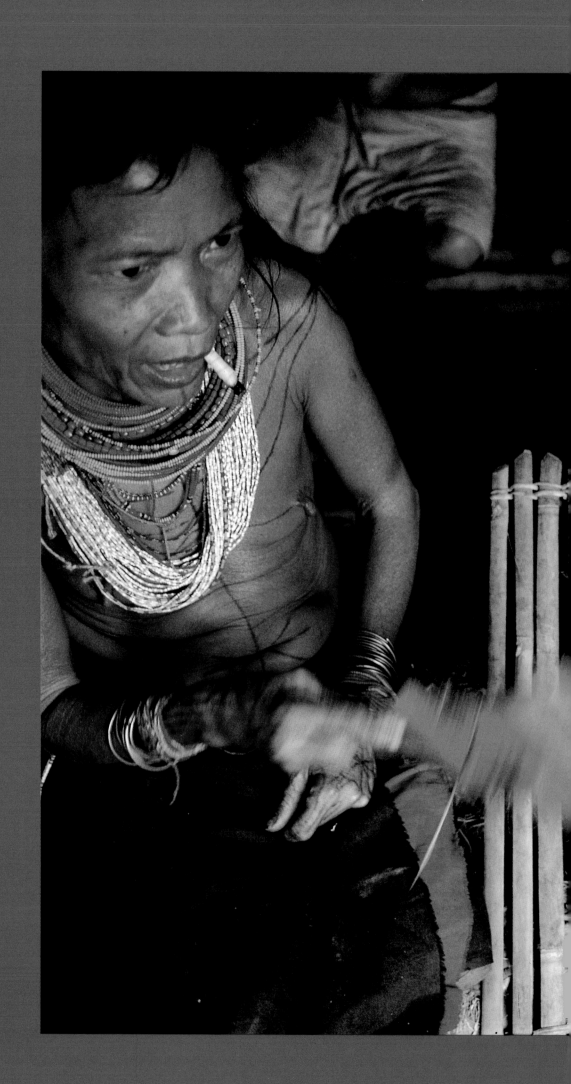

Aman Lau Lau's sister Leiai is
fanned by her mother while being
tattooed. Leiai received her first
tattoos at seventeen.

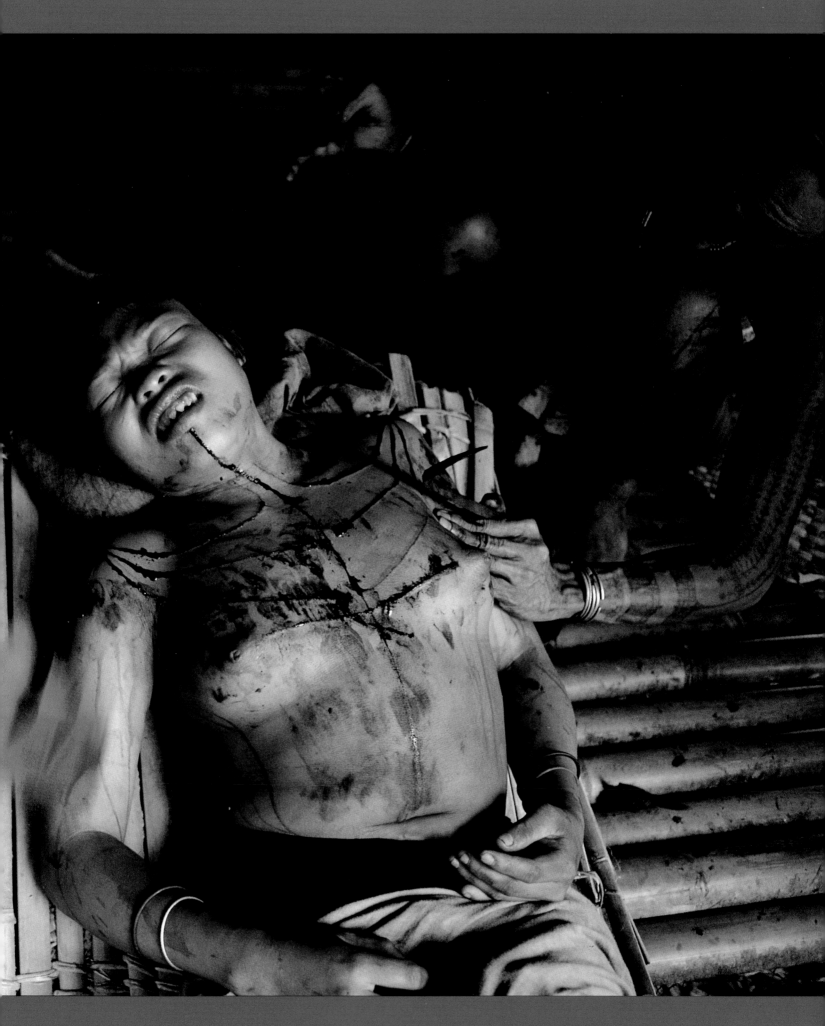

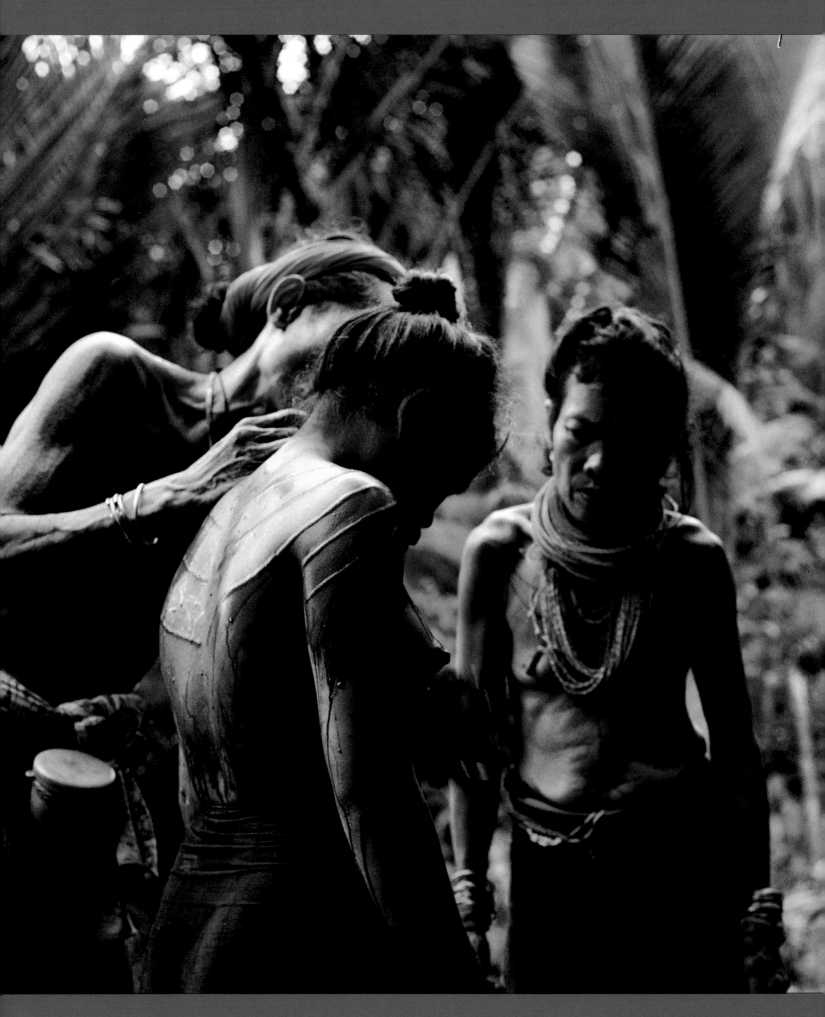

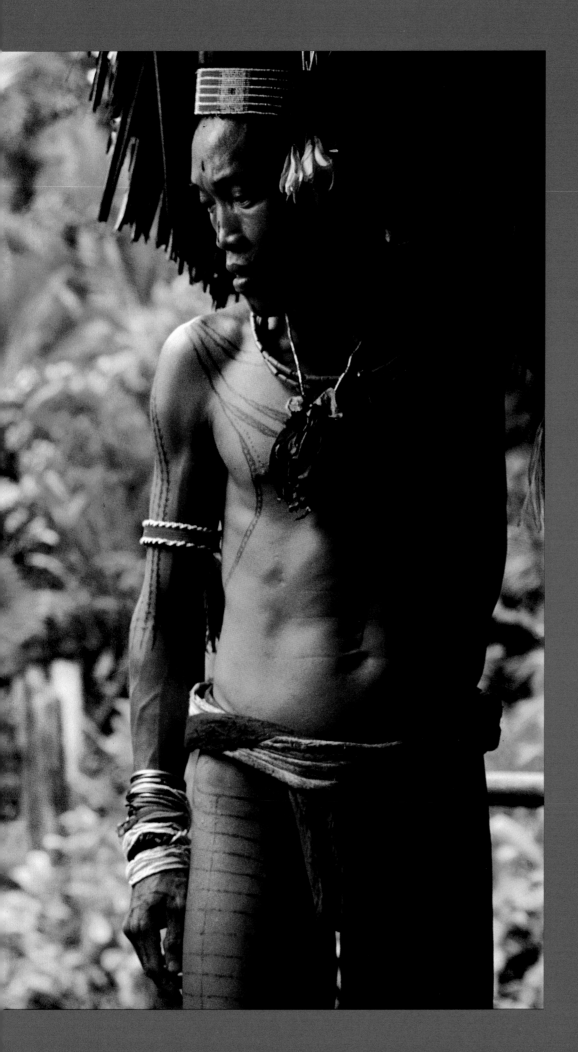

The tattoo artist inspects his work as
Leiai's marks begin to welt.

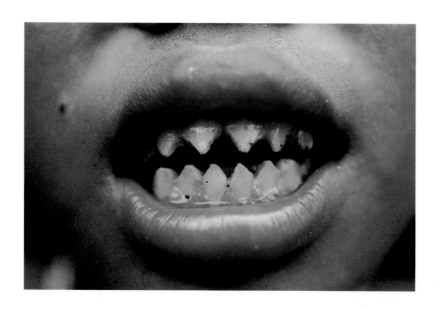

Beautification begins with teeth chiseling (*pasi piat sot*). Aman Lau Lau's youngest sister, Godai, was thirteen when she chose to undergo the rite. She did not complain, saying, "It is a tradition for the Mentawaians, and tradition is our strength."

Overleaf: There is conversation and joking on the porch of the longhouse, the place for relaxing. Outside, Aman Lau Lau and an elder *kerei* prepare magic to protect the pigs from danger.

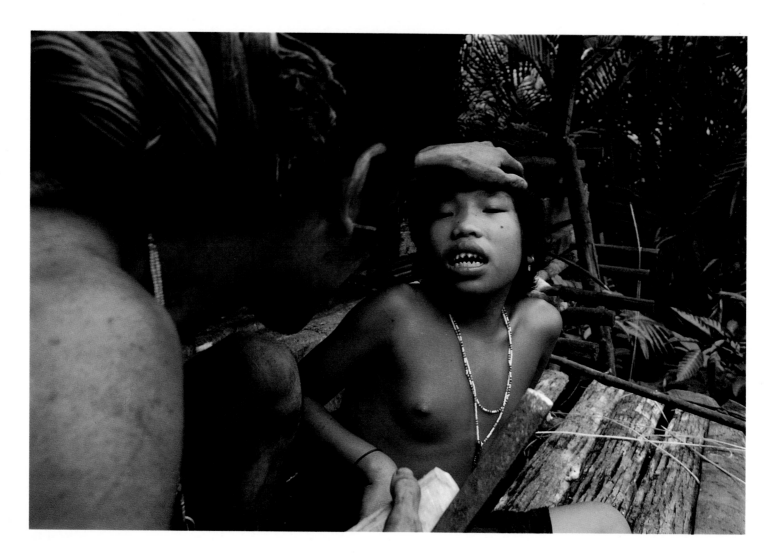

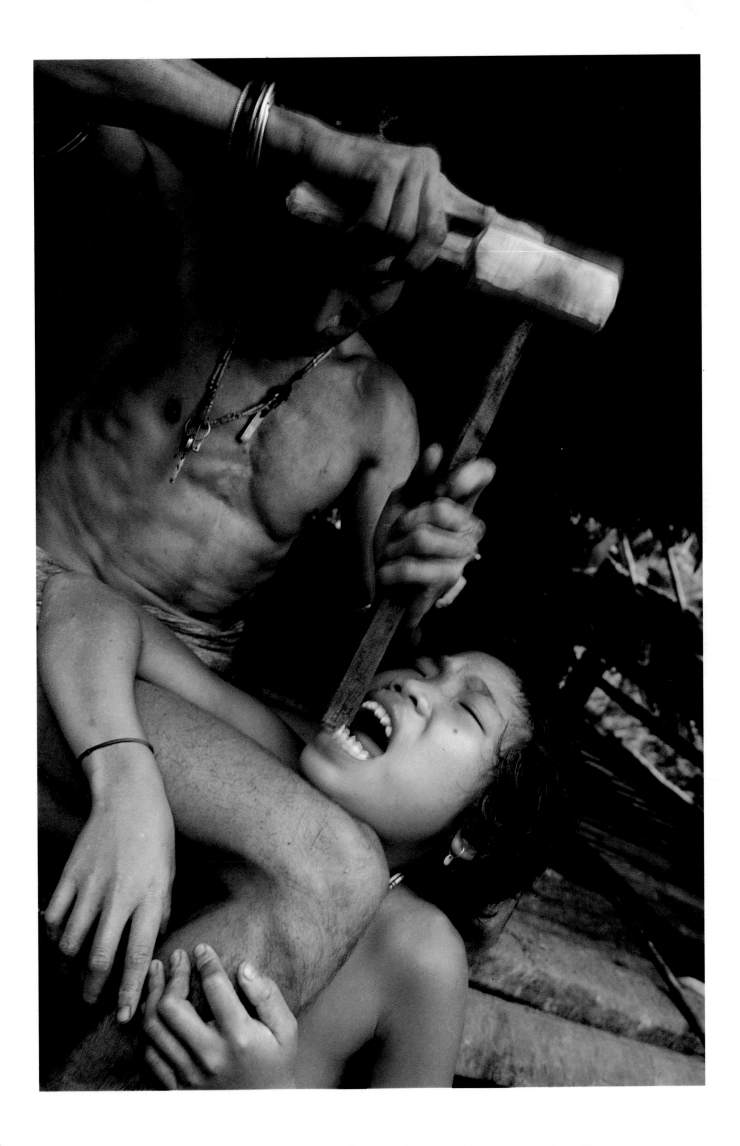

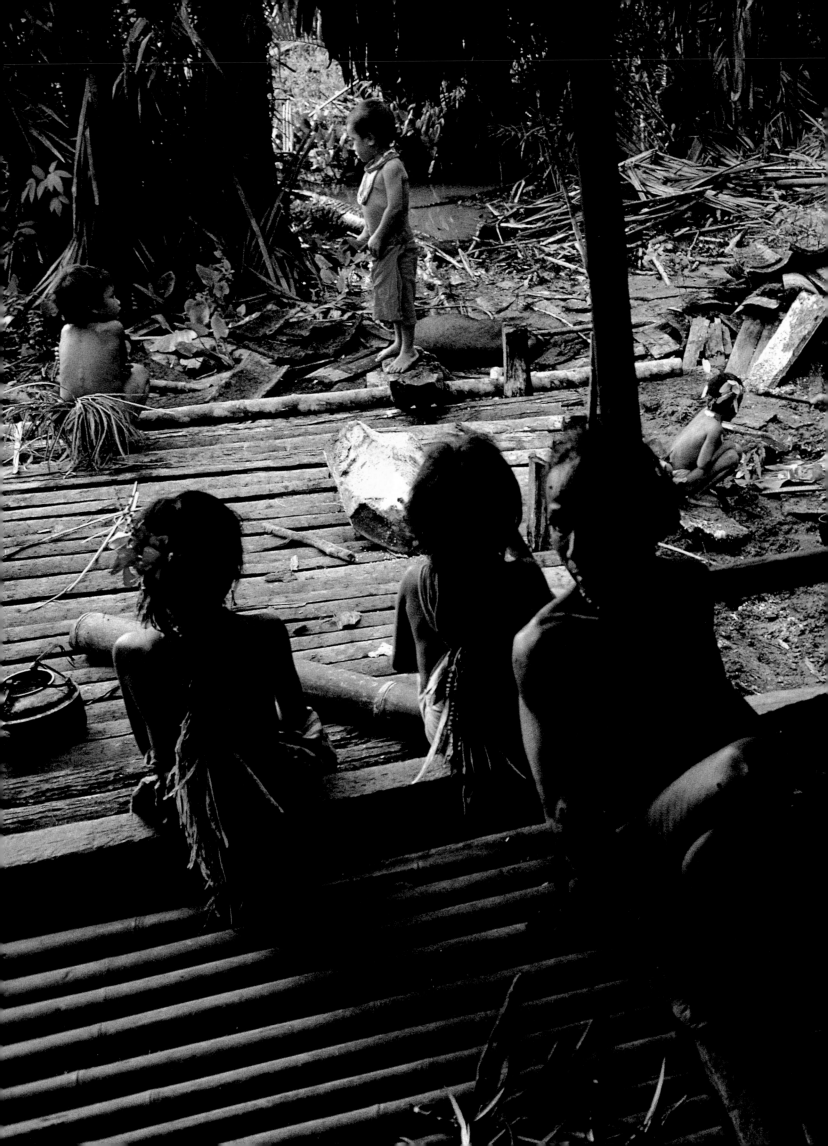

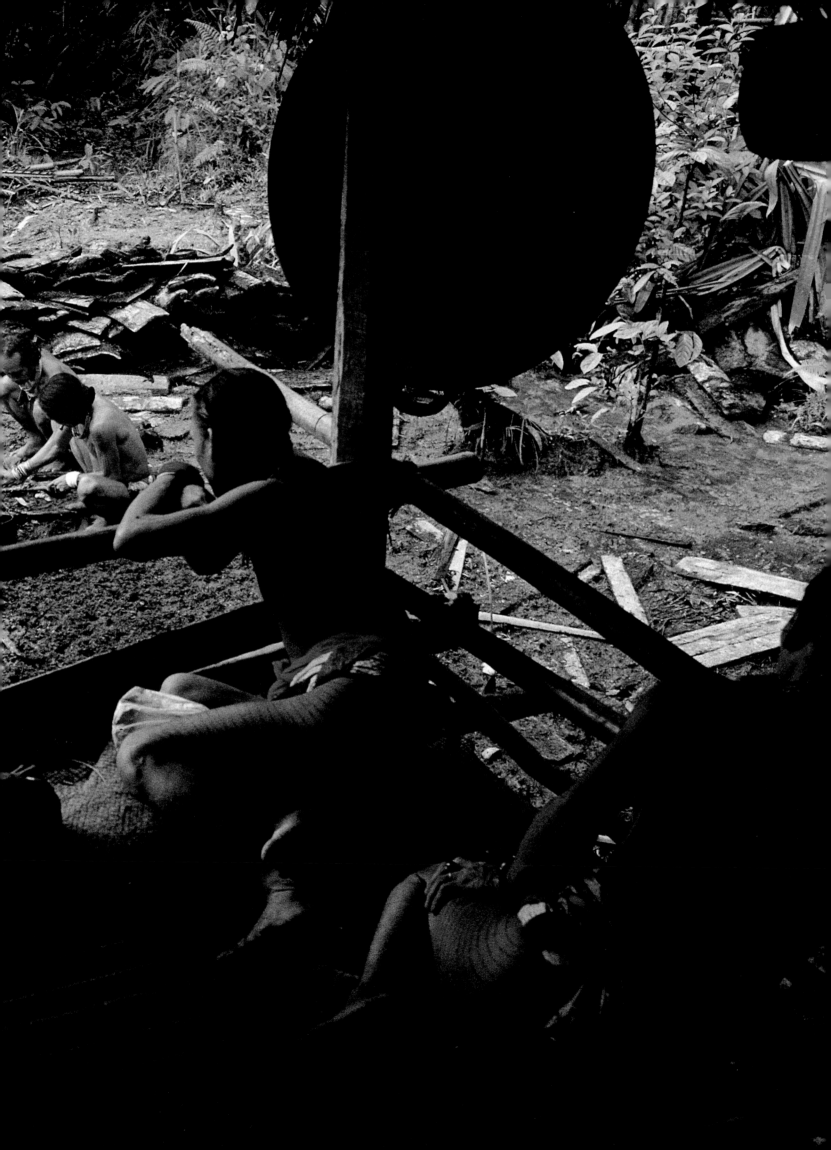

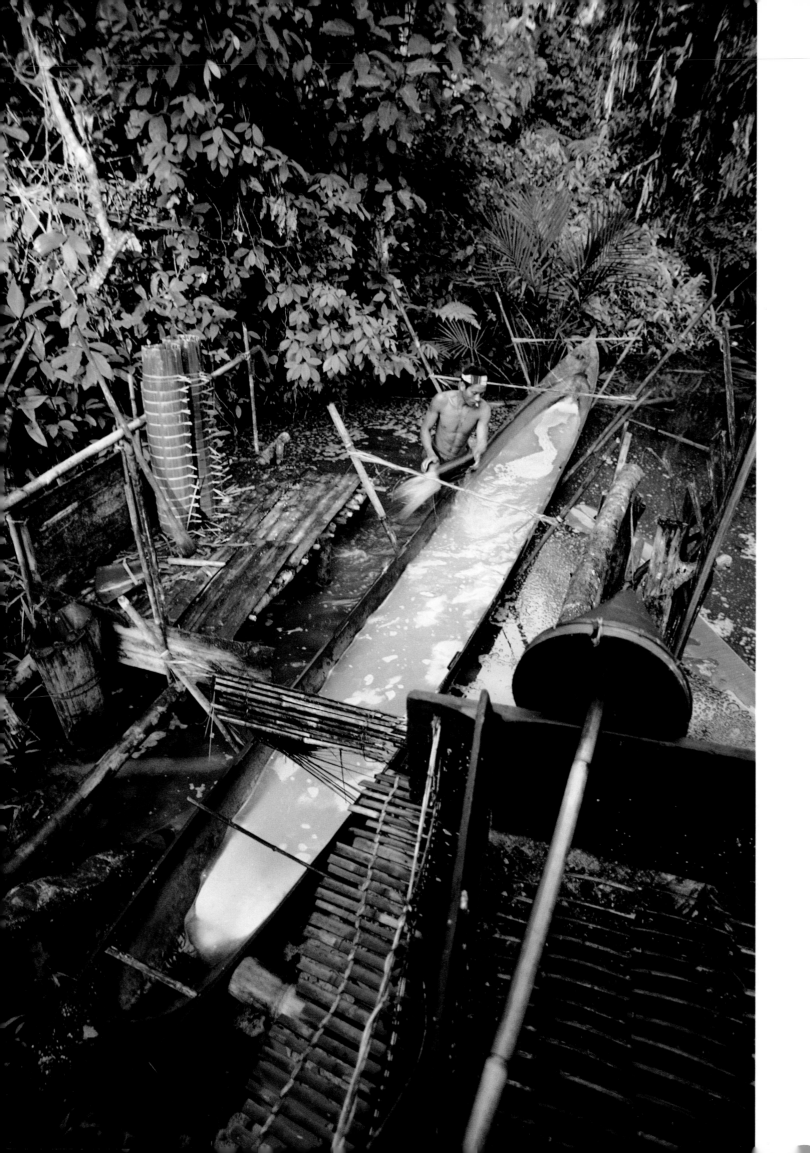

The Mentawaian food staple, *sagu*, is grated from the pith of the sago palm, then sieved, soaked, and stored. Sago is one of man's earliest and most time-efficient foods.

Pages 72 and 73, top left: Jackfruit and durian are favorite fruits. Food sharing is obligatory, and eating alone is considered perverse. *Bottom left:* The women gossip while breaking apart a fallen sago palm for grubs, which taste nutty when roasted. *Right:* Aman Depa wrestled this beehive from a hollow tree after first smoking out the bees.

Pages 74 and 75: The women use handmade nets to fish the streams for shrimp, frogs, small fish, and an occasional turtle. The catch is placed in a length of bamboo slung on their backs. The most productive time is after dark, when the women continue to fish, using torches.

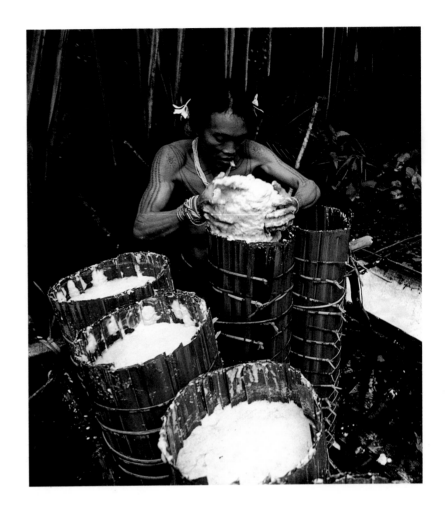

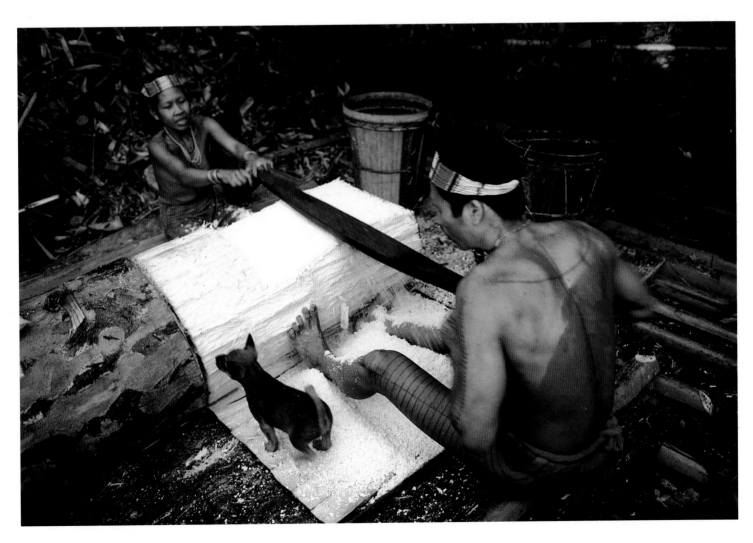

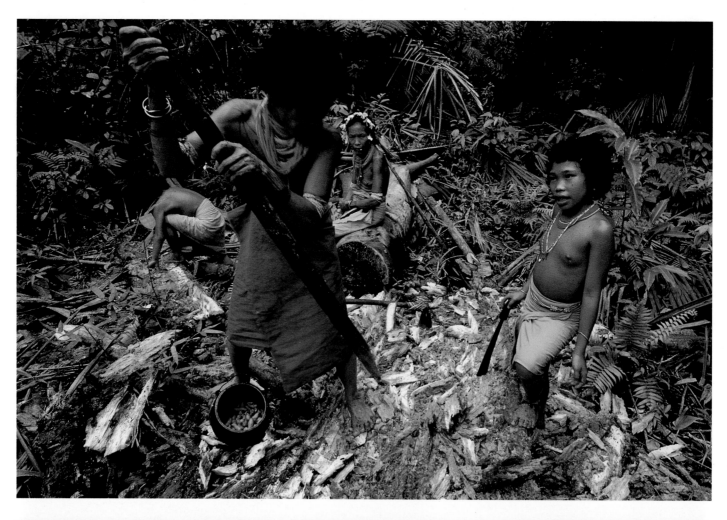

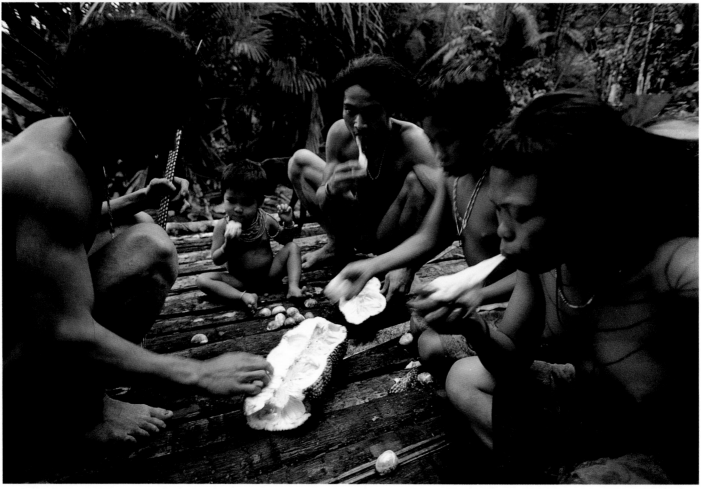

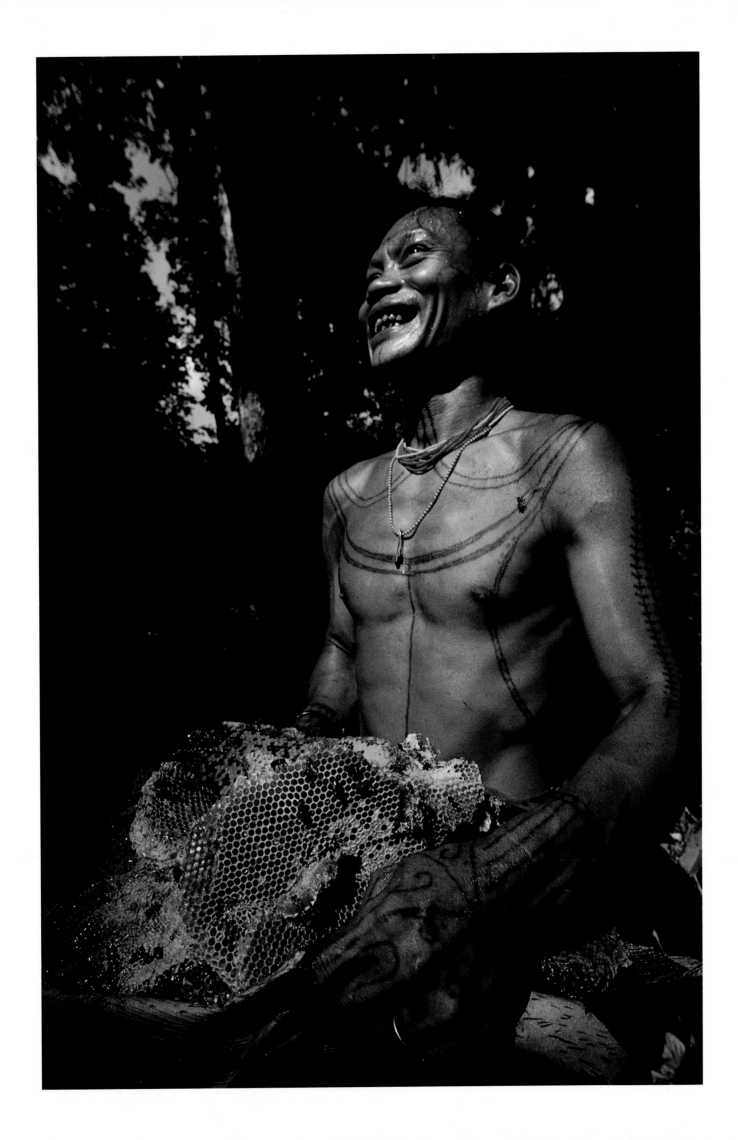

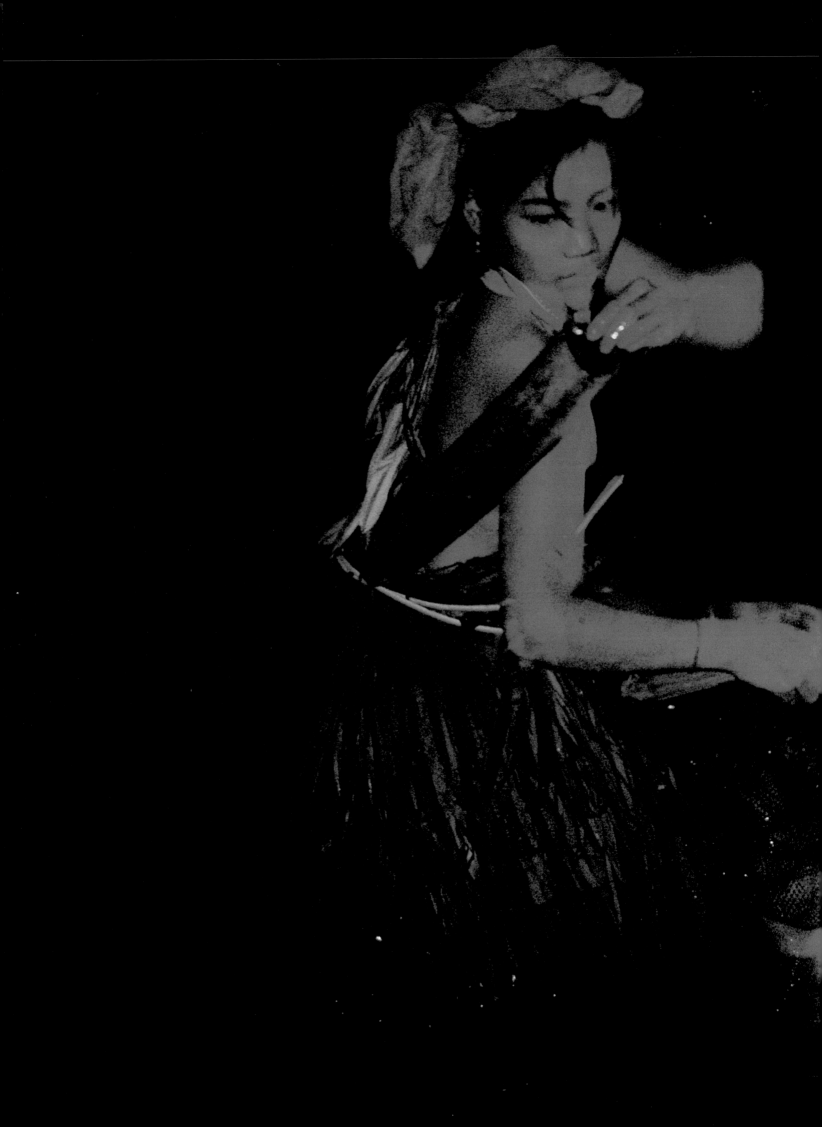

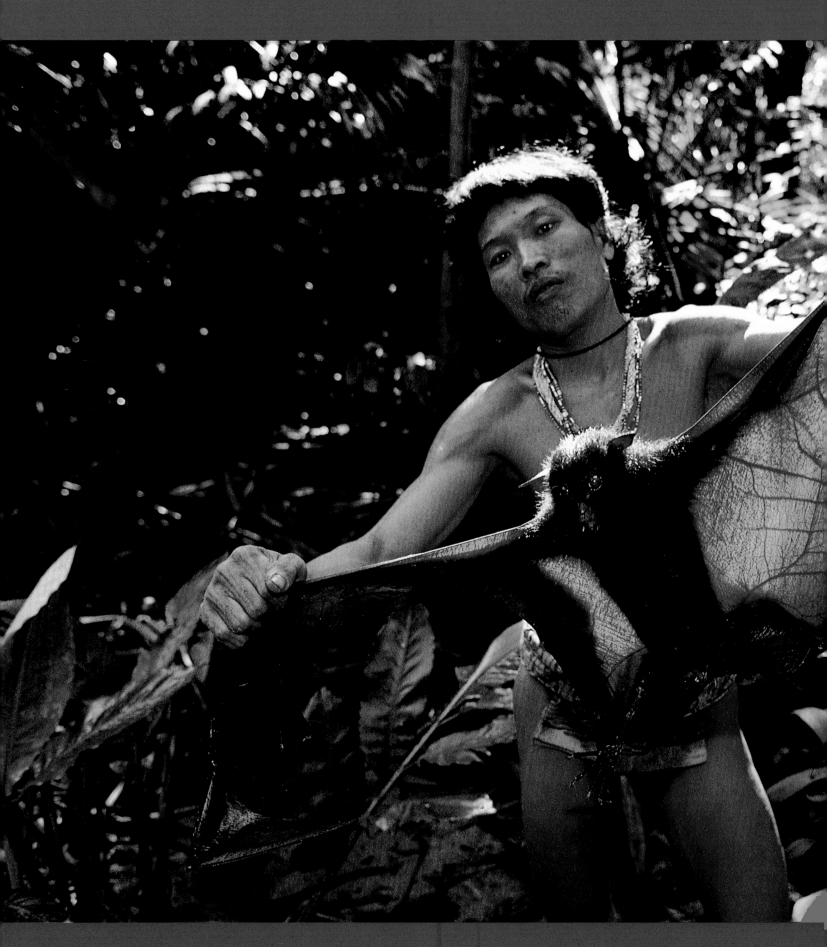

YESTERDAY I SAW TUMBU and inquired about his pet flying fox. He had kept it for seven years after it was injured during a hunt. Tumbu rolled his eyes in an odd way, encouraging further questions, and said it had died. Tumbu and I, both bachelors, joke in a way not possible with most Mentawaians due to their conservative attitudes. "Girls," he said in a disdainful tone. "They ate him." It seems three girls were passing by Tumbu's hut while nobody was home. The girls stole, cooked, and ate the pet bat. "They were hungry." Tumbu tapped into local gossip (*pangalukat*) and learned who the rascals were; he later negotiated a damage settlement of tobacco.

Overleaf: Giant leaves become umbrellas as young women set about securing the log pathways and collecting the rain.

Pages 80 and 81: Aman Lau Lau's daughter Tingi and son Bakat play in the rain during a flood while the women keep watch.

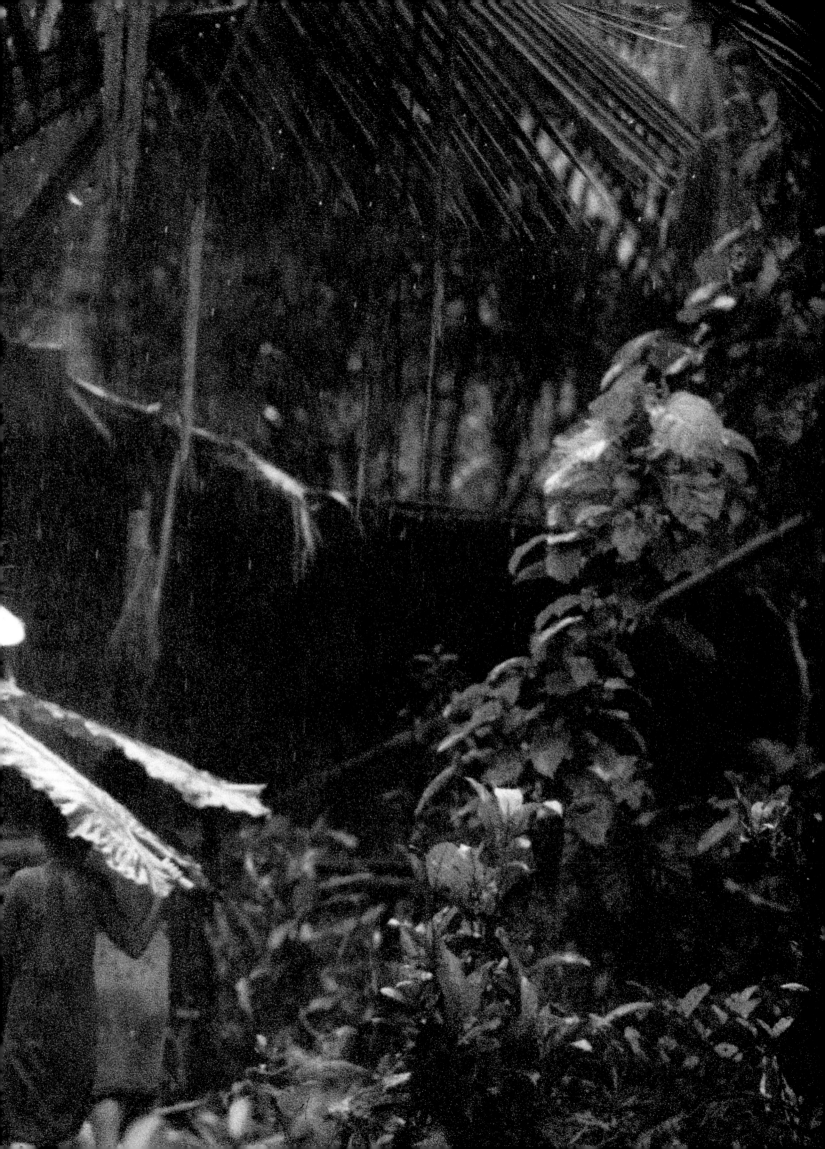

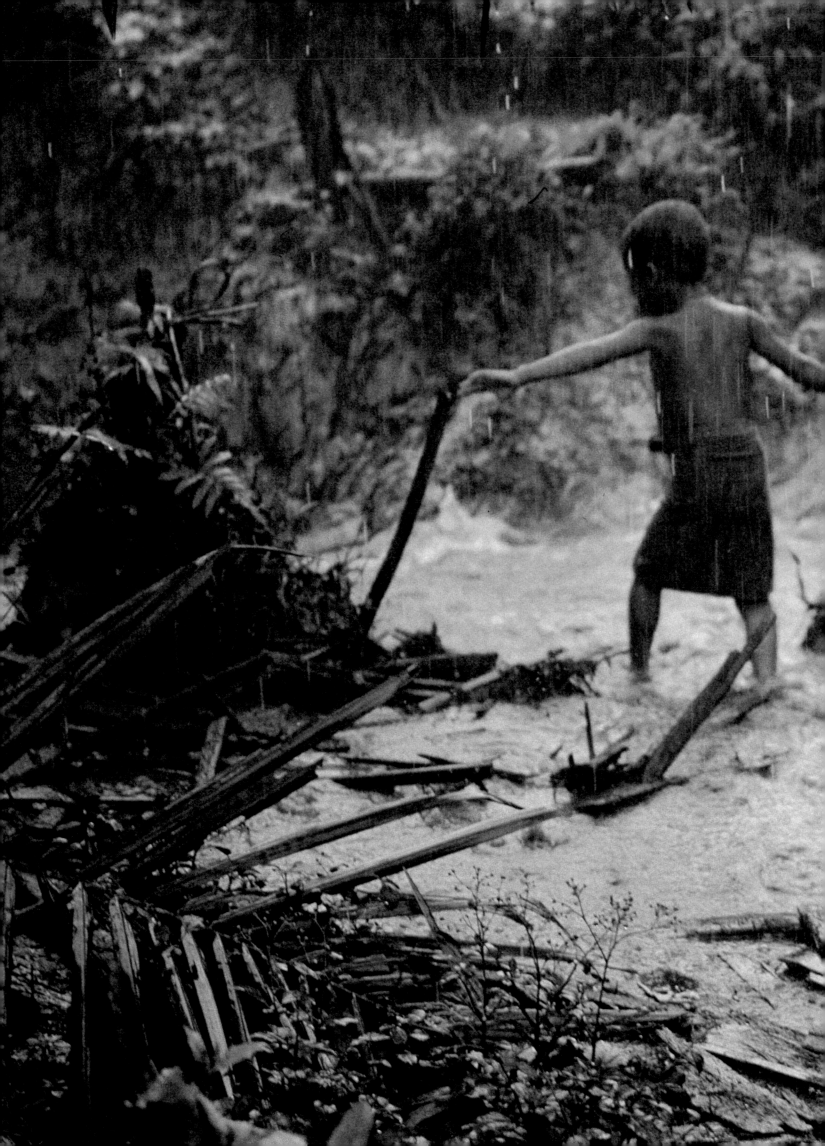

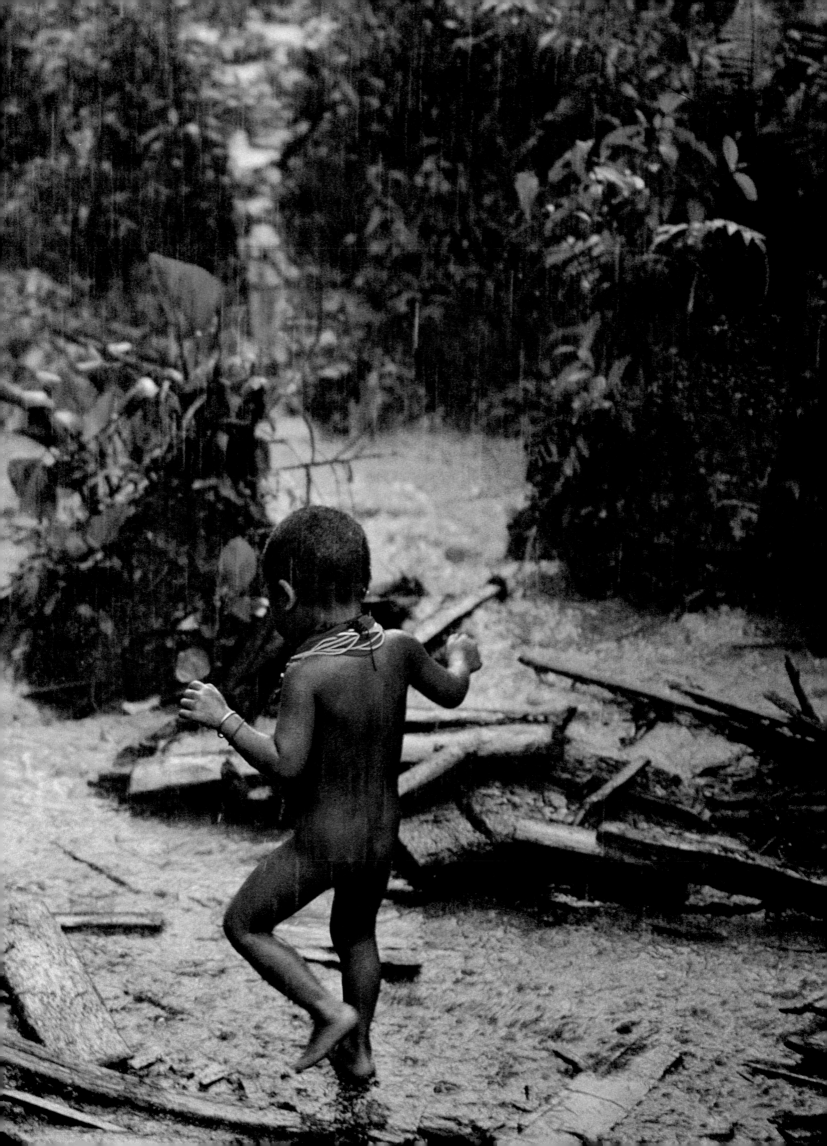

THIS EVENING we had a very heavy rainfall for an hour or two. The river swelled to four times its normal depth and two of the girls were stranded on the other side. Lau Lau, Leiai, and I scrambled to pull the canoes to safety, securing them with rattan. The usually clear swimming hole became a whirlpool and the "jumping tree"—a coconut palm that grew at a forty-five-degree angle—has fallen due to erosion.

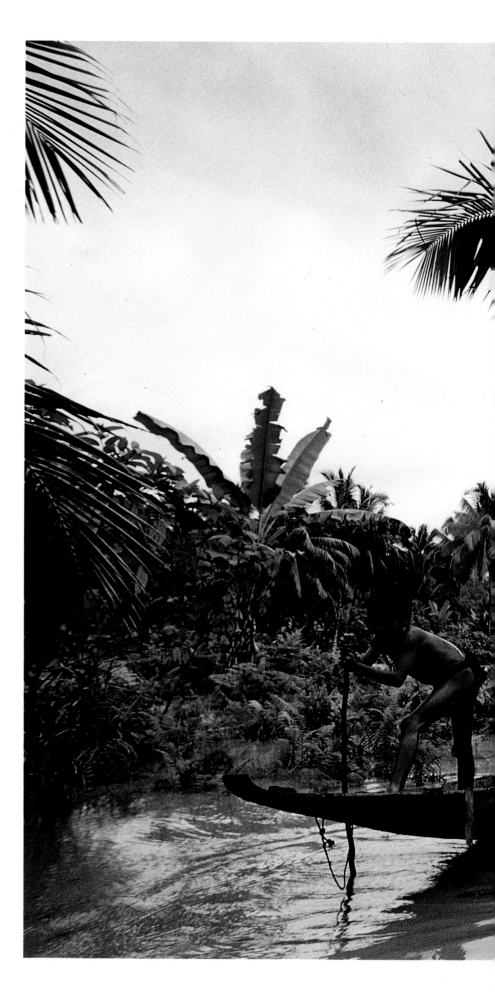

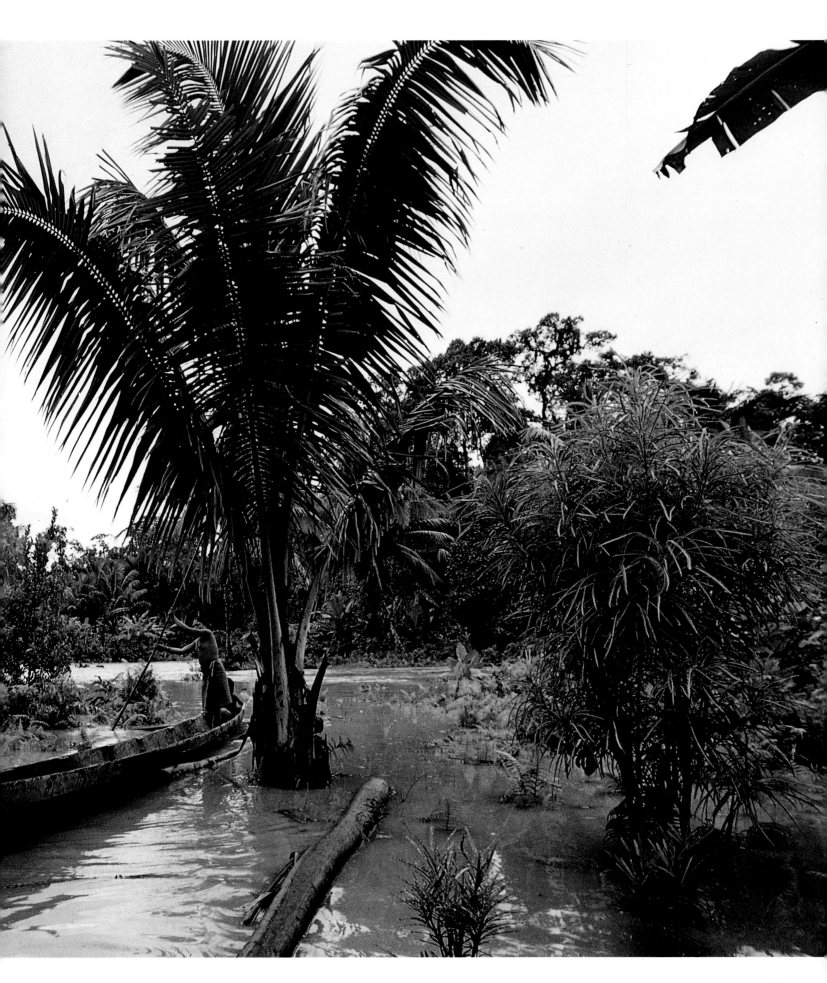

Lau Lau uses a long stick with a natural glue on the tip to catch dragonflies, which he then singes in the fire and eats. Like the other bugs the children seek for fun, they are crunchy and sweet.

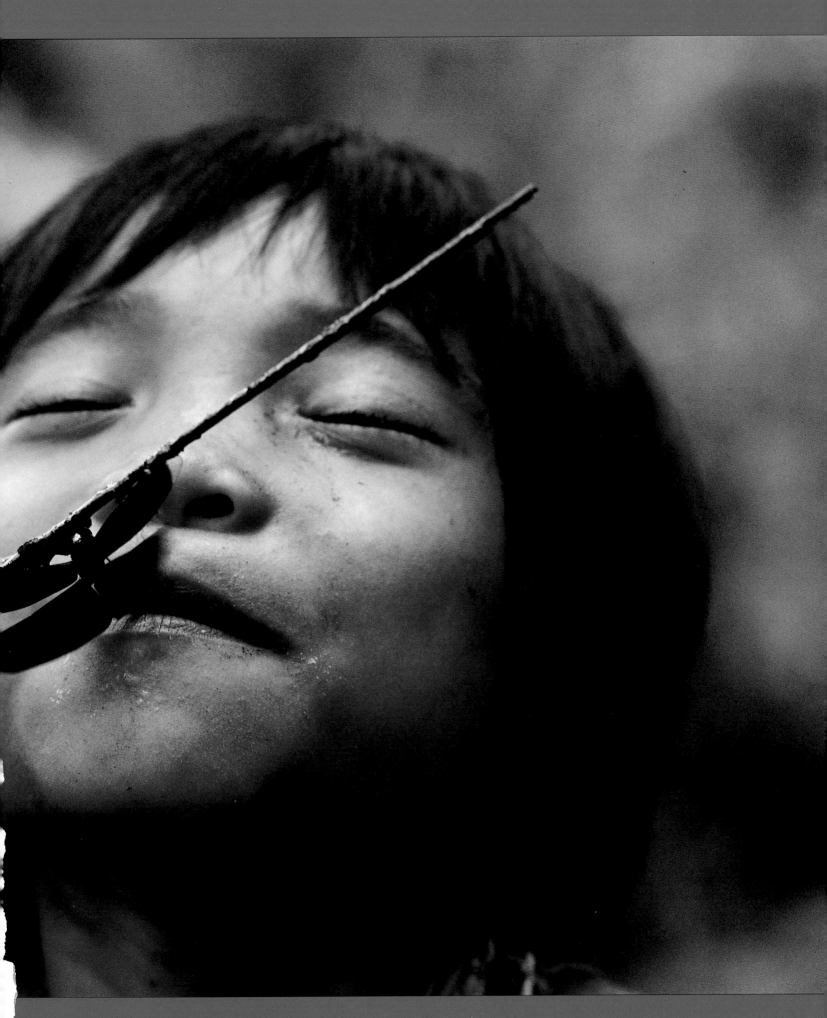

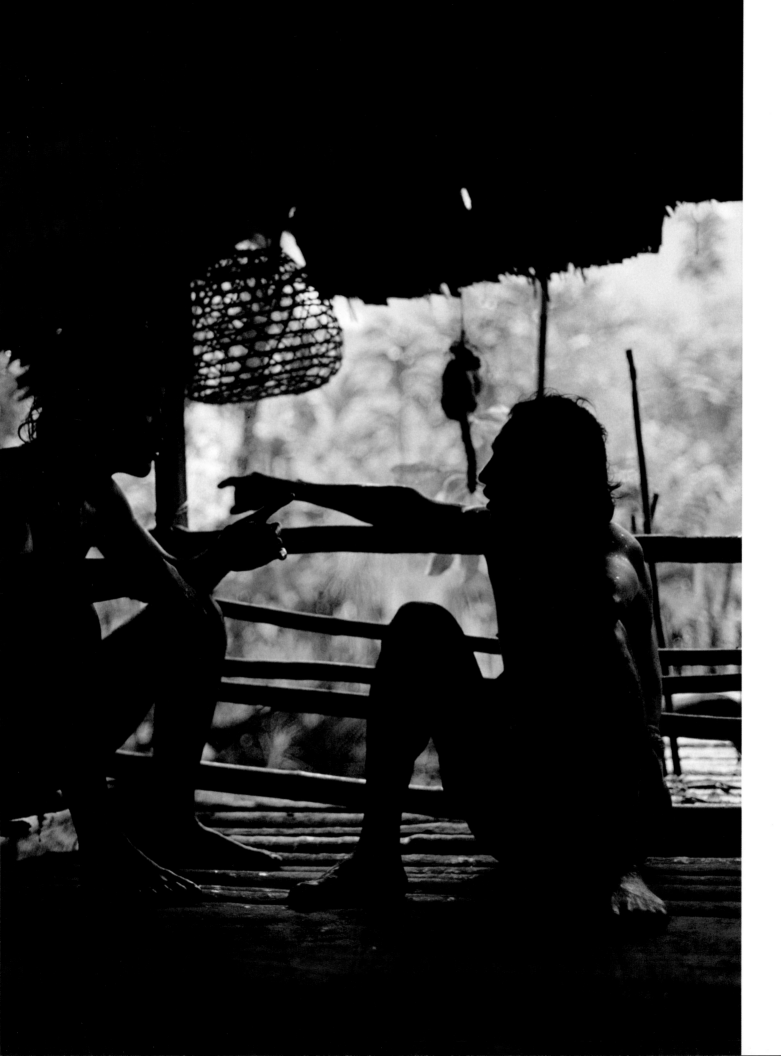

RITUAL HEALING

Healing is the essence of shamanism. Once the *kerei* are called and accept the appeal to rid someone of an illness, all other work becomes taboo. They may not leave until the ailment is cured or they are dismissed. Though the normal payment might be a chicken or piglet, it is not expected nor would it be the motivation for healing.

Bai Tao Beleu Manai had been sick for two days when Aman Lau Lau Manai was called upon to cure her. Her husband chose Aman Lau Lau because of his good record and close proximity. We arrive after dark. Aman Lau Lau diagnoses the cause to be a breach of sexual taboo, which occurs when the consumption of wild game is not accompanied by sexual abstinence. Wild game are thought to be the domesticated animals of people from another dimension, and compensation must be made after the hunt.

Overleaf: **With dawn's first light Aman Lau Lau goes into the jungle to collect medicines.**

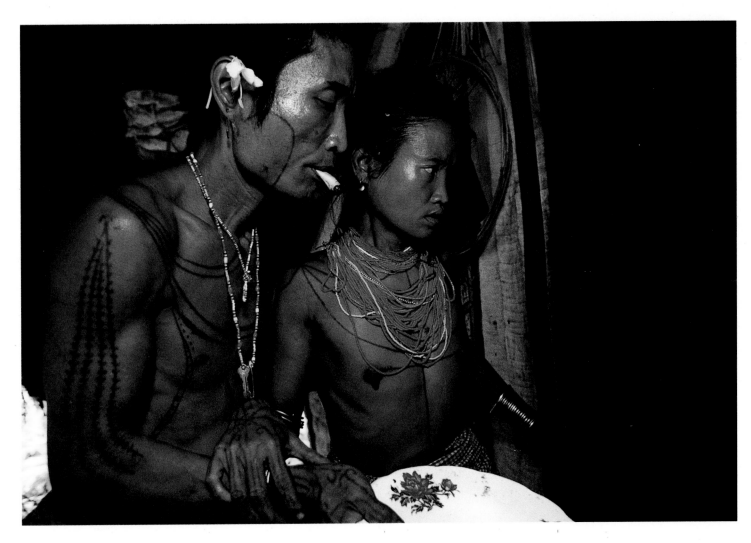

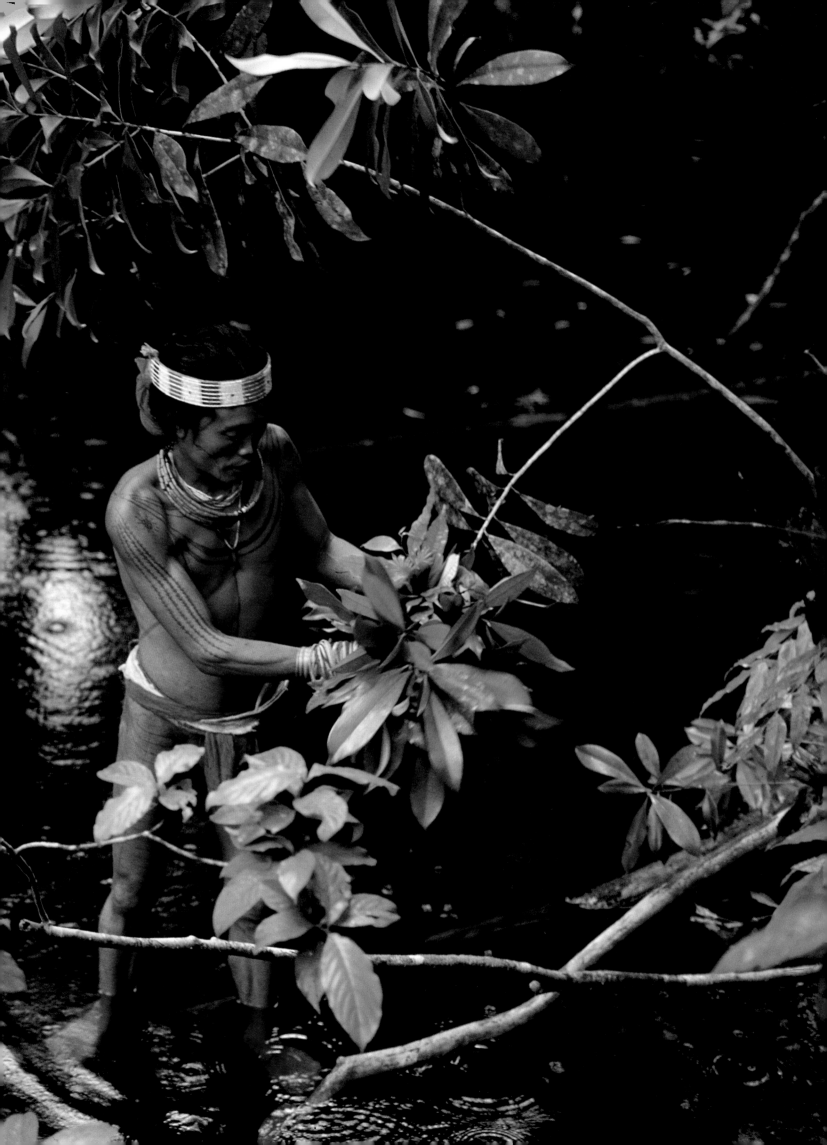

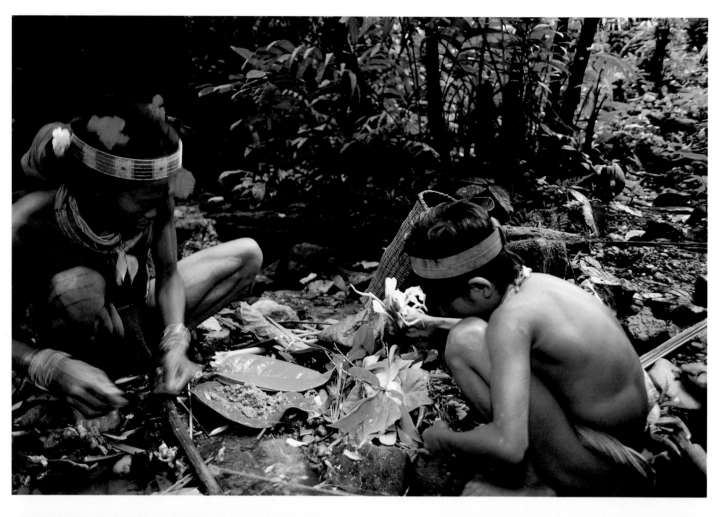

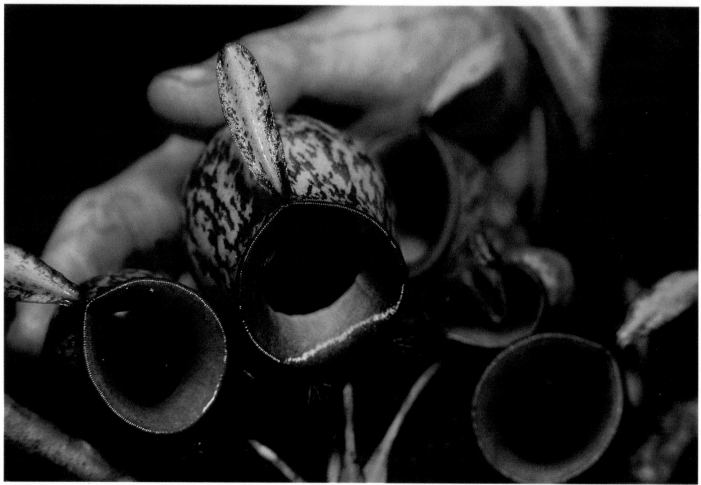

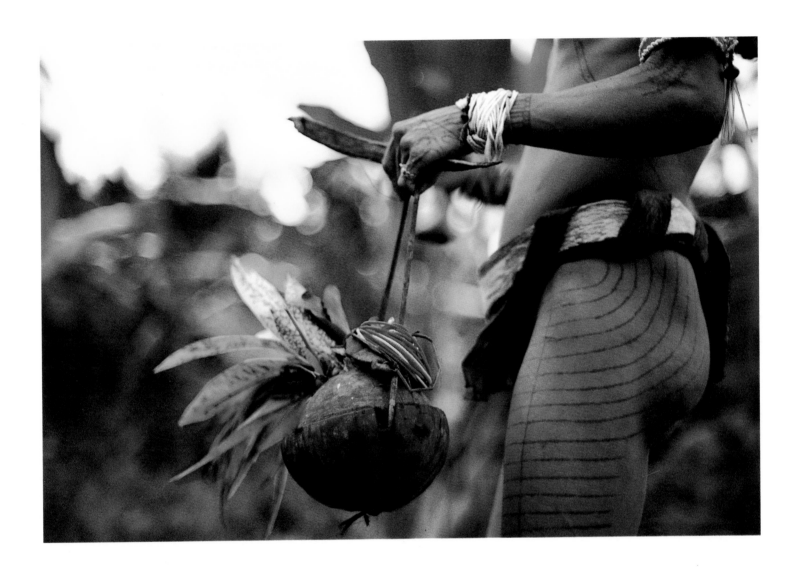

Above: The patient's family heirlooms and beads are ritually cleansed near the river.

Opposite, top: Aman Lau Lau and his son prepare the mixtures of medicinal plants, which are grated and stored in leaf packets for oral consumption and massage. This is private work, not to be viewed by others. *Opposite, bottom:* The pitcher plant is thought to hold sacred waters, which are applied for mystical purposes.

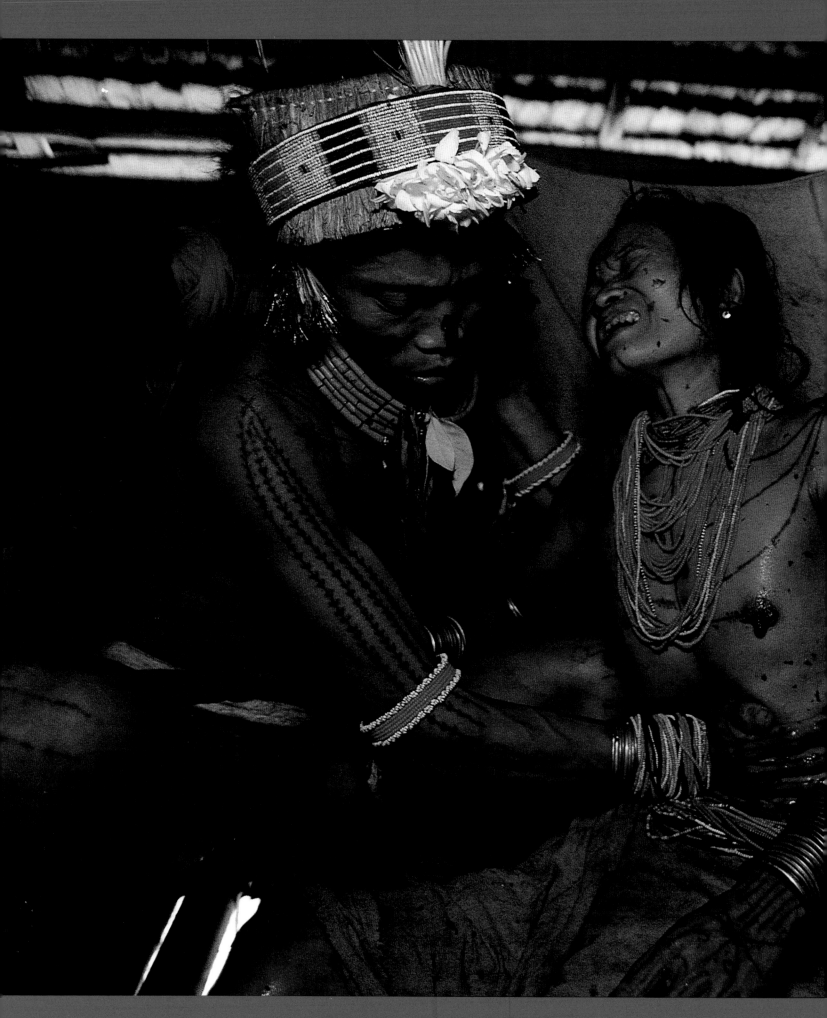

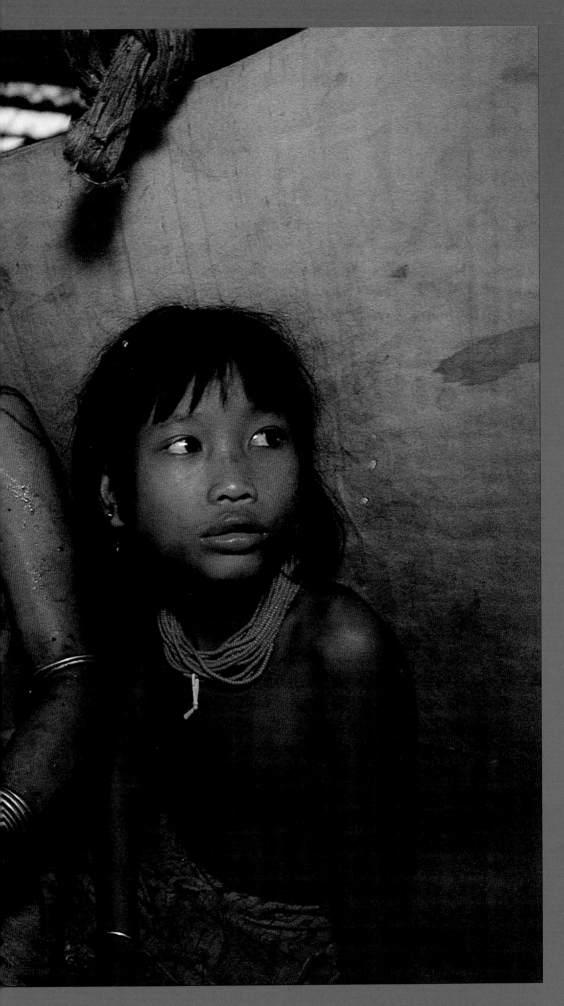

Bai Tao Beleu Manai is suffering from abdominal pain. Aman Lau Lau has given her a concoction to drink and is squeezing and massaging another into her forehead, torso, and hands. After addressing the physical symptoms, he turns to their supernatural causes.

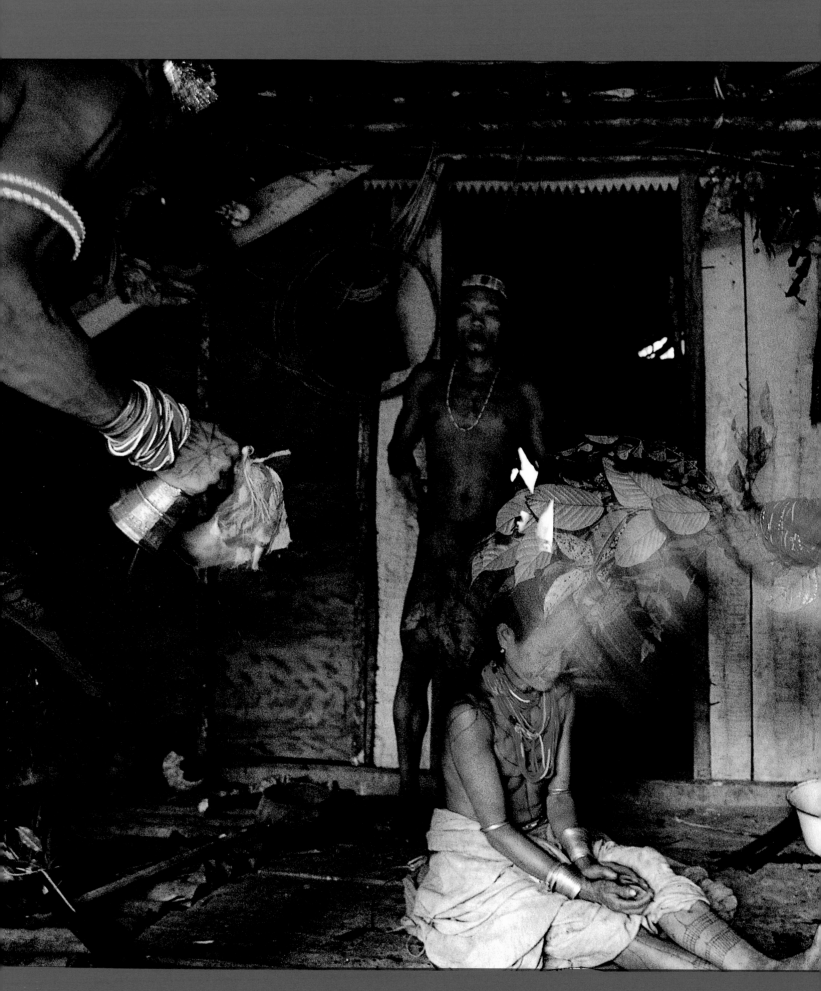

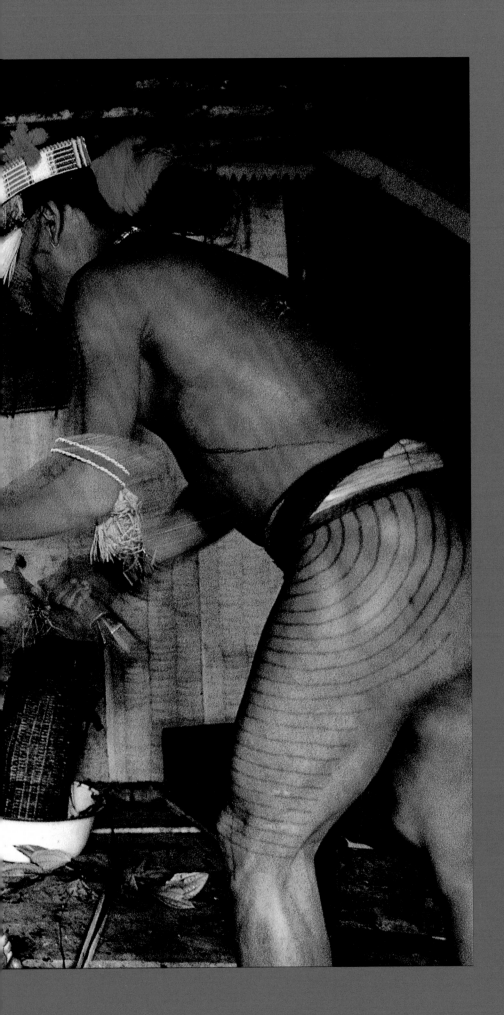

The *kerei* ring their bells and chant, shooing away the evil (*bajou*) and calling for Bai Tao Beleu Manai's displaced spirit. That night Aman Lau Lau and another *kerei*, Toktuk, danced themselves into trance in search of answers. Simultaneously, the patient's fever broke while she herself was in trance. She was well several days later and we returned home.

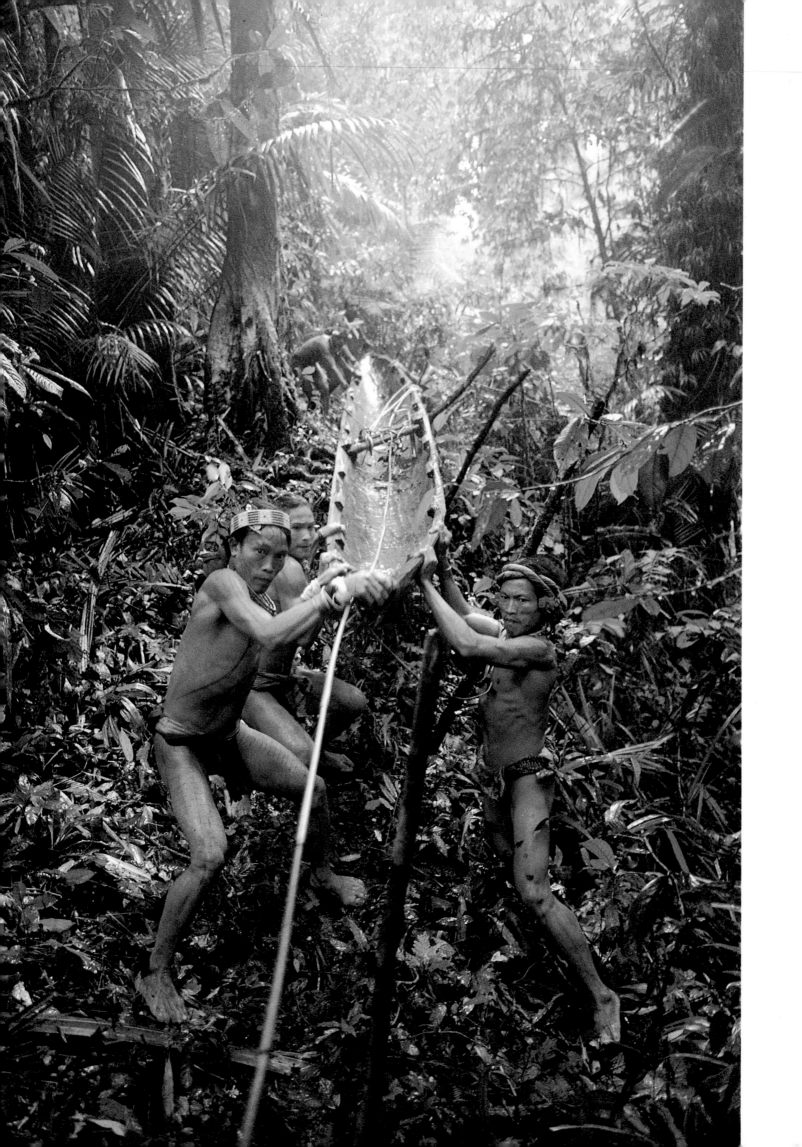

RIVERS TOWARD TRADE

Paddling downriver toward Muara-Siberut, the island's main port, Aman Lau Lau and his son Lau Lau stop to change from loincloths into shorts and shirts to conform to the decree of officials there. The port's inhabitants are predominantly Muslim Minangkabau from Sumatra—traders, merchants, and government employees. There are Catholic and Protestant churches and a small clinic that services the locals. In the 1970s and more recently, police detained traditional Mentawaian men in order to shear their hair as a message to those upriver. The Mentawaians are nonconfrontational. At times police missions have resulted in the burning of some longhouses and the *kerei*'s religious articles, including the prized magic box, *salipa*, which holds potions and mementos.

I received a distressing letter from a Dutch friend, an academic interested in Siberut. There is news of forced sterilization by injection in coastal villages. Apparently, women were called into the villages and inoculated by a government doctor for "good health and less children." The treated women became desperately ill. Once the doctor retreated, a Protestant sister from Muara arrived to aid the women's recovery.

Concerned with petty corruption and the suppression of the Mentawaians' traditional religion, in 1988 Aman Lau Lau and I decided to travel to

Rivers are the arteries of Siberut: travel is by dugout canoe (*abak*). Made from the large Shorea trees, the canoes are important possessions. Before clan members cut a tree, they conduct many rites to assure a safe exit for the spirits living in the forest canopy. Friends and in-laws join in hewing the canoe; for their help the host shares his meat and tobacco. *Opposite:* When the nine-meter-long canoe is nearly completed, it is drawn down to the river and paddled home for finishing. *Below:* A festival to bless the new canoe for safe travel.

Pages 98 and 99: Rattan, here being loaded into the canoe, is the Mentawaians' main barter good.

Pages 100 and 101: Rattan is taken by dugout canoe to the main port of Muara, where it is exchanged for tobacco, cloth, flashlights, and machete blades.

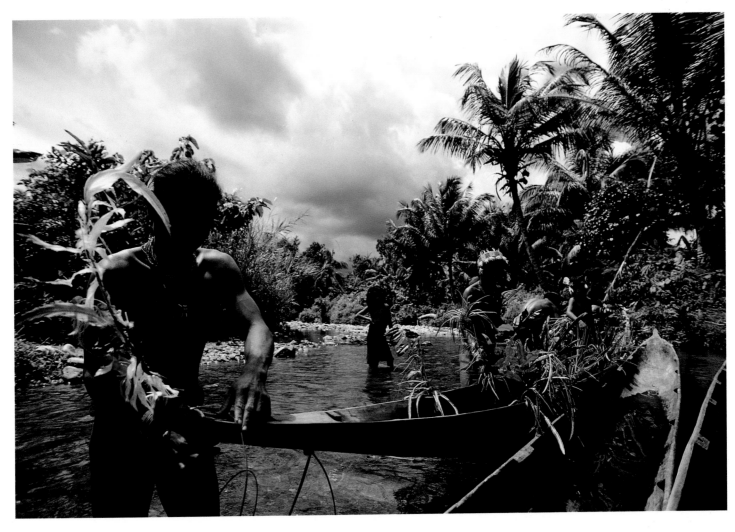

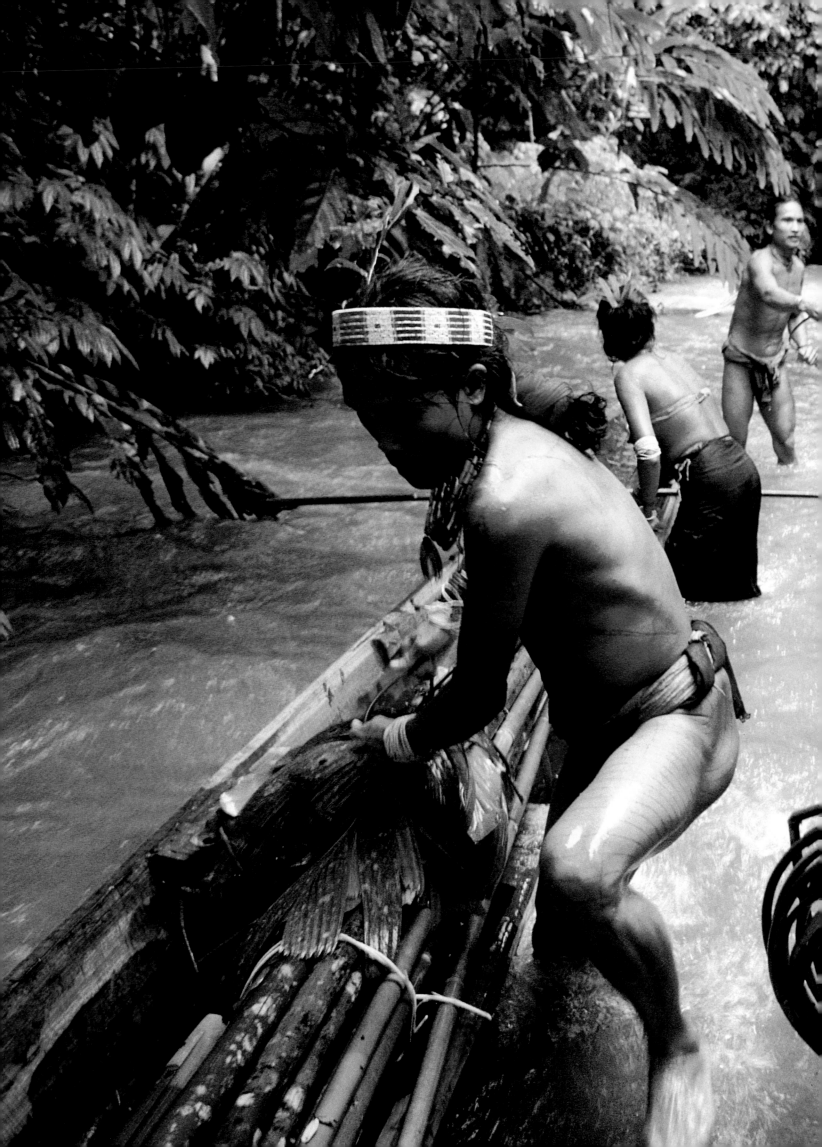

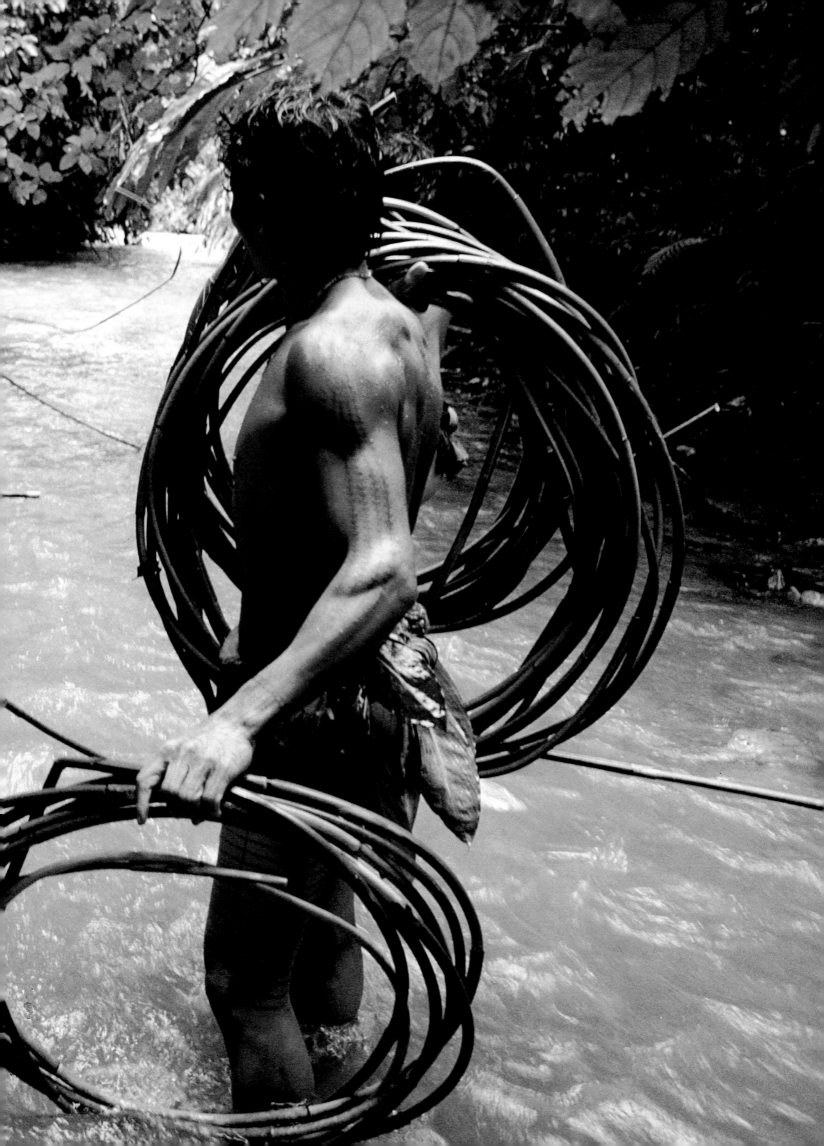

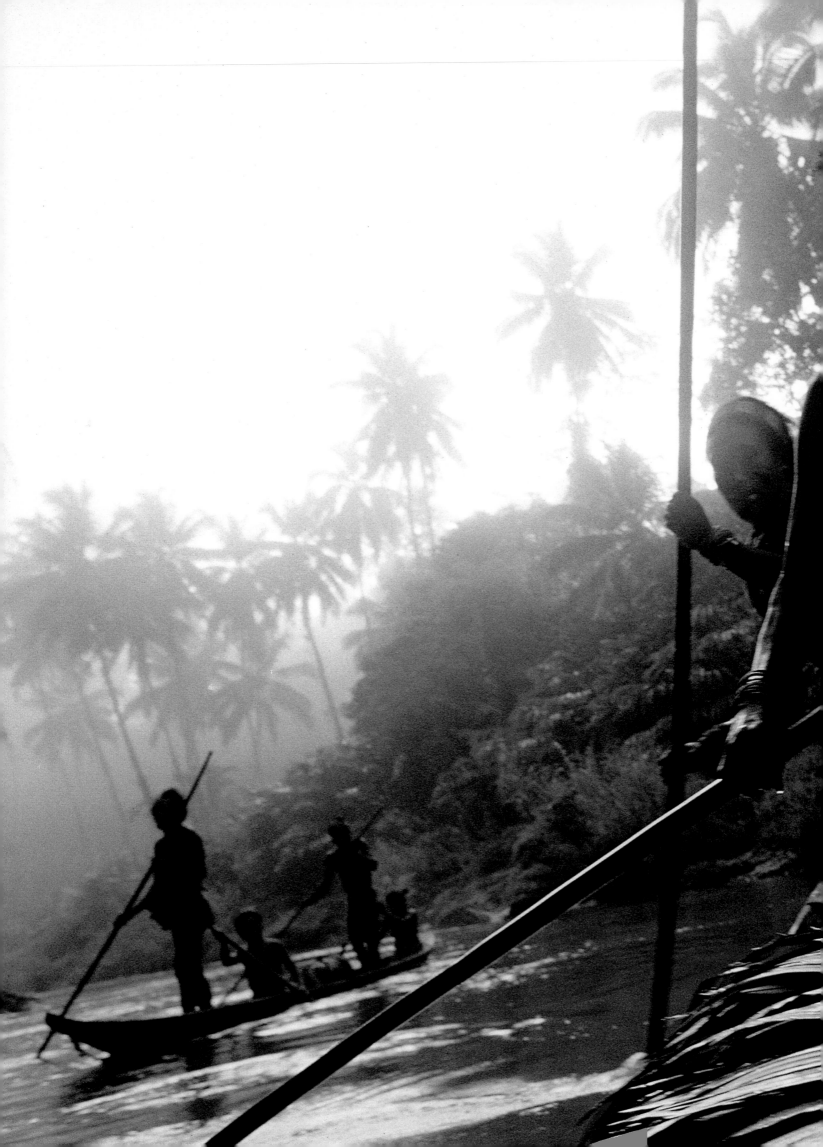

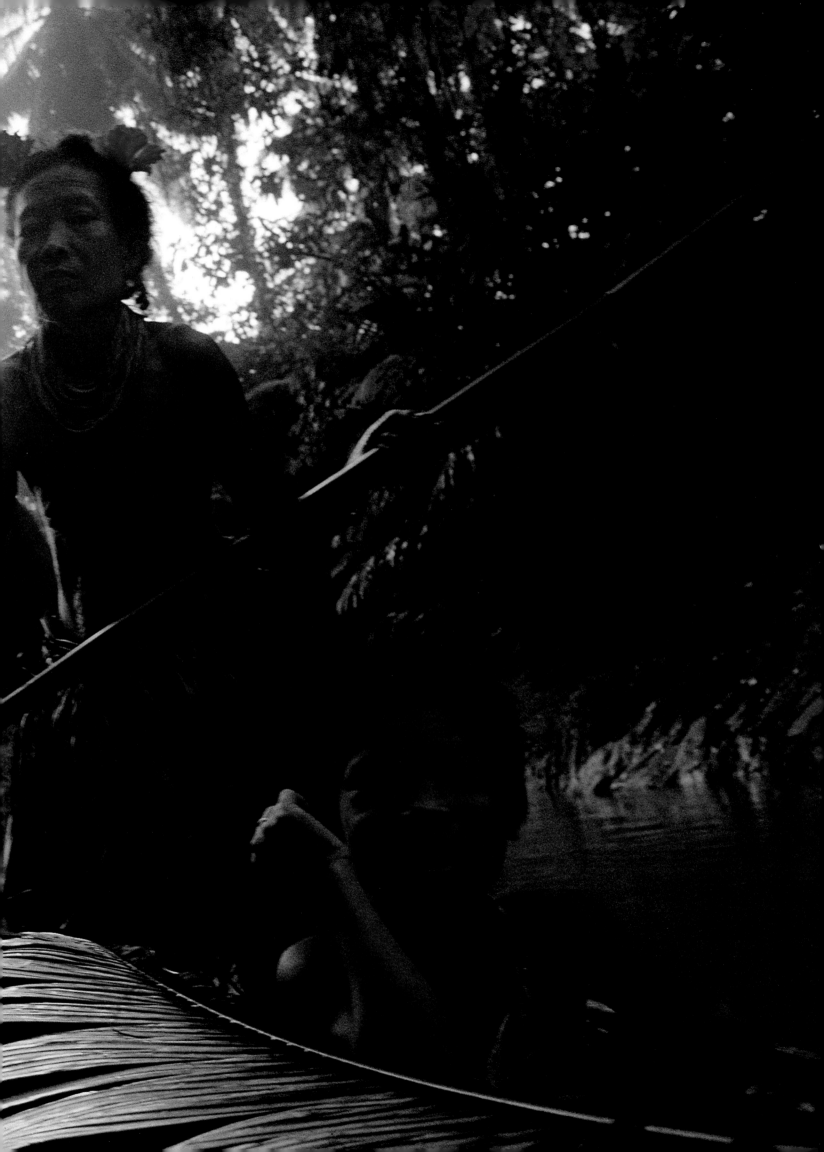

Sumatra to meet Governor Hasan Basri Durin. It was Aman Lau Lau's first trip off the island. Our trip together was like a dream—sharing his first encounter with a car, a horse, and so many other things. Just as he had cared for me during our many months in the jungle, I now looked after him in the outside world. The governor greeted us cordially and without delay. I translated for Aman Lau Lau, expressing our concerns, and the governor assured us that Indonesia is indeed a democracy, that all citizens are free to practice their own beliefs and religion. The trip provided Aman Lau Lau a certain immunity from interference back home. A year later he went on "the flying silver boat," an airplane, to Jakarta, after he was invited to dance at a cultural festival.

My worries about these corrupting influences proved unfounded. Aman Lau Lau truly didn't desire modern possessions. After being welcomed in Jakarta traditionally dressed, he said he could no longer accept infringements upon his people when at home on Siberut. I laughed as he told his family about Jakarta—a place where there are so many people they look like ants. I felt honored when he confirmed to his family my thoughts about their personal wealth, which consists of an abundance of natural resources and traditions. At the end of each trip I would show my gratitude and commitment to Aman Lau Lau and leave behind a special gift; usually a large gong, a calf, or a young water buffalo.

In the last few years, aloeswood trees (*gaharu*) have been harvested relentlessly on Siberut. When older *gaharu* trees are discovered to have a certain disease, the resulting fragrant sap provides a highly sought-after incense that fetches high prices in Saudi Arabia. Greed has led some Mentawaians to abuse their traditional taboos. Aman Lau Lau told me that he did not care to seek the treasure, because he was too busy with work and family.

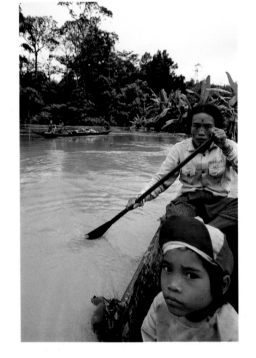

Above: **Having changed into shorts and shirts, Aman Lau Lau and his family approach the port.**

Right: **The family barters for goods at a shop.**

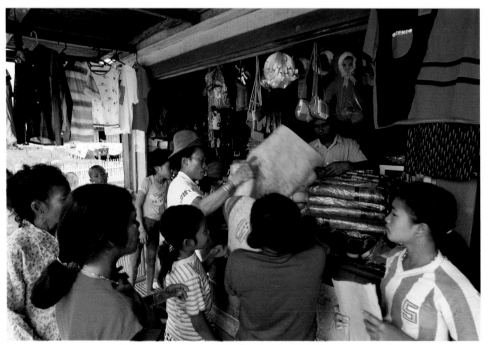

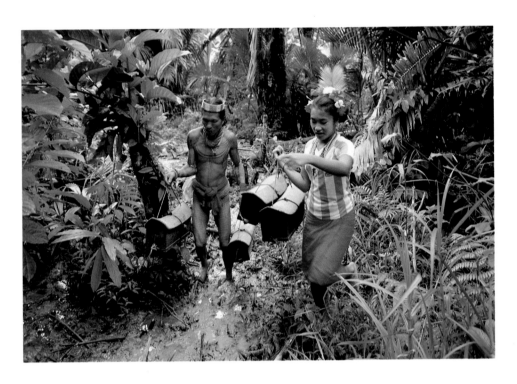

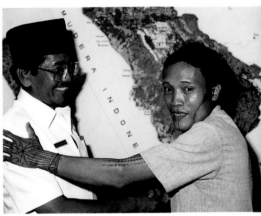

Left: **Aman Lau Lau's in-laws hurry to hide the shaman's magic boxes in the jungle after word of an approaching government party arrives.**

Below: **The governor of West Sumatra, Hasan Basri Durin, greeting Aman Lau Lau Manai.**

It was the young unmarried men who did it. Five years ago cash was almost unknown, barter was the norm. Now everyone talks about money and its power.

The most recent threat to the Mentawaians' traditional existence is tourism. Ironically, the presence of foreigners is forcing the Indonesian government to conclude that archaic local customs may be valuable economically. Greedy Sumatran guides arrive on Siberut with insular tour groups that are unprepared and uneducated in the ways of the Mentawaians, frequently ignoring the local customs. Locals feel cheated by gawking outsiders who leave so little of value in their wake. Though the Mentawaians welcome individual travelers, they see the growing number of insensitive tourists as an imposition.

The Mentawaian culture has existed, ecologically balanced, for centuries. Now, the last traditional Mentawaians waver on the brink of destruction. Shamanism is alive, but the Mentawaians live and think in the present; they cannot comprehend a future that deviates from their past. Yet the past holds answers to the future for all mankind. This form of shamanism is a religious testament to the early migration of peoples from central Asia and Siberia to Oceania and the Americas. It embodies ancient knowledge that is alive today, yet unquestionably endangered. We now know that the key to many cures for modern man exist in the rain forests of the world and need only be rediscovered. In 1981, the World Wildlife Fund published a significant research report, "Saving Siberut: A Conservation Master Plan." The suggestions that it offered have been largely disregarded; however, intelligent conservation efforts offer the final hope. Primary rain forests and their traditional keepers are not renewable resources. Once gone, they will be lost forever.

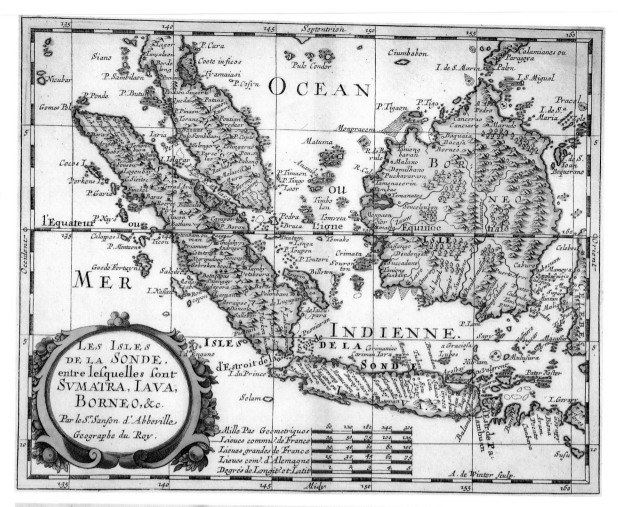

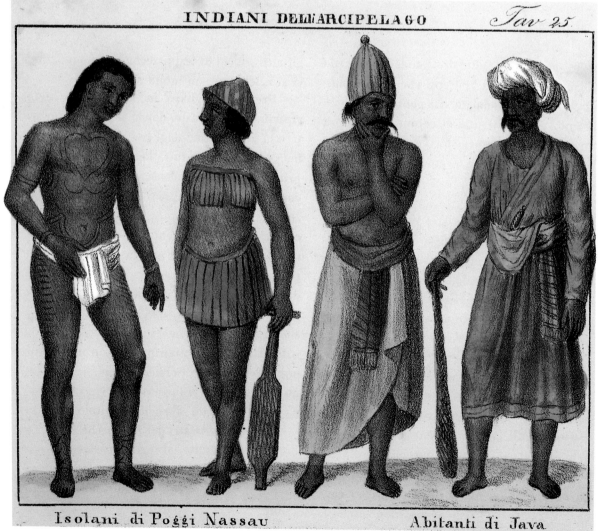

INDIANI DELL'ARCIPELAGO Tav. 25

Isolani di Poggi Nassau Abitanti di Java

SHAMANS ON SIBERUT
MEDIATORS BETWEEN THE WORLDS

REIMAR SCHEFOLD

I had been living for almost two years in the longhouse of the Sakkudei clan in the interior of the island of Siberut when we were called to a neighboring group. A young man about sixteen years of age by the name of Sigilaket had been missing for several days. He had gone hunting in the forest in the morning and had not returned. Everyone looked for him, but in vain. And now, they said, he was suddenly back, painted and decorated with flowers and plants; at first they could not understand his language and no one could speak with him.

When we arrived at the longhouse, at Sigilaket's *uma*, everyone was excited. Sigilaket told how his eyes had suddenly been "opened" in the jungle. He had seen the entrance to their ancestors' *uma*, striped in the colors of the rainbow, and he had been invited to enter. Their house was huge and glittering, and was decorated with blossoms and large shining gongs. He heard the singing voices of the ancestors, but he had not seen them. After some time they sent him home and told him they would call him back later. He said he awoke in the forest, and that he wanted to return to the spirits.

To this day I still do not know what really happened to Sigilaket. The Sakuddei told me many stories about young people who had penetrated the world of the spirits and had been adopted by them, sometimes forever. I had considered these stories to be legends, but now I realized that the Sakuddei meant real occurrences. In order to convince me, they pointed to Sigilaket's decorations; they must have come from the ancestors since he did not have a bush knife with him to make these decorations by himself.

We went into the *uma*. There was Sigilaket, sitting on the dance floor, weeping, in a strange state between trance and consciousness. He repeatedly sang songs, answering calls from the ancestors that were audible only to him. Everyone agreed that his life was in the direst peril. The people of Siberut say that once a person's soul has eaten with the ancestors and decorated itself in their presence, then he must die. Sigilaket had, as a living being, crossed the border into the realm of the afterlife and thereby attained a proximity to the ancestors that, in the realm of this life, can only mean death.

Sigilaket's confused state was an indication that his soul found life with the ancestors more attractive than existence in the *uma*. There was only one way to dissuade his soul: to show it the possibility of gaining access to the other world while remaining in this life. There is among the Mentawaians a category of people to whom this possibility is available—the shamans, the *kerei*. This could be a way to cure Sigilaket. The *uma* was decorated with flowers and carvings; a large ritual celebration was given with many guests, sumptuous meals, and dances night after night. At the high point of the festival Sigilaket was adorned like a *kerei* in festive attire from tip to toe and consecrated as a kind of provisional shaman. This was to show his soul that its wishes could also be satisfied in this existence and that life is worthwhile.

During this festival the entire *uma* was bewitched. Sigilaket kept tearing himself away from the festivities, running into the forest weeping and singing; he had to be brought back by force. But gradually he calmed down. The

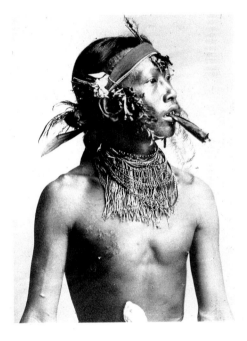

The Dutch photographer C. Nieuwenhuis took this photograph c. 1895 on Pagai, the southernmost island of the Mentawai archipelago. Nieuwenhuis owned a photo studio in Padang, West Sumatra, and traveled several times to Mentawai. His photographs bear witness to the romantic view of the Mentawaians typical of 19th-century colonialists and were, at the time, widely collected by tourists.

Opposite, top: Sanson d'Abbeville's 1670 map of Sumatra, Java, and Borneo. *Opposite, bottom:* The engraving *Indiani Dell'Arcipelago*, 1841, depicts the Mentawaians of the Pagai Islands with inhabitants of Java.

other shamans took him into their circle and together they sang the triumphant exaltation of a new *kerei*:

> You are the blossom for me, white *tebba* flower,
> With prickly fruit, with sweet-smelling fragrance, *leoi*,
> Aptly you adorn the head of my friend,
> My friend, the youth, who bears you, *oi*,
> On the back of the dance floor, blossoms of equal size,
> Equal are his steps in dancing,
> Rhythmically he stamps on the boards, *leoi*.

> You, too, I mix among my blossoms, flower of the *ikug* bush,
> The short-stemmed, that grew of itself, *leoi*,
> In the new clearing, in the new garden on the riverbank.
> Aptly you adorn the head of my friend, *leoi*,
> My friend, the *kerei*, the new *kerei*,
> Equal are his steps in dancing,
> Rhythmically he stamps on the boards, *leoi*.

Several years later, when visiting the island again, I returned to the valley of the Sakuddei to find that Sigilaket was married. He was now a *kerei* and had returned to his daily life.

THE ISLAND OF SIBERUT

Continual care for one's soul is a guiding principle in the life of the Mentawaians. In the humid climate of the tropical rain forest, existence is constantly threatened by disease. For this reason the population density on Siberut has, through the centuries, remained very low. The Mentawaians attempt to explain illnesses and to control them. The way in which this is done is intimately connected with their traditional way of life.

Siberut, the northernmost island of the Mentawai archipelago, lies some sixty miles west of Sumatra and is approximately 1,500 square miles in area. The interior is hilly and covered with thick primeval forest. Between the hills lie broad valleys through which rivers meander. During the many rainfalls there are periodic floods, which deposit fertile earth on the riverbanks and in the marshy lowlands.

Dotted along the rivers lie the traditional longhouses, the *uma*s. The people travel in dugouts up and down the rivers, which are the most important channels of communication among the *uma*s. An *uma* is a village under one roof, with room enough for a group of some five to ten patrilineally related families, which are, as a unit, also called an *uma*. The layout and the use of the house reflect the Mentawaians' strong sense of community. All *uma*s stand on stilts. The entrance is at the front via a notched tree trunk, which serves as a stairway. The first room, an open airy veranda, is a common room, a place to converse and to receive guests. It is here that most of the men sleep at night. Some of the men also bed down in the first interior room, a large hall with a common hearth for ceremonies and a wooden floor for the dances performed during ceremonies. A door leads into the second interior room, where the women and small children sleep. During the day meals for the individual families are cooked here on open fires.

In the *uma* each family is subordinate to the community. Around the *uma* lie plantations where each family owns its own small house, its *sapou*, where they keep chickens and pigs. In everyday life, families will live in these houses for weeks on end and enjoy some measure of privacy.

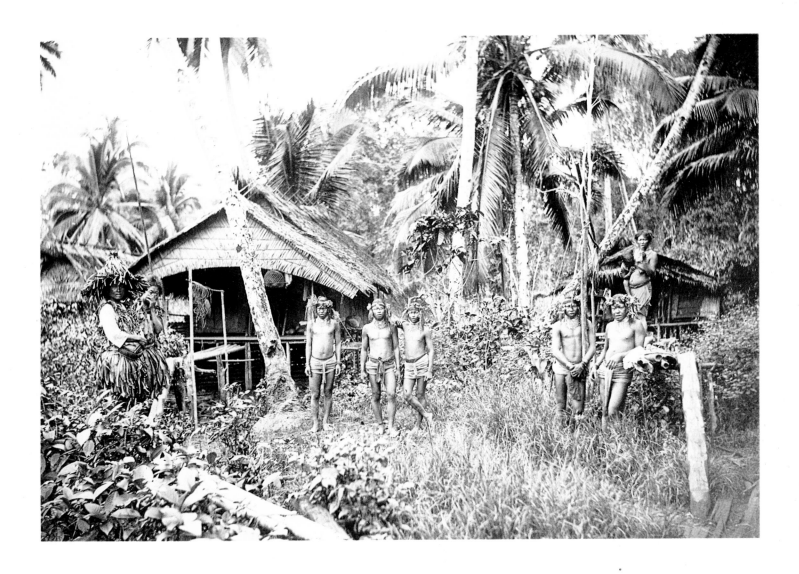

Daily work is divided evenly between men and women. The main component of the Mentawaian diet is flour from the kneaded pulp of the sago palms that grow in the marshy lowlands, a product of the men's work, as well as taro and bananas, which are grown by the women on the riverbanks. Along the river there are also coconut palms. Next to rattan and other forest products, coconuts are the most important goods for exchanging with traders from Sumatra. In return, the Mentawaians receive what they cannot produce by themselves: material for mosquito nets, iron tools, tobacco, and glass beads. In daily life, pork and chicken are supplemented by fish caught by the women. At the conclusion of the communal festive rituals there is also meat from the hunt, above all monkeys, which the men kill with bow and poisoned arrows in the forest.

In the traditional *uma*, children grow up free, with few restrictions. Since there is no division of labor except that defined by gender, children learn work roles by imitating grown-up activities. Toward the end of puberty they are tattooed and their incisor teeth are pointed. The boys in particular gradually begin to lay out their own fields and to raise chickens by themselves. The girls help their mothers; they will not acquire their own domain of work with their own tools until after they marry and go to live in their husbands' *uma*s.

Wives always come from another *uma* in the valley. Exogamous marriage is one of the most important means of ensuring good relations with other *uma*s. The Mentawaians recognize no political organization above that of the *uma*; it is each group's responsibility to regulate its relations with its neighbors. The Mentawaians' explicit ideal is one of peaceful coexistence in which no one is

Nieuwenhuis took this picture on Pagai using a plate camera, c. 1895. He achieved surprisingly fine results under difficult circumstances, carefully arranging the people in their lush tropical setting while producing an impression of relaxed harmony. Depicted are the inhabitants of two single-family houses on their plantations. The men are wearing the traditional loincloth made from bark; the woman, left, is wearing a traditional banana-leaf dress for daily work in the gardens.

a bother to the other. However, this ideal contradicts another wish, which continually leads to tensions: each group keeps an eye on its own reputation and would like to outstrip the others in prestige. There are perpetual rivalries and quarrels, sparked off, for example, by insinuations about theft or sorcery. It is not uncommon for open conflicts to arise that can last for years. In this regard, marriages form a mitigating counterweight to reduce this tension.

An *uma* can only truly rely on itself. Anyone in need can call on the help and support of the whole community and during festivals everyone has the same rights regardless of their individual contributions. Yet even in this communal setting there are continual differences of opinion. It is the dichotomy between private interest and group solidarity that most often causes disagreement. One individual may wish to reserve his personal wealth for private relationships that may help him gain followers and prestige in the valley, and for this reason he may neglect the solidarity inside the *uma* that his companions expect from him. The group cannot force him to conform; the *uma* does not have any organized political leadership. The only remedy lies in discussions involving all the members of the community. If the problem cannot be resolved in this way, there is only one resolution: the opposition moves out and founds a new *uma*.

The Mentawaians' economic situation is comfortable. Despite the simplicity of their working techniques, each household can produce everything that is needed for their traditional life. A much greater source of worry is the abiding tensions in the social realm. The continuity of everyday life is always endangered by the inner contradiction between the wish for harmonious relationships and the competitive urge for greater prestige, and by the consequent conflicts within the *uma* and between the groups. It is the model of these conflicts that the Mentawaians use to explain phenomena that threaten them physically every day: sickness and disease.

MAN AND HIS ENVIRONMENT
The Mentawaians believe that everything that exists has a soul—not only human beings but also animals, plants, and things. Things are not objects that

Nieuwenhuis depicts an unusual mixture of grim and smiling expressions. The title "Mentawai Radja's" appeals to Western exoticism, but makes no real sense in the leaderless society of the Mentawaians. Bows never actually are drawn when not shooting and the shield for headhunting is being utilized as a theatrical prop.

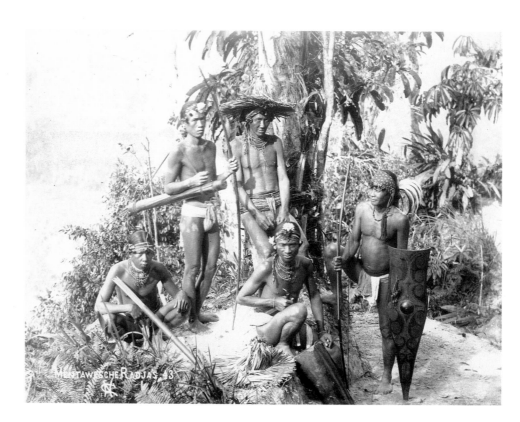

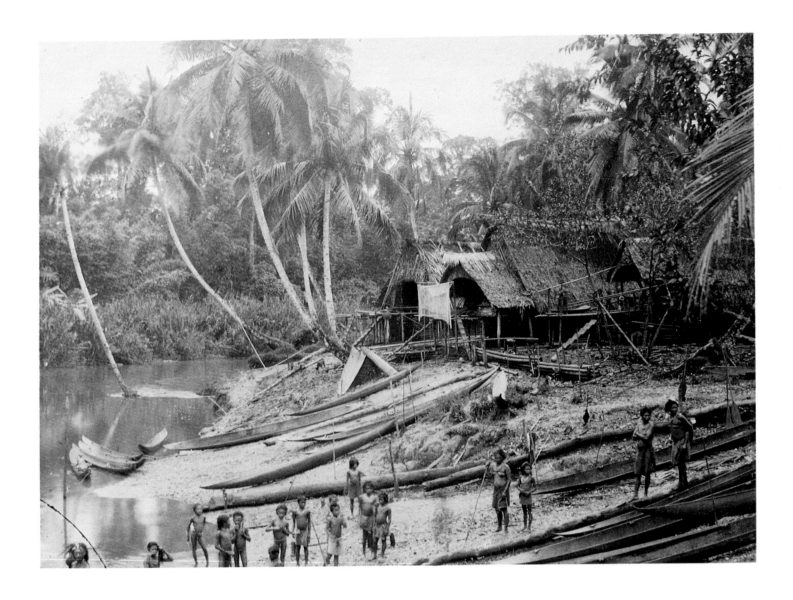

A landing area providing access to a village with a traditional *uma*, or longhouse, in the background.

can be used according to one's liking, but rather are subjects that must agree with their use. If you ask someone for something, you have to show consideration for his personality and offer him a return gift for his services. Similarly, things expect you to take their nature into account when you are using them and to refrain from other actions that are inconsistent with your activity. This is why there are specific taboos in Mentawai for each important undertaking. Anyone who fails to obey these taboos sets the things against himself. For example, a husband may not make a dugout canoe while his wife is pregnant: the hollowing out of a tree trunk is not compatible with an activity that is oriented toward avoiding premature "hollowness," i.e., carrying a child to full term. If he does not bear this in mind, he will bring down the wrath of the trunk upon himself and the canoe will not be a success. Its anger may also be directed at the man himself and cause him to fall ill.

The spirits expect similar consideration. In the world of the Mentawaians there are spirits everywhere—under the earth, in the immediate vicinity, in the forest, and in the sky. Several of these are evil and have to be avoided; others are favorably disposed to humans. People feel closely connected to the spirits of their own ancestors. However, there are other spirits that have a special relationship with the *uma*. For example, the mythic origin of the first longhouse is traced back to an orphan boy who had gained his knowledge from a crocodile spirit. Because of his companions' envy, the boy later moved under the earth, where he lives on as the spirit of earthquakes; he is still offered sacrifices during each great ritual. The spirit of the crocodile continues

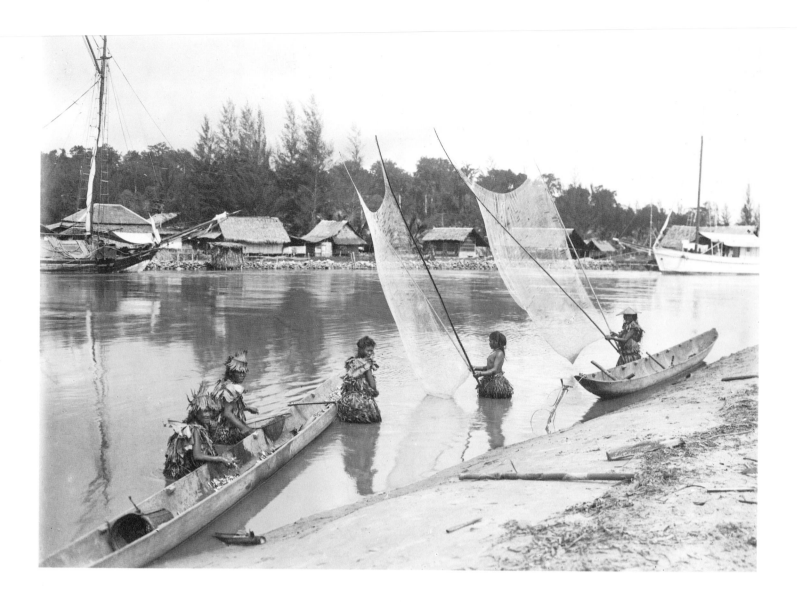

to watch over the *uma*. If someone goes against the nature of the community and behaves badly, for example, by eating meat alone behind the others' backs, he will be insulting the spirit of the crocodile and will have to reckon with its revenge. The spirit will then come into the *uma* and cause the guilty one to fall sick.

The spirits of the forest are owed special consideration. They too are closely linked to the people. In a myth it is told that the people of primeval times split into two groups, each with its own domain. The first group became the ancestors of the people who now live along the riverbanks; the other became the spirits of the forest. Behind the apparent wilderness lies their special world, hidden from men, a culture of the beyond. They share this world with the actual ancestors of the individual *uma*s, for their settlements are also located in that world of the beyond. Anyone going on a hunt, or indeed wanting to fell trees in order to lay out a field, must first ask them for permission and make sacrifices to them. Otherwise, the guilty are threatened by disease.

The common factor in all these causes of illness is that man has set the phenomena of the environment against himself by acting recklessly. There is also a common factor in the manner of healing; a cure is possible only once the injured parties have been placated. The angered things are "cooled down" by magical means, and the spirits are appeased with sacrifices. The intermediary in these contacts with the realm of the spirits is the shaman, the *kerei*.

The spirits do not only hand out punishment; they also offer protection and help. To this end they are invited into the *uma* for ceremonies and sacrifices. Again, the shamans play a central part in these invitations. At the end of the great group ritual, the *puliaijat*, the entire community goes into the domain of the ancestors and spirits. Sigilaket's story shows how dangerous it is for a living being to enter directly into that realm. This group incursion, however, is a symbolic visit that makes it possible to secure the spirits' help without having to get too close to them.

The visit to the ancestors marks the conclusion of the great festival of the *uma*. During the weeks of ritual activity, the group has been consolidated and reinvigorated by religious means. In several phases of the festival, neighbors are invited and friendly relations are reestablished; in other phases, the group closes itself off completely, prepares sumptuous banquets, ceremonially invites the ancestors as guests, and celebrates with them the solidarity of the community. Yet in both individual and collective ritual acts, the principle of rivalry also repeatedly comes to light, challenging and alienating opponents. Toward the end of the ritual, the group withdraws to a hunting camp in the jungle for several days.

In this ritual, the jungle appears quite explicitly as the domain of the ancestors and spirits. In an introductory ceremony in the forest the people ask the spirits to grant them success in hunting. The game animals, the monkeys, are considered to be the domestic animals of the spirits. During the *puliaijat* ritual, the community has sacrificed meat from their own domestic animals to the spirits. Now the spirits announce whether they have accepted these offerings and approve of the ritual. It is through success in hunting that the spirits guarantee the blessings that the world of men, with all its conflicts, sorely needs.

CARE OF THE SOUL

By living according to traditional rules of behavior, man can avoid insulting supernatural powers and thereby provoking their anger. Yet the inner contradictions of daily life yield an ever-present threat: the soul may lose its pleasure in this dubious existence and withdraw to the ancestors. At this point the person must die.

Even under normal circumstances the soul of a human being can roam freely; its experiences during these roamings provide the material for dreams. Danger looms if the soul does not want to return. To counter this danger, the Mentawaians try to live in a way that is pleasing to the soul and keeps it near at hand.

Out of consideration for their souls they avoid all rushing around. *Moile, moile*, "slowly, slowly," is one of the most commonly heard expressions on Siberut. In very general terms, a peaceful, harmonious, not too stressful existence corresponds to the desires of the soul. Bountiful, regular meals are part of this concept, as is particular care of one's outward appearance. Someone, be it man or woman, who neglects his body, or does not tend his long hair, or does not decorate himself with flowers and glass beads will cease to be attractive to his soul. As important are the permanent decorations of their bodies that the Mentawaians indulge in: tattooing and the pointing of the incisors.

"AMIABLE SAVAGES"

The richness of the Mentawaians' conceptual world contrasts strangely with the simplicity of their technical and social organization. In this contrast are reflected on the one hand the ancient prehistoric foundations of Mentawaian

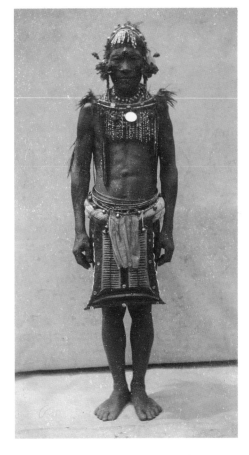

P. Wirz, portrait of a *kerei* in full attire, from South Siberut, c. 1927.

culture and on the other the long period of relative isolation in which that heritage developed on its own. The roots of the culture are several thousand years old and stem from the first agrarian settlers immigrating into Indonesia from the Southeast Asian continent. It is to these bearers of the Neolithic tradition, the Austronesians, that almost all languages spoken in Indonesia today are traced back.

Later developments in Indonesia influenced the Mentawaians only tangentially. There is little evidence of contact with the Early Metal Age—in art, for example, and in the trading contacts with the more developed societies of Sumatra that must go back hundreds of years. The specific characteristics of Mentawaian culture, however, developed locally. The culture is distinguished by its cautious emphasis on harmonious relationships, which applies in equal measure to relationships between social partners and to the visible and invisible phenomena of the environment. This is expressed symbolically in the desire of the human soul for balanced and peaceful coexistence in which there is room for leisure and beauty.

The first indication of contact between Mentawaians and Europeans dates from the records of a Dutch vessel in 1621. However, it was not until the beginning of the nineteenth century that detailed reports about the Mentawaians were provided by Western travelers. From the very earliest onward, these reports bear witness to a fascination with this exotically primitive people. The Mentawaians are described as "amiable savages," as "lively and fiery" yet

Inhabitants of a typical village have gathered for a portrait; the traditional *umas* are seen in the background.

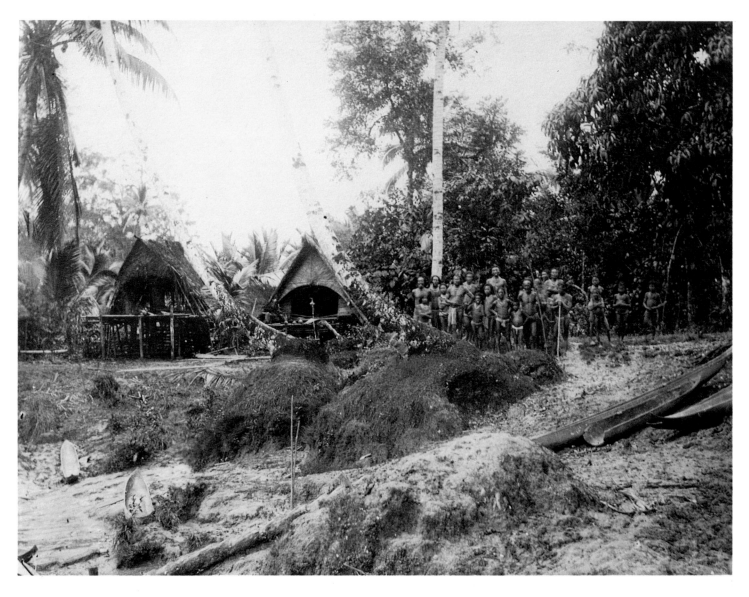

"gentle and peaceful." And the writers like to use the name of the archipelago as it appeared on old sea charts to characterize the prevailing atmosphere—the "Islands of Good Fortune."

This romantic image began to change as soon as the travelers no longer came simply as visitors, but started to make demands. At the beginning of the present century, the Dutch colonial government and the Rhenish Mission had established themselves in the archipelago. The ethnographic reports from both of these spheres of influence are all colored by displeasure that the thankless savages were unenthusiastic about honoring adequately the offer of a higher civilization. The Mentawaians' long periods of leisure were now ascribed to their "lazy, underdeveloped, and stupid" natures, and the missionaries complained about the "distress of a poor people trapped in terror of evil."

Nevertheless, the influence of the colonial government remained rather superficial, save for a few operations designed to pacify the islands. In particular, there was a rigorous prohibition of head-hunting, a custom that anyway played a much less important role in Mentawaian life than in neighboring Indonesian cultures. This ancient Austronesian practice did not attune well with the Mentawaians' striving after balance and harmony, and it was renounced with little notable resistance.

It was not until Indonesian independence in 1950 that aggressive attempts were made to modernize. Traditional culture was forbidden as heathen, and every Mentawaian had to join either Christianity or Islam. The population was forced to leave the old *uma*s and to group together in new villages of one-family units with a church and a school. Traditional garb and tattooing were also prohibited as signs of improper primitiveness.

The Mentawaians were generally unable to fend off this massive attack on their traditional way of life, and they adapted to the new conditions. Only in the interior of Siberut did a few groups succeed to some extent in escaping from the disruptions of modernization. In the past few years this has been made easier for them. Under the banner of renewed interest in the values of the old Indonesian cultures, the government has become more tolerant in its attitude. The voices of international organizations have certainly helped by demanding a more careful handling of the cultural heritage as well as of the unique flora and fauna of the islands.

Today, it is the young, educated Mentawaians who have become most mindful of their ethnic roots. They defend themselves against the condescension to which their people have been exposed, and seek ways to assert Mentawaian identity within modern developments. They draw their inspiration from the very individual who was always the first to be attacked by both government and missionaries, the individual in Mentawaian culture who produces its richest and most impressive manifestation—the shaman, the *kerei*.

THE KEREI

The modern Christianized villages on Siberut give a rather dismal impression. The religious roots of the cultural heritage that once made the "savages" so "amiable" and that provided the traditional stimulus for architecture, dress, and decoration no longer exist. For the time being one hardly notices any attempt to make something special from the new, imposed housing or the modern dictates concerning dress. Remnants of an independent cultural tradition are more likely to be found in the field houses, where the people feel less observed. In the new settlements life often seems rather depressing.

And then it can happen that one suddenly comes across a magnificently

decorated group of shamans on their way to a healing ceremony. The contrast could not be greater. The Mentawaians say that the spirits and the souls can be influenced in these ceremonies only when they meet worthy opponents. In order to be worthy, the shaman must correspond to the traditional image of the *kerei* with his special garb; this is how one can see him in many areas of Siberut again today. This worthiness is not limited to his external characteristics. What makes such an extraordinary impression when you come across a group of shamans is their proud demeanor and self-confidence. They clearly regard themselves as an elite. No wonder they have today become a kind of ethnic symbol for the young Mentawaians.

Shamans exercise their duties both inside their own *uma*s and at the invitation of neighboring groups. They have a double task, a healing and a preventive one. Both call for an intimate relationship with the otherworld of the souls and spirits. In the healing ceremonies the goal of the shamans is to appease and remove the powers responsible for the illness, to calm the soul of the patient, and to cool off the diseased body. In the communal rituals they preventively help ward off destructive supernatural influences and call on good forces. For all these tasks the shaman uses not only sacrifices but also magical means, in particular parts of certain plants, whose souls are activated by incantations. Many of these actions can, in principle, also be undertaken by other adults, but the shamans confer on them a particular importance. This is due to the shamans' special ability: they can see the souls, the ancestors, and the spirits, and they can communicate with them. Thus, they can inform them of the wishes of the living and learn certain things from them, such as the cause of an illness. One expression of this link with the world of the supernatural is the trance.

However, the power of the shaman can only be fully realized if he attunes his life to his role as a *kerei* and adheres to the corresponding rules of behavior. For example, in everyday life a *kerei* may not eat certain animals, such as squirrels, which are regarded as somewhat questionable though permissible for others. There are stricter taboos for shamans during the exercise of their functions. If they do not adhere to these restrictions, they are endangering both the success of their activities and their own persons. These taboos apply not only to the shamans but also to their wives. While their husbands are active as shamans, the *kerei* wives may not fish or cultivate, and they may do only the minimum to take care of the domestic animals. As a sign of their special circumstances, they decorate themselves with flowers more lavishly than usual. All sexual intercourse is taboo during this time.

As a consequence of these rules, the shamans are, if anything, economically worse off than the other men. Furthermore, they hardly receive any private compensation for the role they play. Their remuneration often consists of an extra portion of meat, which they take home with them. But the crocodile spirit mandates that no one in Mentawai eats meat alone. What a *kerei* brings home is divided among all the members of the *uma*. This promotes the shaman's prestige among his companions but yields little personal practical gain. Besides, personal inhibitions about being in the limelight, the fear of these taboos, restrains many young men from becoming *kerei*. In central Siberut, only about one fourth of the men become shamans.

Because of this dichotomy—on one side the drawbacks, on the other the distinction of belonging to an elite, as well as the personal prestige that accrues from that position—it is frequently the father who takes the initiative of having his son consecrated as a shaman. This will at the same time enhance his own reputation, for a respectable *kerei* initiation requires one to regale helpers and guests with dozens of pigs and hundreds of chickens. Anyone

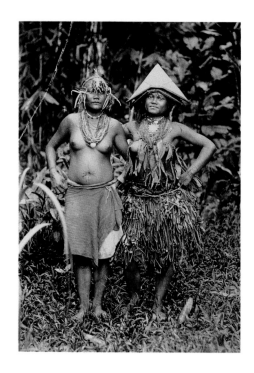

C. Nieuwenhuis photographed these two women from Pagai, the southern Mentawai islands. The women strike a traditional dance pose at the instigation of the photographer. The hat on the woman at the right is typical for the southern Mentawai islands and the rattan band she wears above her breasts is used by nursing mothers to increase milk production.

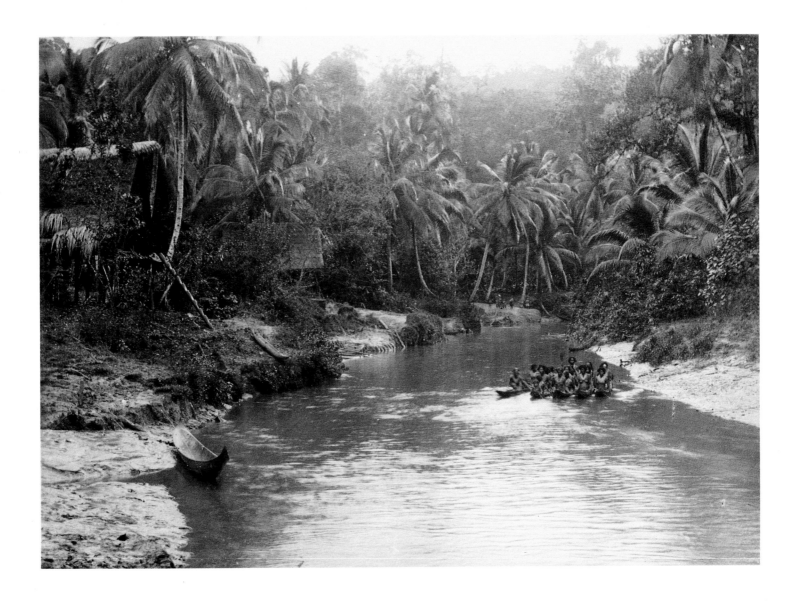

who gives such a festive celebration is praised throughout the entire region.

For a noninitiate to have trances and visions, as was the case with Sigilaket, is thus not the only way to become a shaman. In other instances the divining capabilities of the *kerei* emerge in the course of his training. They are a favor from the supernatural powers, a sign of thanks for the many sacrifices made to them. It is also a favor that the shaman receives the ability to remove the visible traces of an illness, for example a small stone, out of the body of a patient. And it is from the same source that he derives the art of dancing in the embers of the fire at the high point of the great rituals. The ceremonies conducted during the initiation of a *kerei* give him his special abilities. The initiation is also partly a training. Most magical means are already known to the novice; indeed they can be used by all adults. What he has to learn are the secret details of the ceremonies that are the exclusive preserve of the shaman. And above all he must acquire the medium through which shamans contact the beyond: the sacred lyrics and melodies of many dozens of *kerei* songs.

THE INITIATION OF A SHAMAN

An initiation, a *pukereijat,* lasts several months. Often two or three novices are trained at once. A master, a *paumat,* is in charge, usually a shaman from a neighboring *uma*; he will later be rewarded for his instruction with pigs and various articles. The ritual begins with a communal ceremony of all the *uma* members, which introduces a period of strict taboo for the novices and

The abundance of dugout canoes illustrates the importance of the river networks, which offer the Mentawaians their only means of communication and transportation in the absence of any regular roads.

their wives. In particular, no sexual intercourse is permitted until the conclusion of the initiation.

After this ceremony, the novices build, with the help of their companions, a small house (*pulaeat*) far away in the quiet of the jungle, where they spend the following period in seclusion. The house is ritually consecrated in the presence of the master and the future shamans' closest relatives. The ancestors receive a sacrifice; they are told what is going on and their help is requested. The master dances next to the sacrifice, sings a few verses from a *kerei* song, and calls to the ancestors: "Look at us, soon your grandchildren will be doing this!"

During the following four or five months the novices stay alone in the *pulaeat*. They live frugally, wear no decorations, and may not be deloused. Their work is to raise chickens and pigs for the coming ceremony, and they plant flowers for the decorations. Toward the end of this period the father calls helpers from his *uma* and from other *uma*s, and they together make the necessary preparations. This completes the novices' period of seclusion. The exit from the *pulaeat* is accompanied by a communal ceremony of all the *uma* members and the helpers.

In the *uma* the master now begins his instruction. He sits down on the dance floor with the novices and teaches them the songs and melodies. There are no secrets about these songs. Observers are permitted to be present throughout the instruction. In the meantime the helpers are producing the articles that are the exclusive garb or equipment of the shamans: a hair decoration of feathers and the ribs of palm leaves, a necklace of ocher-colored cylindrical glass beads, a dancing apron fashioned from pieces of cloths of diverse hues, a headband, and woven upper-arm rings studded with beads. As containers for these attributes, wooden cases are made and decorated with carvings.

In the ceremonies that follow, the process that has begun is further developed. Numerous pigs are slaughtered; for each one a decorated bamboo pole many meters high is erected on the riverbank to bear witness of the magnificent ceremony to the neighbors. Finally each novice receives "seeing" eyes. He goes with the master to a hidden location in the jungle, where he must swear never to reveal the secret. How exactly this secret is formulated, I have never precisely heard. Old shamans tell that the novice is summoned to massage a little illness stone from a spear that has been taken along; this stone has been placed in the spear by the ancestors as a test. Because the novice is unsuccessful, the master shows him how it is done. After that the novice gets a splash of pungent ginger juice in his eyes from a little bottle and in this way comes to be "seeing." The master asks him what he sees. If he sees a young boy, he will soon die. It is in keeping with the instruction, however, for him to see an old man, but at first in a blur; only after the novice has turned away and looked at him behind his back in a mirror can he perceive him clearly.

Several days later, in the *uma*, comes the high point of the initiation, *alup*. Decorations are laid out on the veranda at night, and the ancestors are called and invited to take as many as they like. Every novice has by now learned to see the ancestors, and he dances on the dance floor with his hands on his loincloth at his hips, watching them intently. If they do not pay attention for a moment, he charges forward to the edge of the veranda and returns with an amulet that he has grabbed from them in his hands. Later the *kerei*'s necklace will be hung with these amulets.

Numerous visitors have come for this night, including special guests, the shamans from a neighboring *uma*. With them the novices perform a trance-

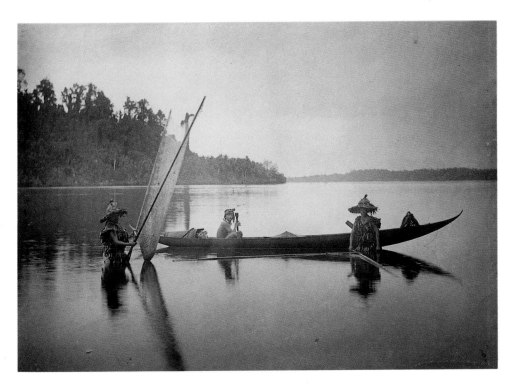

In a romantic moonlight setting, two women fish while a man paddles the canoe.

inducing dance, the *lajo*. The master holds a small model canoe and dances with it. The dance is accompanied by a song that describes how the shamans travel to a great mythical *kerei* by the name of Pageta Sabbau in order to gain some of his strength. Then everything becomes quiet. The master sits down in front of the hearth, and the novices dance a bird dance, without the accompaniment of the drums, and then squat down.

In the role of Pageta Sabbau the master asks: "Who are you, who is dancing here?"

"I, a *kerei* from a long time past," the novice answers, testing Pageta Sabbau, and dances anew.

"No, you are a new *kerei*."

"Yes, old one, I am a new *kerei*."

"I, nephew, I am an old *kerei*."

"Then I come for your strength, I come for your honor!" And the novice dances again. The spirit of Pageta Sabbau has now come close and hovers above both of them. Suddenly the young shaman reaches up and takes an amulet from the spirit. Immediately he is convulsed in a trance on the floor. Then trance-inducing dances are danced all night, and for the first time the novices dare to step through the fire.

For the young *kerei* and their *uma* there now begins a long transitional period leading to the resumption of everyday life. The new *kerei*, together with the master and his wife, pay peaceful visits to the friendly shamans of a neighboring *uma*, where they are received and regaled with great honors. The young *kerei* are, now that the ritual has been just completed, at the height of their powers, and the inviting shamans initially hide in mock terror when their guests arrive. Then the new *kerei* receive an enthusiastic welcome. Together they dance *lajo* dances, but first the guests dance alone to show their maturity. And again the song resounds:

Aptly you adorn the head of my friend, *leoi*,
My friend, the *kerei*, the new *kerei*,
Equal are his steps in dancing,
Rhythmically he stamps on the boards, *leoi*.

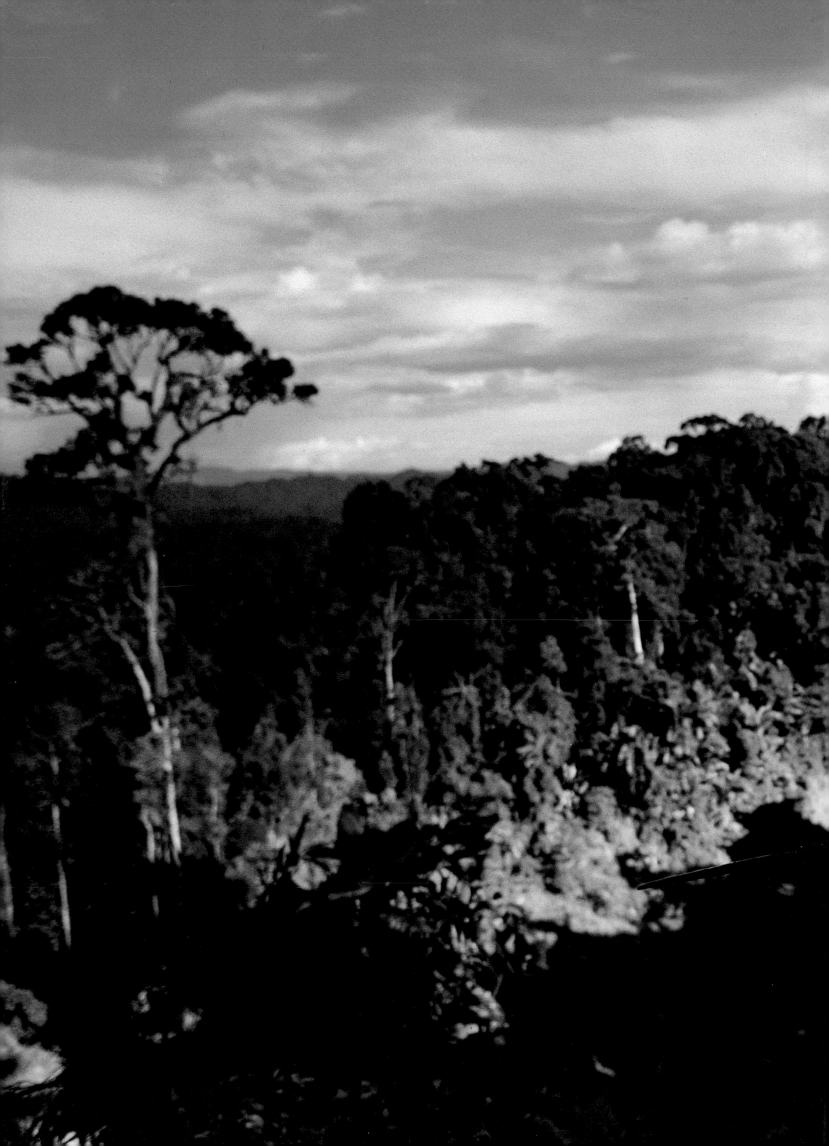

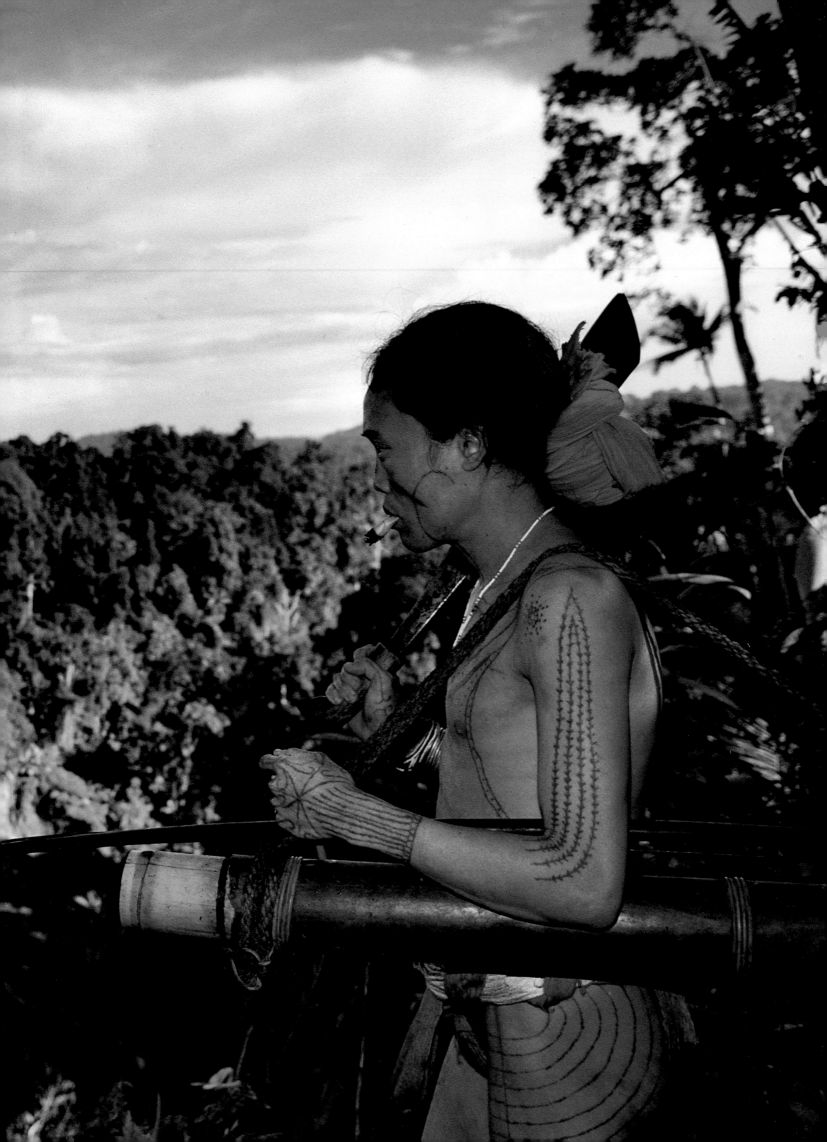

THIS BOOK IS DEDICATED TO
AMAN LAU LAU MANAI AND HIS FAMILY.

On a project spanning eight years there are many people to thank. Just a few of them are Lee Chang Nam, Lincoln and Mayumi Potter, Hasan in Padang, Hiroshi Yasumura, Akifumi Tanaka at Nikon, Rolf Bökemeier at *Geo*, Hisae Kawahara, Kaz Tsuchikawa, Takizawa, and Abe-san at Cibachrome Japan, Mr. Shigeru Chatani, Fuji Film Professional Products, Henry Heuveling van Beek, Gerard Persoon, Reimar Schefold, Michael Hoffman, Wendy Byrne, Genie Leftwich, and my editor at Aperture, Andrew Wilkes, who had the vision to bring this book to print. Finally I thank my brother, Tom, and my parents, Karen and Charles, for understanding my extended absences.

There will always be mysteries, secrets, and some things untold.

Ka pora sabeu, sika sara—ku repdep Mentawai.

Copyright © 1992 by Aperture Foundation, Inc. Photographs copyright © 1992 by Charles Lindsay. Historical Essay copyright © 1992 by Reimar Schefold. Text copyright © 1992 by Charles Lindsay.

All rights reserved under International and Pan-American Copyright Conventions. No part of this book may be reproduced without written permission from the publisher.

Library of Congress Catalog Card Number: 92-71039
ISBN: 0-89381-520-9

Charles Lindsay is represented by Q Photo International, Tokyo, Japan.

The staff at Aperture for *Mentawai Shaman: Keeper of the Rain Forest* is:
Michael E. Hoffman, Executive Director
Andrew Wilkes, Editor
Michael Sand, Managing Editor
Genie Leftwich, Copy Editor
James Anderson, Martha Lazar, Editorial Work-Scholars
Stevan Baron, Production Director
Sandra Greve, Production Associate

Book and jacket design by Wendy Byrne

Composition by The Sarabande Press, New York. Separations by La Cromolito, Milan, Italy. Printed and bound by C & C Joint Printing Company, Hong Kong.

Aperture publishes a periodical, books, and portfolios of fine photography to communicate with serious photographers and creative people everywhere. A complete catalog is available upon request. Address: 20 East 23rd Street, New York, New York 10010.

Selected images from *Mentawai Shaman: Keeper of the Rain Forest* are available in limited-edition prints through Aperture. A share of the proceeds from the sale of these prints goes toward supporting this project, devoted to saving the Indonesian rain forest, and to the ongoing ecological conservation programs of Aperture, a non-profit, educational, public foundation.

First edition
10 9 8 7 6 5 4 3 2 1

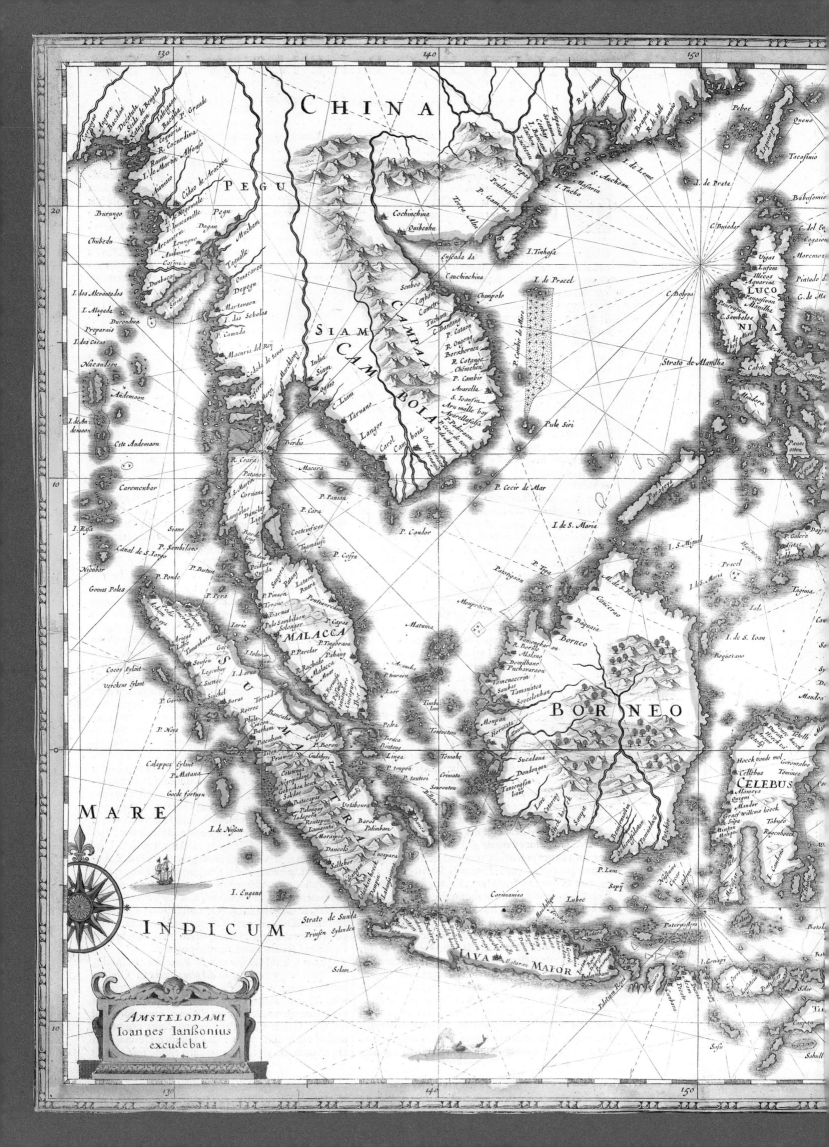